THE PHOTOGRAPHER'S GUIDE TO THE
STUDIO

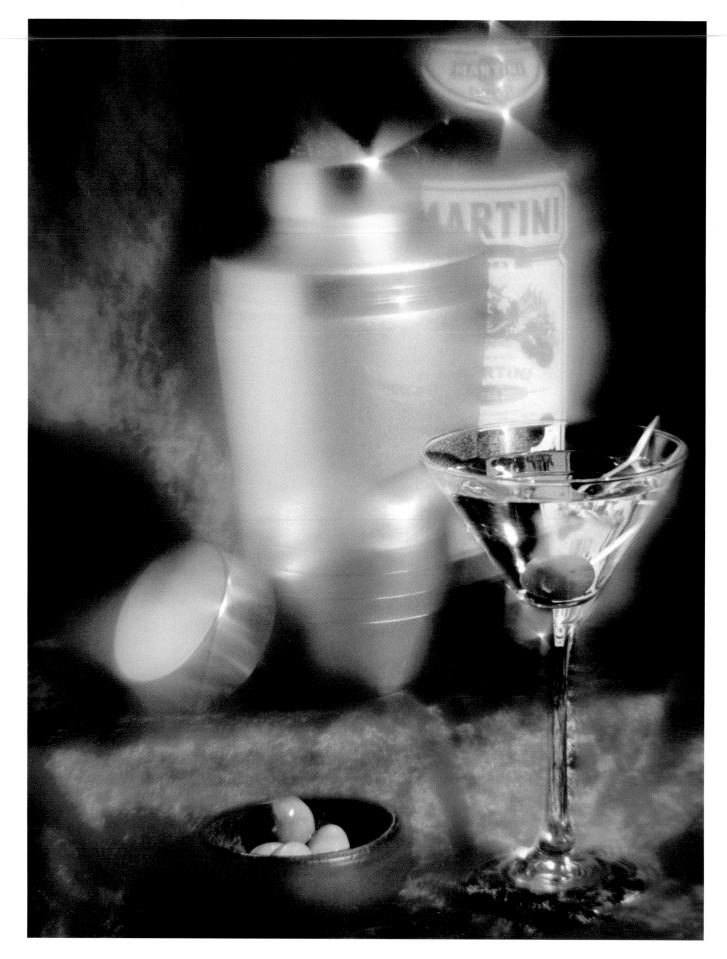

MARTINI (SEE PAGE 35)

THE PHOTOGRAPHER'S GUIDE TO THE
STUDIO

Roger Hicks
and
Frances Schultz

also featuring the photography of Marie Muscat-King

David & Charles

A DAVID & CHARLES BOOK

First published in the UK in 2002

A catalogue record for this book is available from the
British Library.

ISBN 0 7153 1234 0 (hardback)
ISBN 0 7153 1399 1 (paperback)

Printed in Hong Kong by Dai Nippon
for David & Charles
Brunel House Newton Abbot Devon

Commissioning Editor Sarah Hoggett
Art Editor Diana Dummett
Senior Desk Editor Freya Dangerfield
Production Roger Lane
Illustrator Peter Daly

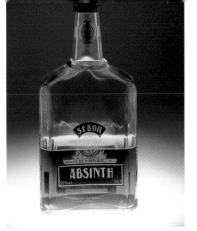

CONTENTS

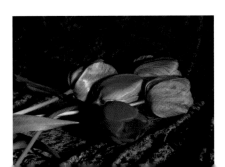

1

Studio photography can be a lot
easier and a lot cheaper than most
people think. This is true whether you
are shooting for your own pleasure
or for money; whether you want
exhibition prints, or a book or
magazine article, or catalogue
illustrations, or pictures for a website;
and whether you are using a brass-
and-mahogany camera from the
dawn of the twentieth century, or
the latest digital camera.

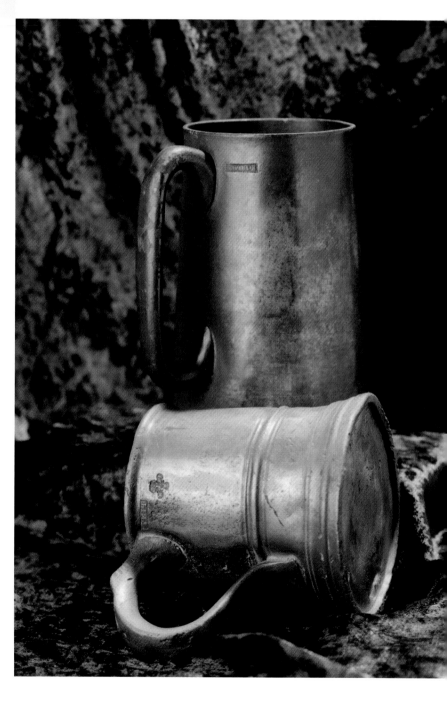

TANKARDS
These are part of a series that Roger has
shot over several years: a more descriptive
caption appears on page 12.

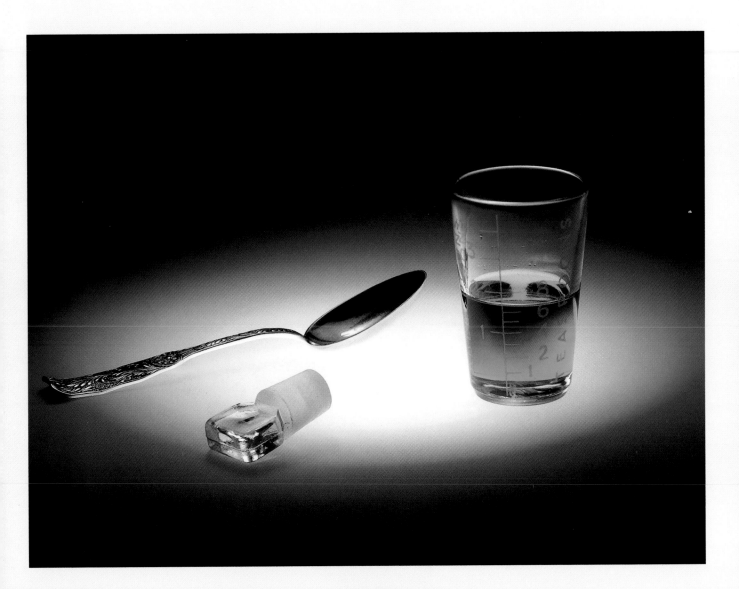

STRONG MEDICINE

The glass, stopper and spoon sit on a sheet of tracing paper laid over a glass cabinet door. The only light comes from underneath, a snooted (page 61) Paterson flash. A mirror and a white polystyrene tile, just out of shot above the subject, bounce light back in to give detail in the spoon. The composition was designed to leave room for the heading and the text on these two pages – a classic example of working to a brief – but the layout has changed since.

Linhof Technikardan 4x5in, 210/5.6 Rodenstock Apo-Sironar-N, 6x7cm Kodak E100VS. (RWH)

AMATEURS AND PROFESSIONALS

Many photographers believe – incorrectly – that studio photography is the preserve of well-equipped professionals. It isn't so. Many amateurs work to at least professional standards, often without realizing it. The only difference is that the professional has to deliver pictures on demand: the amateur doesn't. Working to order is a skill in its own right, but it doesn't necessarily mean the professional takes better pictures. Studio photography is open to all.

Even among studio-based professionals who work to the very highest standards, be it in advertising or portraiture or anything else, there are plenty whose work is limited and frankly formulaic. The formula may be their very own, and it may look gorgeous; but they might fare no better than a skilled amateur if they had to turn their hand to some other aspect of photography. By the same token, the skilled amateur can soon achieve proficiency in studio photography.

Then there are people who need studio illustrations for catalogues or websites or whatever, but can't afford to have them shot professionally – though if high-quality pictures really are essential, a business model that excludes the cost of producing such pictures is arguably badly flawed.

Types of studio photography

When it comes to deciding what sort of picture you need, the most important thing is what you want it for. This is much more important than whether you call yourself a professional or an amateur, or whether or not you get paid for your pictures.

For example, the requirements for a good portrait remain constant, whether it is paid for or not. Both fine art and advertising place many of the same demands on the skill of the still-life photographer. A catalogue picture must illustrate the subject adequately, whether it is aimed at mail-order (or on-line) sales, or at showing the fine points of a collectable on a website.

Studio techniques for all

Much of the information in this chapter is as relevant to general photography as to studio photography, but we make little apology for including it. Studio photography is not a special order of creation, open only to the chosen few; to forget this is to introduce all kinds of barriers, spectres and bogeymen that stand in the way of mastering a subject that is relatively simple technically, but allows enormous rein to your personal vision.

Paradoxical as it may seem, we hope that this book may even be useful to users of (reasonably) simple digital cameras, or for that matter to 'non-photographers': those who need images, but take no particular pleasure in making them, and have no desire to learn a great deal about photographic technicalities. Obviously, most of the book is aimed at those who are already committed photographers, but many (though far from all) basic studio skills are so easy to acquire that they can benefit everyone.

▶ **GUITAR**
Marie Muscat-King was not a professional photographer when she shot this picture: she still clung to the relative security of the day job. But could anyone have captured the sheer energy of the music better?

PATERSON FLASH, NIKON F, 85/1.8 NIKKOR, KODAK PORTRA 400VC. (PRINTED BY FES)

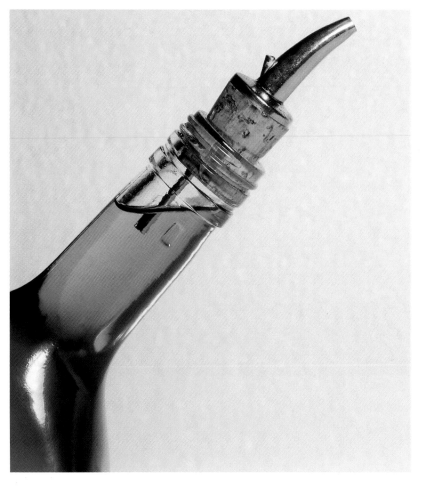

▲ **OLIVE OIL POURER**
A good advertising shot would have oil running out of the pourer (recycle it with a small jug), but this is a start. Practise shots like this if you have aspirations to advertising. The Paterson flash was in front of the subject, to camera right; a mirror behind the subject, to camera left, reflected light through the green-gold oil.

LINHOF TECHNIKARDAN 4x5IN, 210/5.6 RODENSTOCK APO-SIRONAR-N, 6x7CM KODAK E100VS. (RWH)

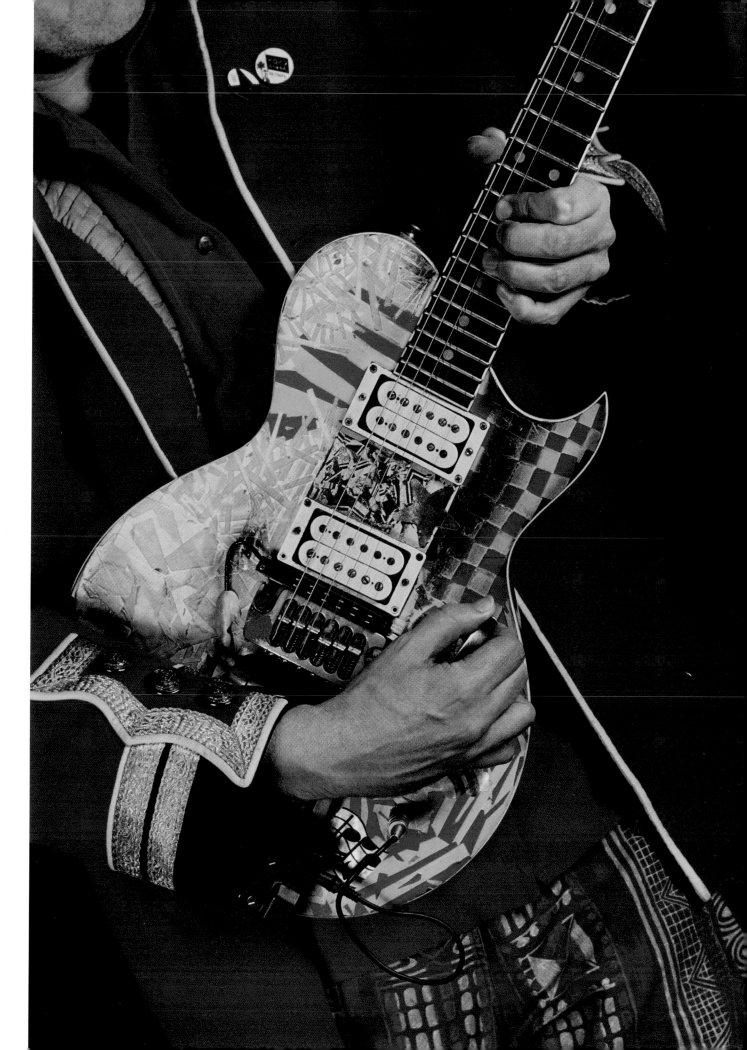

FINE ART AND THE STUDIO

Sooner or later, most serious photographers start to produce pictures that are worth hanging on a wall: pictures that not only they, but also others, can enjoy as works of art. These can succeed (or fail) on many levels. A work of art must be as carefully targeted to its potential buyer as a piece of furniture or a motor car – and it is just as subject to fashion.

The kinds of art to which the studio lends itself are principally the portrait and the still life. Portraits are more often applied art than fine art, but then, the division between art and artisanship is often overstated. A great photographic portrait can be a work of art; the fact that a bad one isn't is no more an indictment of photography-as-art than a bad daub by an unskilled painter is an indictment of painting-as-art.

Still lifes demand rather more pressingly to be taken as Fine Art (with capitals), because few people feel so deeply about a basket of vegetables, or a couple of pieces of pewter, that they want pictures of them on the wall for the subject's sake. Rather, a still life is hung on the wall for its own sake, as a picture: the old definition of 'pictorialism'. Much photography that was truly awful was done in the name of pictorialism, which brought the word into disrepute, but we believe that the term is overdue for revival, without the pejorative overtones it once enjoyed.

Yes, but is it art?

Art, according to some critics, is what artists say it is. A more cynical but more realistic definition might be that art is what artists can persuade someone to pay them for. Although this is a good working definition, we (and, we suspect, most of our readers) would set our sights a little higher, without however adding much in the way of further definition: art is what you can get someone to pay you for, because they appreciate your originality of vision.

When someone buys one of your prints, they are buying nothing except your talent, your vision, and your ability. That's a good feeling. Better still, you are being paid in hard currency, not mere appreciation.

Do not, on the other hand, imagine that you are likely to become rich. We know a number of very fine photographers who produce stunning pictures – principally still lifes, or heavily reworked portraits – and we know them well enough to know that when they sell a picture, it's a real red letter day. There are very few photographers whose prints sell for high enough prices, and often enough, to earn even a modest living. The general advice must always be: don't give up the day job.

► **IN CASE OF INVASION...**
...church bells will be rung. These props just seemed to suggest a still life: the gun, the World War II map, the keys. People buy pictures like these: they are intrigued by them.

GANDOLFI VARIANT WITH 5x7IN/13x18CM BACK, 210/5.6 RODENSTOCK APO-SIRONAR-N, ILFORD FP4 PLUS. (RWH)

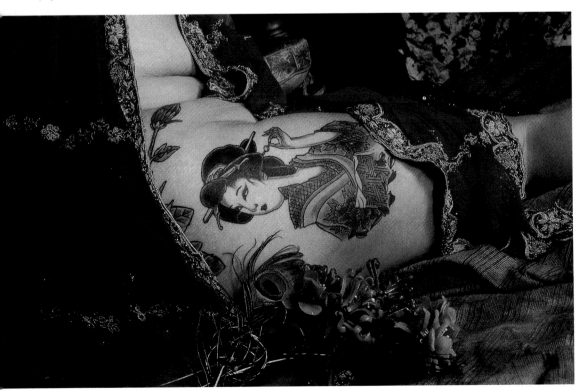

◄ **TATTOOED LEG**
Art is not necessarily 'pretty-pretty'. People also buy for shock value; for novelty value; and because a particular style or subject matter is fashionable. But shooting for any of these (shock, novelty or fashion) is likely to be unsuccessful unless you put something of yourself into the shot as well.

NIKKORMAT FTN, 85/1.8 NIKKOR, FUJI ASTIA. (MMK)

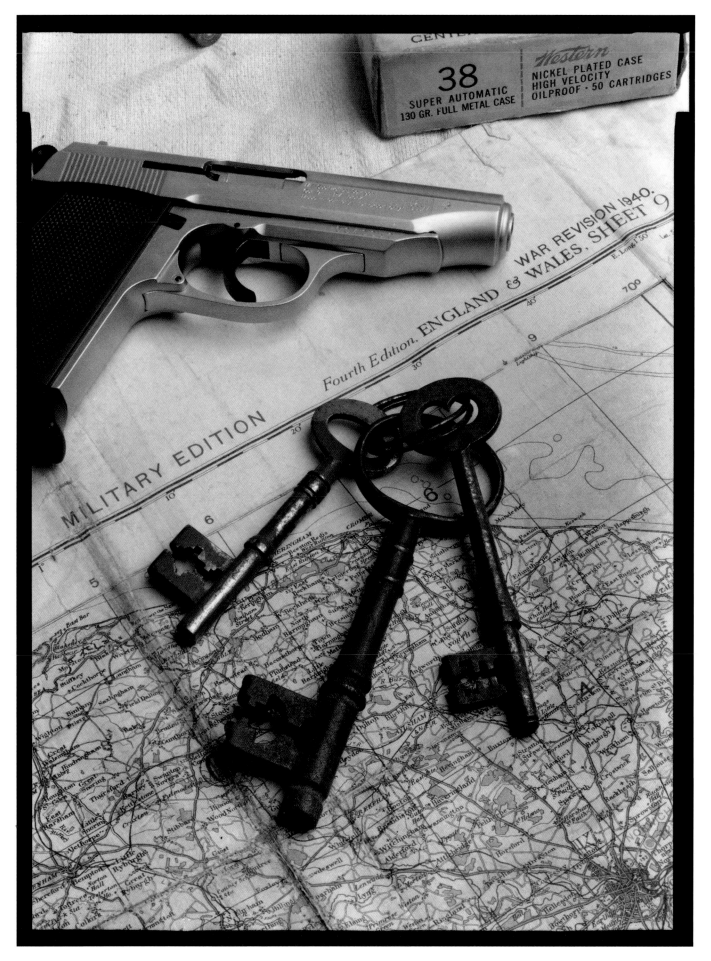

STUDIO SHOTS FOR COMPETITIONS

Most photographers first attempt to reach a wider audience via competitions. Studio pictures can be particularly suitable for this purpose, for a number of reasons.

Firstly, few entrants have even rudimentary studio skills. They successfully doom themselves before they even start, because they are convinced (wrongly) that studio photography is too difficult and too expensive.

Secondly, because studio photography is independent of the weather – and even of the availability of daylight, in most cases – the studio photographer has a much wider window of opportunity in which to shoot.

Thirdly, the studio photographer is much less constrained by the fleeting moment. In portraiture, for example, it is as important as ever to press the shutter release at precisely the right moment; but the light and shadow should be under the photographer's control, and the subject can be asked to repeat the expression. Moreover, many still lifes can remain unchanged for hours or even days.

Fourth, the studio photographer can examine his or her pictures, then re-shoot almost endlessly in the light of the lessons learned. Compare this with, say, a balloon festival. Get it wrong, and you may not be able to re-shoot for a year.

Fifth, there is novelty value. Judges see an awful lot of pictures that are not very good. The well-executed studio picture can stand out by reason of its dissimilarity from just about everything else that is submitted – and once your picture has been noticed, instead of merely dismissed as 'Just another _____', your chances increase dramatically.

How to win

Merely because you submit a studio shot for a competition, it does not mean that you are exempt from the normal rules for winning – but if you are sufficiently organized to make good studio pictures, then you should be organized enough to win competitions.

Read the rules, and obey them: don't submit colour pictures for black and white competitions, or prints for slide competitions, or pictures that are larger or smaller than specified.

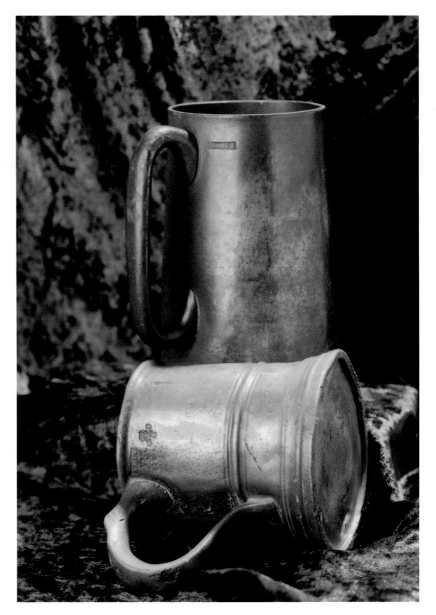

Enclose return postage and packing, and make sure the pictures have at least your name on them, and preferably your address as well.

You should stick to the subject. 'Stretching' and reinterpreting the brief, or making visual puns, is perfectly acceptable; submitting pictures that don't fit the brief is not. The number of people who do so is always unbelievably high.

Try to second-guess the judges. You can never know their minds fully, but you can try to make a better guess than the other entrants.

Remember that minimum and maximum print sizes are intended to weed out eye-strainingly small enprints and hard-to-handle oversize prints, but they can also be used creatively.

▲ **TANKARDS**
Roger used a 5x7in Gandolfi with a 210/5.6 Rodenstock Apo-Sironar-N to shoot these tankards on Ilford FP4, then made a contact print on 8x10in Centennial printing-out paper. If a print 'wants' (or in this case, needs) to be small, consider printing it on a bigger piece of paper with a wide border: fiddly little enprints or postcards are often dismissed with barely a glance, but a big print with a small image can have considerable impact.

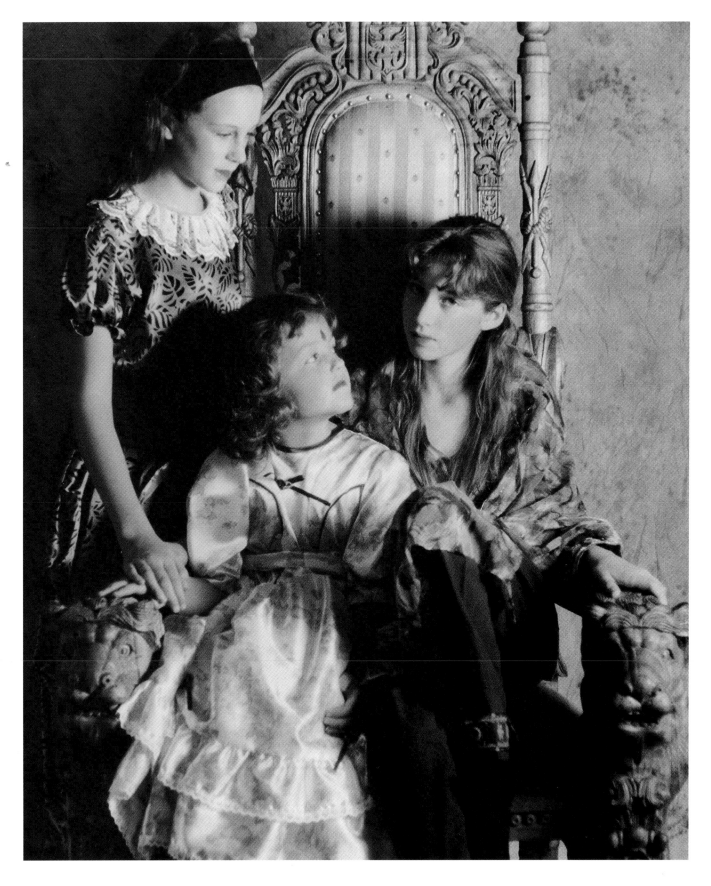

THRONE

Hand colouring can easily tip over into saccharine sentimentality (which is what some competitions
are after!), but on this occasion it genuinely does capture some of the magic of childhood.

NIKKORMAT FTN, 50/2 NIKKOR, ILFORD 100 DELTA. (MMK)

EARNING MONEY IN THE STUDIO

◀ **DEAN**
This was taken using tungsten 'Hollywood' lighting: a 300W spot as the key (page 48) and a 500W 'bowl and spoon' as a fill (page 48). The secret of the vintage look – which is very saleable – was the 1960s 8x10in De Vere camera and early twentieth-century 21in/7.5 Ross lens, shooting on Ilford HP5 Plus.

(RWH)

Neither fine art sales nor competition wins are likely to make you rich. A more reliable route to riches, or at least to a living, is commissioned work: portraits, advertising still lifes, catalogue illustrations. Most reasonably proficient amateurs can easily acquire the skills that are needed at all but the highest levels of studio photography – and most professionals, even those working at the highest levels, started out as amateurs.

The main thing to remember is that studio skills must be heavily supplemented by business and other skills: booking, scheduling, costing, prop finding and more.

Second, quality must be taken for granted: spot-on exposure, perfect control of sharpness, excellent colour balance, and so forth. As already intimated, working in the studio makes it easier to achieve all these desirable goals, simply because the photographer is in control of more variables.

Third, money spent on studio equipment can

make life easier. For instance, a highly skilled darkroom technician can make stunning 12x16in/30x40cm portraits from a 35mm negative; but if you start out with a 6x7cm negative, even an average commercial printer can make an excellent print. Similar arguments apply to buying studio lighting, camera stands, and so on.

Photos for publication

It is sad but true that photomechanical reproduction does not do anything like justice to the vast majority of pictures, whether studio or not. Some photographers take this as a counsel of despair, and are content to deliver indifferent pictures that are then made worse by the printer. In the studio, though, where you are fully in control, it is often as easy to take pictures that will reproduce perfectly as to take ones that will not.

The most useful single piece of advice we can give is to keep the lighting as flat as you can without its actually becoming boring: 'blown' highlights and blocked-up shadows are much easier to avoid in the studio than in the outside world.

Stock photography

The days when newspapers and magazines could get away with 'grey pages' of solid text are long gone – but often, the pictures have no real function other than to break up the text, and they are bought from a picture library. Many of their best-selling shots are set up in studios, or using studio skills.

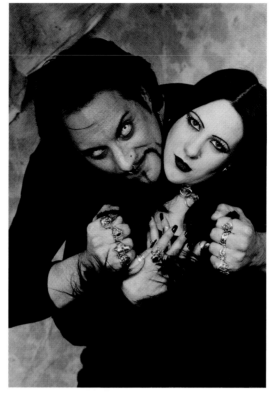

◀ **BEAUTY AND THE BEAST**
Sharlene and Steve enjoy dressing up – and they are rather better at it than most people! If you can take pictures of this standard, you can sell portraits.

Nikkormat FTn, 85/1.8 Nikkor, Kodak Portra 160NC. (MMK)

Examples are legion. The bride looking at her watch. The alert-looking policeman. The harassed executive, head sunk in hands. Often, they aren't particularly good portraits. But they fill a need. And they are comparatively easy to shoot. There is generally less demand from stock houses for studio still lifes, but look carefully as you read your daily paper or scan a magazine, and you will see more and more examples. It is an avenue that you may well care to consider.

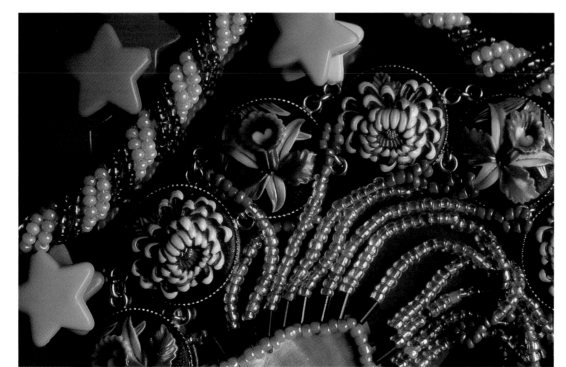

◀ **BEADS**
A shot like this is in constant demand as a backdrop in 'comped' or assembled pictures, where text and other subjects are 'dropped in' against an attractive but not overly dominant background.

Nikkormat FTn, 50/2 Nikkor, Kodak E200. (MMK)

2

A STUDIO
OF YOUR OWN

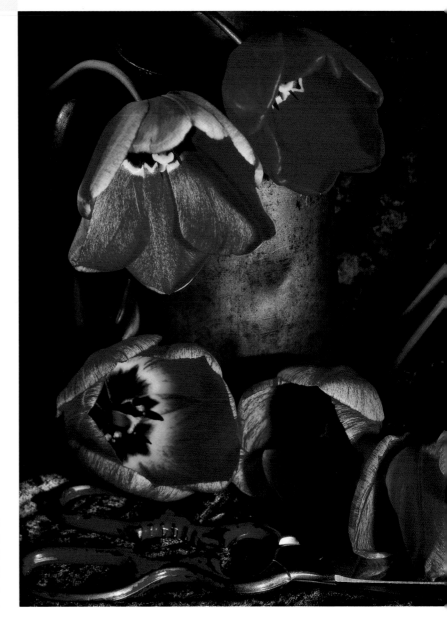

Studio photography – like all photography – is the art of illusion. It doesn't matter what is going on outside the frame, in space or time. The difficulty lies not in persuading other people of this, but in persuading yourself. You know what is there; you are all too aware of the shortcomings of the set, the difficulties you face. But show someone else the picture; ask their reaction; and see what they say when you point out perceived shortcomings. You could be pleasantly surprised.

TULIPS
These were from the first year we ever had a good crop of tulips in our garden, and we both photographed them repeatedly until they (and we) had begun to wilt. See also pages 26–7.

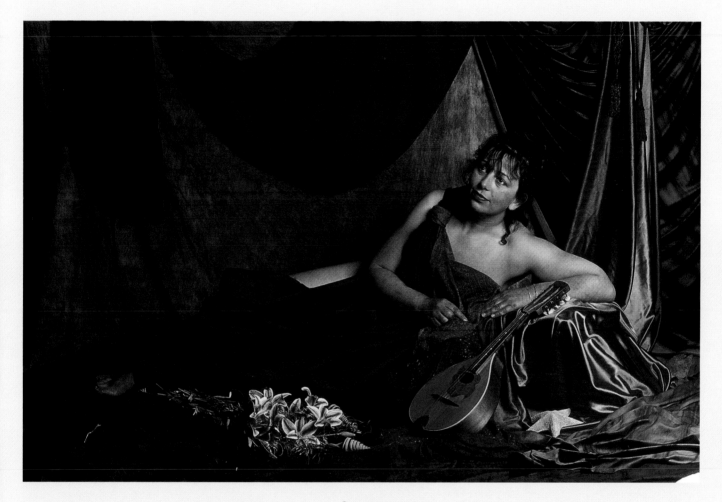

ODALISQUE

The sultry, scantily clad vamp reclines in a Turkish seraglio, surrounded by rich fabrics. It doesn't matter that she's in a café in Ramsgate, Kent; or that as soon as the shot is finished she is going to put on a warm, fleecy dressing-gown; or that the rich fabrics came from the remnant shop across the road. It's all illusion.

NIKKORMAT FT3, 70–210/2.8 SIGMA APO, KODAK EBX. (MMK)

STUDIO SIZE: HEIGHT AND WIDTH

The term 'photographic studio' is somewhat misleading. The image it conjures up is of something rather grand, distinctly unaffordable, and probably a bit intimidating.

It's not like that. Or at least, it doesn't need to be. Of course, it's nice to fantasize. Who wouldn't like to have the run of an Edwardian portrait studio, all huge windows and potted plants, or a fashion studio in the Swinging Sixties with purple background paper and a whirring, clattering F36 pulling grainy Tri-X through a Nikon F?

But most studios are distinctly less magnificent – ours included. We have illustrated whole books with a combination of location work (albeit using studio skills) and a table-top 'mini-cove' (page 26) in the dining room of a tiny Victorian two-up, two-down working-man's cottage. We shot two cookbooks in our garage when we lived in California. And most of the studio shots in this book were shot either in our studio, which is the parlour of a rather larger Victorian house, or at Marie Muscat-King's place. Her first studio was a low-ceilinged cellar, though nowadays she uses a much bigger room. The only drawback is that the bigger room is a cafe during the day, so she has to move all the tables around in order to make room to shoot...

The greatest single luxury in a photographic studio is space, and plenty of it. The more space you have, the easier it is. After all, you can always work in the corner of a big studio, but it's hard to expand outside the walls of one that is too small.

A great deal depends on the sort of work you do, of course, and it is possible to create quite stunning results in the most unpromising spaces, if you are prepared to adapt your technique to suit your space. Even so, it's best to look at the ideal studio first, and then at the compromises you may have to make.

Height

We use quite a lot of overhead lighting, generally a soft box (page 61) for simple product shots; the caption to the camera picture shows just how much height this entails. For a portrait with an overhead soft box, you need more like 3m (10ft).

If you don't have this much height, there are several options. Some soft boxes are slimmer than ours. Alternatively you can work on a lower table, perhaps even on the floor. Or you can bounce the light off a white-painted ceiling: this is less efficient, and less controllable, but still perfectly satisfactory for many applications. Or you can live without overhead lighting altogether.

Width

Just as a theatre requires 'wings' to allow the actors and scene-shifters to come on stage from the sides, a photographic space also requires room at the sides to set up lights. Even a table-top set-up normally requires at least 1m (3ft) of working space either side. If you've anything stacked against the walls, you'll need another 1m (3ft) to allow for that: a total of 4m (13ft). It is possible to work in a space smaller than this, but it is difficult. In fact, even with a 4m (13ft) space, the width of our studio, we can confirm that working in it comfortably is pretty difficult.

▼ ► **STILL LIFE AND SET-UP**
The set-up that Marie used to take a still life (*right*) is shown (*below*). As you can see, the still life could have been taken in quite a small room; but enough space to shoot the set-up (which is a fairly typical mid-sized shot) is another matter entirely. The cameras in both cases were Nikkormats, an FT3 and a FTn; the film, Kodak EBX.

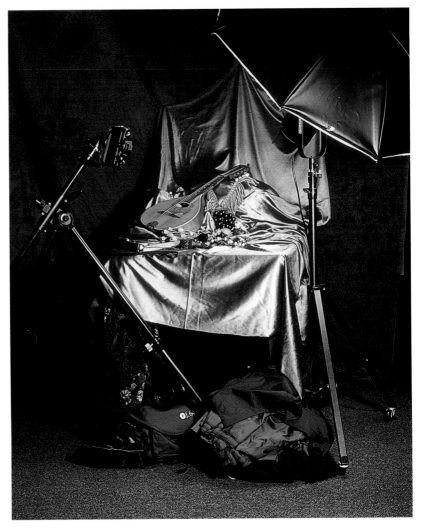

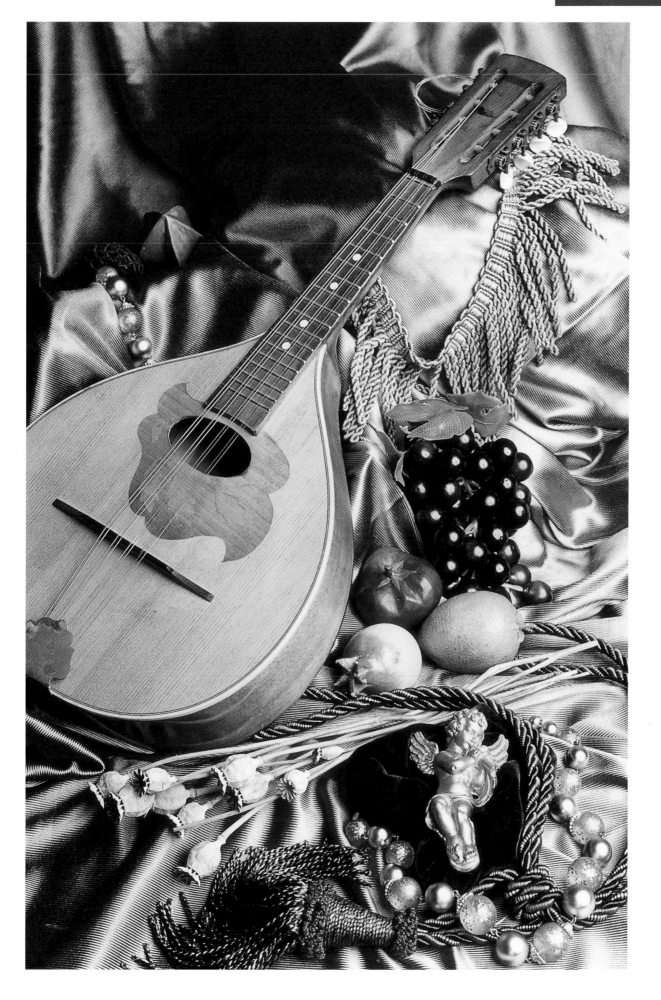

STUDIO SIZE: LENGTH AND STORAGE SPACE

The minimum convenient length for a portrait studio is quite shocking. For a seated half-length portrait, you generally need at least 1m (3ft) between the subject and the backdrop, and at least another 1m (3ft) behind that for backlights. Then the camera needs to be up to 2m (6ft) in front of the subject, and you need another 1m (3ft) for the photographer to get behind the camera. That's an overall length of 5m (16ft).

Mercifully, this size does not increase as much as you might expect if you want to shoot full-length portraits, because you can get away with a shorter lens.

If you aren't doing portraits, but just table-tops, you can often get away with a good deal less length, as little as 3m (10ft) or even less if you don't use backlighting; although a room that small can be oppressive.

Storage

It's not just shooting space that you require in a studio: you need storage space, too. For cameras, if you keep them there; for lights and lighting stands; for background supports; for backgrounds (including rolls of background paper); for props; and for all kinds of accessories, such as lens shades, filters, meters, extension cords, gaffer systems (page 75) and more.

If you have enough storage space, and if you don't have too much equipment, it is entirely possible to set the studio up, and take it down again, whenever you need it. The rest of the time the same room can be used as a garage, or parlour, or guest room, or for whatever purpose you need.

You must, however, beware of acquiring more gear, especially bulky, heavy gear. Our old IFF studio stand is one of the most useful things we own, but it stands almost 2m (6ft) tall; it weighs at least 100kg (2cwt); and its big, triangular leg layout means that it would require a cupboard at least 1m (3ft) deep to swallow it. It's not the sort of thing you can leave casually in the corner of the drawing room, though to be fair, big, old-fashioned focusing spotlights do have a sort of period charm as décor.

▼ **SWORD AND SORCERY**
This toy sword is the sort of thing that anyone might see, and consider photographing – and fail to get right. The rich fabrics provide the extra dimension of fantasy, and including only part of the sword – the hilt, with all its symbolism – further avoids undue literalism. A single Paterson electronic flash with a plain reflector provided the light: the sword was on the floor, and the 'studio' was a modestly sized sitting room.

NIKKORMAT FTN, 85/1.8 NIKKOR, KODAK E100VS. (MMK)

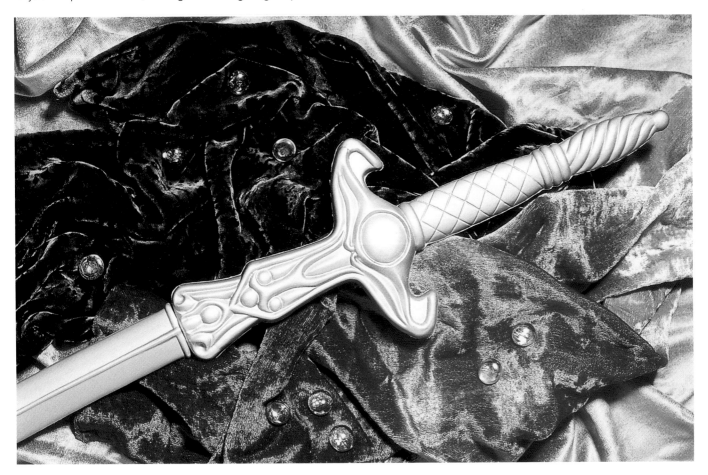

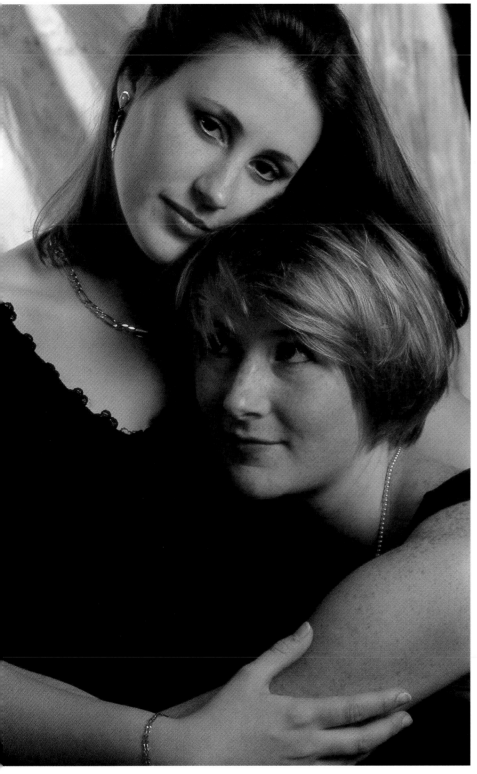

◄ ▼ SISTERS

A besetting problem with amateur portraiture is shadows of the subject on the backdrop, which is why you need space between the two. These two pictures demonstrate that in portraiture a great deal depends on small details. The expression of the dark-haired girl changes hardly at all, and the main difference in the expression of the fair-haired girl is in the direction of the eyes; but the mood is surprisingly different.

A bounce umbrella, high and to camera right, provided the key (look at the nose shadows), with a fill from a shoot-through umbrella low and to camera left.

NIKKORMAT FTN, 85/1.8 NIKKOR, FUJI 100. (MMK)

STUDIO DÉCOR

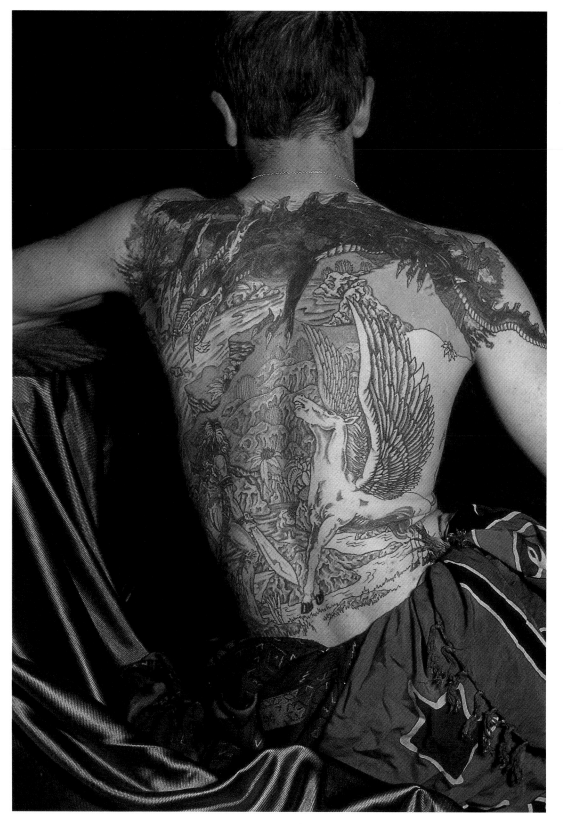

◄ **TATTOOED BACK**
The backdrop is a builders' drop-cloth (dust sheet), dyed at home in the washing machine and hand-daubed with dye on a sponge to give texture; the satin drape is from a discount fabric shop, a great resource for the studio photographer.

NIKKORMAT FTN, 85/1.8 NIKKOR, FUJICHROME 100. (MMK)

A studio that has no other uses can afford to be pretty bleak, so long as you habitually use separate backgrounds (page 68). Bare concrete walls are entirely acceptable, preferably painted white or cream in order to provide a reasonably cheery working environment.

Excess reflection from light walls can be controlled with 'black bounces' – large flats that are painted with blackboard paint to absorb unwanted light. Painting the studio black makes lighting easy, but is oppressive. And avoid strongly coloured walls, as they colour the light that is reflected from them: green is particularly unappetizing, unless you shoot only in black and white.

If your studio also has to do double duty as a living room or bedroom, you are likely to have less space, and you may well need to use some of the furniture and the décor of the room itself as part of some of your pictures. With small table-top shots it shouldn't matter, but with portraits, it may well.

After many years of experience, we can only offer a thoroughly craven way out. Choose décor (and furniture) that is as neutral and adaptable as possible, and build one corner of the room pretty much as a set. As you are decorating it, try out lighting positions to see which ones work best, and build to those.

In fact, you may wish to go further than this. For some years now, we have been meaning to re-do the bookshelves in our drawing room, and the fireplace that they flank. A massive backdrop of books (we have both the *Encyclopaedia Britannica* and the *Encyclopedia Americana*) makes a wonderful background for a certain type of portrait. You may get tired of the same furniture in each shot, but for each new sitter, it is a new experience: your skill lies in using the lighting that best reveals their character.

'Coving'

The shooting area in many professional studios is 'coved', with all corners radiused. When freshly painted out and evenly lit, no corners are visible: the subject appears to be hanging in space, or to be in the middle of an infinitely large room – hence the common term 'infinity cove'.

Many infinity coves are very large indeed. The first one where Roger worked was big enough to take two cars, side by side. Full 'coving' in a small studio is unlikely to be practicable, but of course, background paper arranged in a smooth 'sweep' is the next best thing.

Blackout

A perennial problem in studio lighting is keeping out daylight, though in practice you don't need

to exclude all daylight, just enough so that it isn't significant when compared with the studio lighting.

Given that our studio has a big bay window facing south, this was quite a problem for us. The solution was 'blackout' curtain lining, a heavy, rubbery fabric, normally white on both surfaces. It is genuinely opaque, and it is more than adequate even with pale curtains.

◀ **MOODY BLUE**
The backdrop here is blue Colorama background paper, 2.75m (9ft) wide. Colorama and similar papers are wonderfully convenient, but some colours are more convenient than others.

NIKKORMAT FTN, 70–210/2.8 SIGMA APO, FUJICHROME 100. (MMK)

▼ **PEACOCK FEATHERS**
With small subjects, you can experiment with all kinds of backgrounds: here, thick, torn paper.

NIKKORMAT FTN, ENLARGER LENS ON BELLOWS (SEE PAGE 115), FUJICHROME 100. (MMK)

POWER, HEATING AND COOLING

Whether you use flash or tungsten lighting, you will need to make sure that you have enough electrical supply sockets in the room for the lights you want to use – and preferably these should be well distributed, so that you don't have cables snaking all over the floor.

An important point is that you have enough power. Watts = Volts x Amps, so that (for example) an 800W lamp running on a 240V circuit requires $800/240 = 3.3$A, while on a 110V circuit it requires $800/110 = 7.3$A.

Neither current draw is likely to exceed a normal domestic supply, but the problem comes when you try to run several lamps off a single circuit. In the UK, for example, where most plugs carry their own fuses (a useful safety precaution), the maximum current is 13A, so the maximum load is $13 \times 240 = 3,120$W, or just over 3kW. In the US, the maximum permitted current draw may be as low as 15A, though it is often higher. At 110V, this corresponds to 1,650W. Overload, and if you are lucky, you will merely blow a fuse. If you are unlucky, you can burn the house down. Check the fuses on the circuits you plan to use, and obey any lighting manufacturers' instructions implicitly.

Power for flash

Slightly unexpectedly, peak power draw for even moderately powerful flash units – 1,200W-s (Watt-seconds) – can be 700W or more: the exact requirements should be in the instruction book. Because the draw is very brief, it may be possible to exceed the maximum power rating

▼ PETER
When you are photographing nudes, you do not want them freezing to death. A warm, clean fleece blanket and a fan heater can both play their part.

Nikkormat FTn, 85/1.8 Nikkor, Ilford FP4 Plus. (MMK)

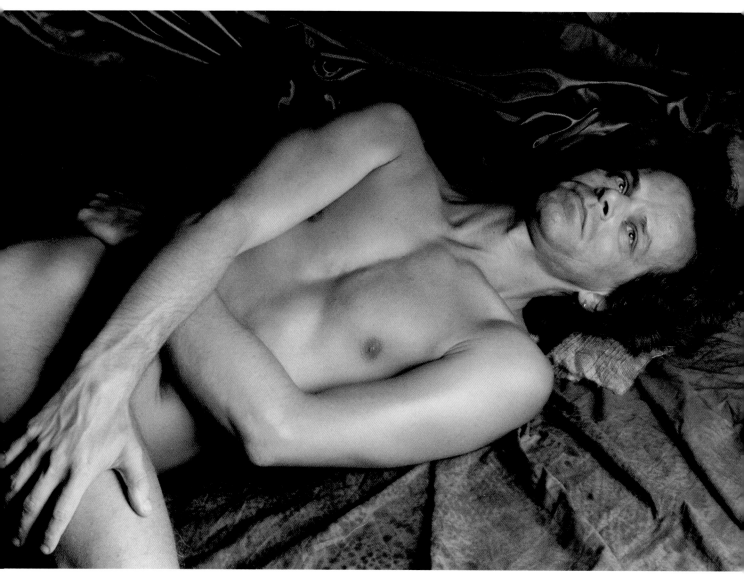

slightly, relying on the fact that fuses take a while to blow: thus, for example, you can often run four 240V units with 850W maximum draw each (14A) through a 13A fuse.

This sort of overloading is hardly to be recommended, though with a fused plug it is not too dangerous. Adding another unit would, however, almost certainly blow the fuse; and with non-fused plugs, even a modest overload could be a real fire risk. If at all possible, consider a fused extension cable, so that any overheating takes place at the cable, not in the walls. We have also seen sequencing boxes that will charge (say) three 10A units, one after the other, from a single 13A source, but we know of no-one making them today.

Cooling and heating

Electric lighting warms a room rather more, watt for watt, than an electric heater. A couple of 800W lamps will have about the same heating effect as a 2kW electric fire. While this may be welcome in the depths of winter, it can be an embarrassment on even a moderately warm day, and purgatory on a hot day. At the very least consider an electric fan, and preferably air-conditioning as well.

A cold studio with flash lighting can be a distinctly unpleasant experience for the model, especially if they are nude, so a fan heater and (if at all possible) a clean fleecy blanket are both very good ideas.

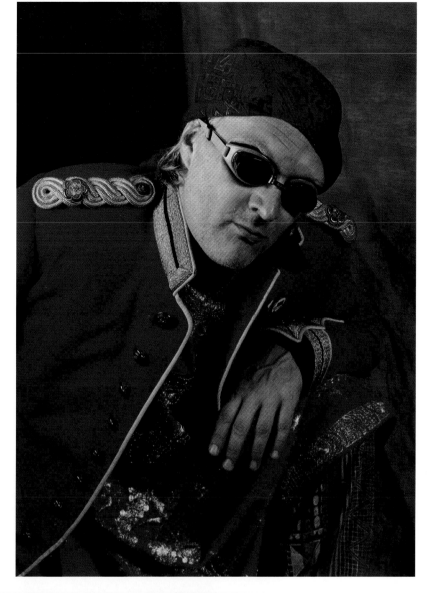

▲ **PAUL**
For costume shots, the studio must not be too hot or the subject will sweat; a fan may be a good idea.

NIKKORMAT FTN, 85/1.8 NIKKOR, KODAK PORTRA 400VC. (MMK)

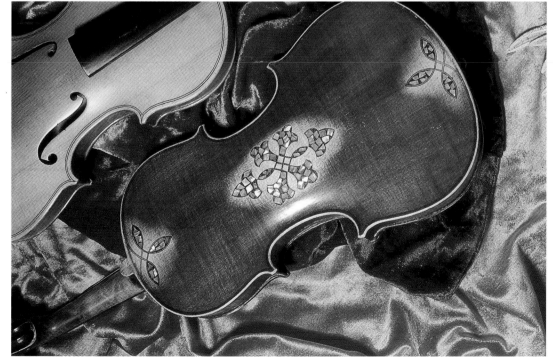

◄ **VIOLINS**
Even inanimate subjects may need climate control: violins are badly allergic to excessive heat or moisture.

NIKKORMAT FTN, 85/1.8 NIKKOR, KODAK E100VS UNDER TUNGSTEN LIGHTING. (MMK)

SELF-CONTAINED AND DUAL-USE STUDIOS

If you only want to do small, table-top shots rather than portraits or big still lifes, it is comparatively easy to set up a temporary studio. As long as you are happy with strongly directional lighting, you can use almost any kind of light. If you want shadowless lighting, life is only slightly more difficult.

A soft box on its own, used with a white seamless paper background, can give all but shadowless lighting. If you want truly shadowless lighting, with a bright background, you will have to transilluminate the background.

The easiest way to do this is with a sheet of opal Perspex or similar acrylic material bent in a gentle S-curve, with a short (10–15cm/4–6in) downward-turning lip at the front; a flat bit 50–90cm (20–35in) long; and an up-curve at the

back, anything from 30cm (12in) to 50cm (20in) high. You can buy 'infinity tables' ready-made (when they are remarkably expensive); or have the top made to order, rather more cheaply, at your nearest plastics fabricator, and then support it on trestles from a DIY store.

To provide a non-reflective matt surface, and to protect the plastic against scratches and marks, cover the table with clean draughting film for each shot. Draughting film is a tough, frosted polyester film available from draughting supply shops. A roll is expensive but lasts a very long time.

Another possibility is to use a shadowless enclosure or mini-cove, which can be lit from any side. The very smallest shadowless enclosure is an eggshell. This can provide excellent shadowless lighting for tiny pieces of jewellery and the like.

▼ ► TULIPS

Subjects such as the ones shown on these two pages can be shot on a table in the dining room, garage or kitchen: wherever there is space. For the flowers on the brown crushed velvet (*below, below right*), there is only one light; the bright white background (*right*) is draughting film, transilluminated with a second light.

LINHOF TECHNIKARDAN, 210/5.6 RODENSTOCK APO-SIRONAR-N, KODAK E100VS. (FES/RWH)

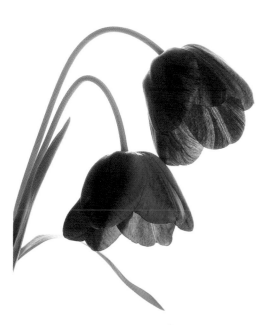

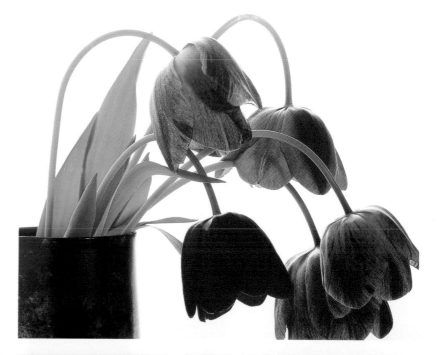

There are various proprietary enclosures, but (once again) we have found it cheaper and better to have one made from Perspex to our specifications: a box about 75cm (30in) wide and deep, and 60cm (24in) high will cover a wide range of small-product applications. In use, a sheet of draughting film is taped to the upper part of the rear wall, to provide a 'sweep'. Like the eggshell, it can be lit from any direction, and we use it all the time for small product shots.

'Gardening'

If you want to shoot portraits or still lifes other than on an infinity table or in an enclosure, you have to train yourself to do the necessary 'gardening' of the background in your dual-use studio. By 'gardening' we mean removing as much extraneous material as possible, and tidying up all that cannot be removed. All too often, perfectly competent studio-type shots are spoiled by incongruous domestic lamps, or electrical sockets, or pictures hanging on the wall (or worse still, dark areas where pictures were, along with the nails or nail-holes), and more. We have even seen boxes of tissues in shot, with a crumpled-up, clearly used tissue on top.

If at all possible, as noted on page 23, it is useful to build parts of the room as a photography set, with particular attention paid to the siting of electrical sockets. If it isn't, then the only way to do your 'gardening' is to train yourself always to look hard through the viewfinder, not just at the subject, but at everything around him or her or it.

STUDIO TECHNIQUES ON LOCATION

◄ **CHRISTMAS TABLE**
This was a collaborative effort, and an example of a 'hybrid' studio: a 'found' set-up, photographed using studio techniques (and a studio photographer's eye). We saw this set-up at Marie's one Christmas, and suggested she shoot it. She did. Another version with a little fill (from an electronic flash) was less successful.

NIKKORMAT FTN, 50/2 NIKKOR, KODAK EBX.

The techniques of studio lighting are readily adaptable to location work, and indeed, it is disputable where 'location' ends and 'studio' begins, if you have enough studio equipment with you. More and more of this equipment is designed for ready portability, and it is possible to carry all that you need in the back of a car. The main difficulty is excluding unwanted light; this is most easily done with pieces of blackout fabric that are pinned, taped or bulldog-clipped to

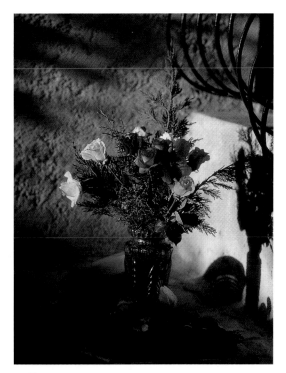

▲ FLOWERS ON STEPS

As noted in the text, Marie often shoots pictures on the back step of her parents' house in the south of France; she does this so frequently that it is almost an outdoor studio for her.

NIKKORMAT FTN, 50/2 NIKKOR, KODAK EBX.

darken the windows as appropriate. The other problem is remembering everything: a checklist is therefore extremely useful.

There are two reasons for setting up a 'location studio'. One is that you need more space than you have in your own studio, and you either cannot afford or cannot conveniently get to a hire studio (look in the *Yellow Pages* to find these). Church and community halls; small theatres used by amateur dramatic companies; friends' garages; even, as mentioned elsewhere, a café that has closed for the day. All can be pressed into service.

The other reason is when you are shooting something where it is easier to take the studio to the subject, rather than the subject to the studio. For example, we once did a book on sushi with Katsuji Yamamoto. It was quicker and easier to set up a studio in the restaurant than it was to transport the *itamae* (sushi chef), the fish, the knives, the plates and so forth to our studio – which, given that it was in a suburban garage, wouldn't have been as satisfactory anyway.

The outdoor 'studio'

The very idea of an outdoor 'studio' may raise some eyebrows, and indeed, it is stretching the

definition of 'studio' somewhat. But some photographers build or adapt part of their houses to provide appropriate and attractive backdrops for photography, while others come to an arrangement with a local attraction for much the same purpose. For example, a couple of miles from where we live is Quex House. This is licensed for weddings, and has a number of attractive settings. Rather more remote, but accessible when we are there, is Fort Ricasoli in Malta. For that matter, when Marie Muscat-King is staying with her parents in the south of France, she often shoots still lifes on the sunny rear steps of their home – almost an outdoor studio for her now.

By making yourself familiar with such settings, and (where necessary) sorting out logistics such as power supplies, water and the like, you can often work on location with the same degree of facility, and much the same degree of control, as you can in a studio.

▼ NUN

We shot this in Dharamsala, seat of the Tibetan Government in Exile: we were asked to photograph prominent Tibetans. The backdrop was a piece of fabric from the bazaar, with dye dabbed on with a sponge, supported on a bamboo framework; the lights were three Elinchroms, only two with modelling lamps, that we found in a store room.

LEICA M4-P, 90/2 SUMMICRON, ILFORD XP2 SUPER. (RWH/FES)

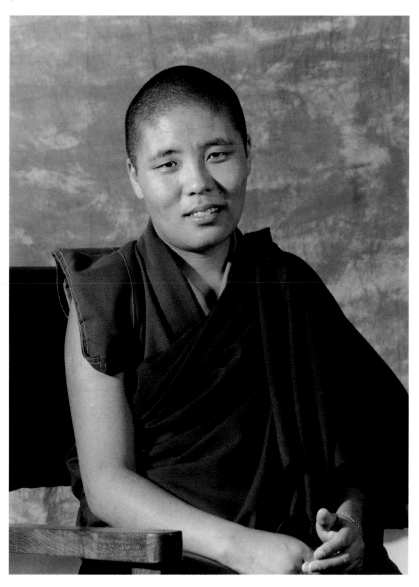

YOUR CAMERA
IN THE STUDIO

3

We have already said that many of the techniques of studio photography can be equally beneficial to users of a wide variety of cameras, from brass-and-mahogany to digital. Now is the time for a slight qualification concerning the cameras in between – and what cameras are best for what purposes.

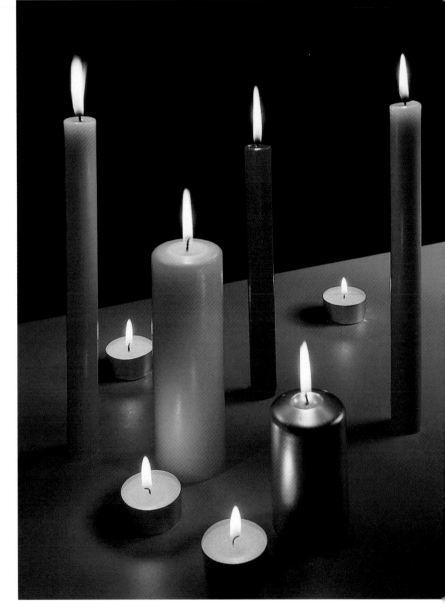

CANDLES
Exploring the underlying similarities of related subjects can often be a fruitful source of ideas and pictures – and can also provide an insight into technical problems and solutions, as described on page 38.

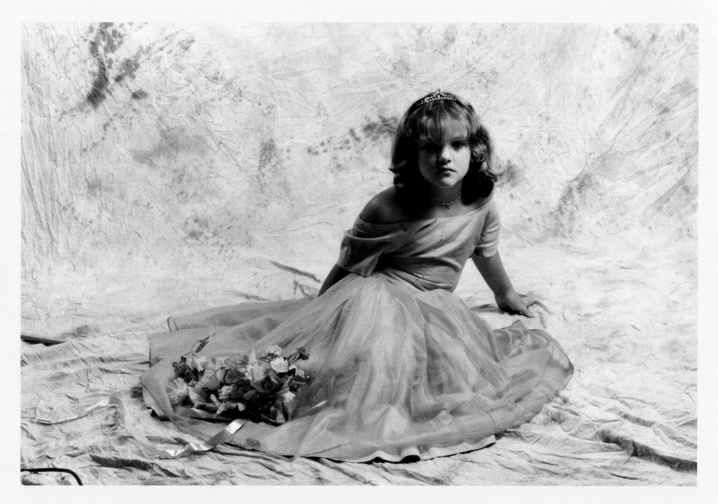

DAISY
Marie used an old Nikkormat FTn with a 50/2 Nikkor – hardly current state-of-the-art
equipment – and equally ancient Courtenay (Paterson) lights, shooting on Ilford XP2 Super.

QUALITY FOR A PURPOSE

Quality is not an absolute, nor can it be defined by a single criterion. The optimum quality for an original fine art print differs from the optimum quality for a website illustration, and both will differ from the optimum quality for a print made for photomechanical reproduction.

Original silver halide prints

'Fine art' prints normally make the highest demands on cameras, lenses and original image size. For the ultimate in quality, contact prints are unbeatable. Next come modest degrees of enlargement. In colour, if the lens is good enough, a 10x enlargement may be acceptable, but in black and white, tonality tends to deteriorate after about 6x at most.

Original ink-jet prints

The very best of these are as good as silver halide, but different, and the next best are the ones that ape silver halide and are very nearly as good. A very high-resolution digital camera (6 megapixels) can rival a high-resolution scan from a 35mm transparency at as much as 20x30cm/8x12in, with lesser resolutions in proportion, though if you are using silver halide, the quality of the scan makes an enormous difference.

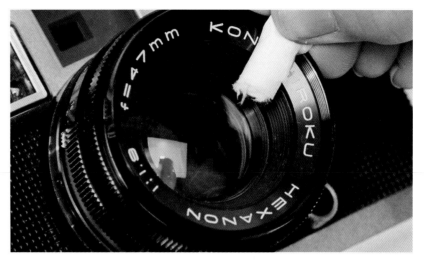

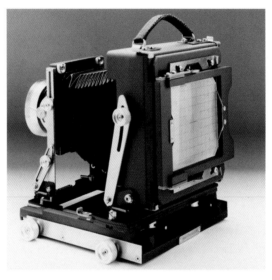

▲ **USING A DIGITAL IMAGE**
For a small 'how-to' shot like this, a digital image may be perfectly satisfactory if it is not blown up too much.

◀▼ **STUDIO SET-UP: CAMERA**
The light here is from an overhead soft box, with a white paper 'sweep'; reflectors either side (sheets of expanded polystyrene); and a black flag over the top to provide the graded ground. The basic set-up would be the same whether you were shooting on 35mm (as here), or medium or large format, or digital.

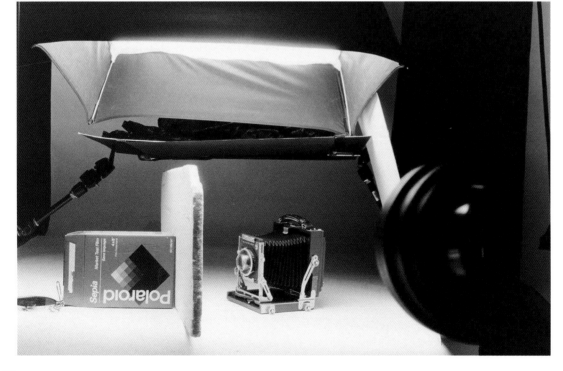

Photomechanical reproduction

Books and magazines are great levellers, and except with the very highest quality printing, at fairly large sizes (whole page and above), the quality advantage of larger formats over 35mm is unlikely to be apparent. For small illustrations, a digital image from a 3 megapixel (or better) camera may look as good as one scanned from 35mm.

There are, however, several arguments for using larger formats. Many clients may expect something bigger than 35mm, whether it is needed or not. Camera movements (pages 38–9) may make it easier to shoot some jobs, as may Polaroids (page 40). There's a 'look' to prints from medium format (MF) and more especially large format (LF) that simply cannot be duplicated with 35mm. Most origination houses prefer larger transparencies.

In any case, some photographers are simply happier with bigger cameras, and there's always the enduring hope that your shot may warrant a really huge blow-up, in which case the bigger the format, the better.

Website illustration

Even the highest-resolution monitors cannot begin to compete with the printed page, let alone an original print. It is easy to make a picture look entirely acceptable on a 19in (50cm) monitor, when a 5x7in/13x18cm print from the same image file would look hopelessly mushy. This is where digital cameras really come into their own: for on-screen use, there is simply no need for anything much better than about a 1.3 megapixel image.

For speed of transfer, it is advantageous to have as small a file size as possible, which can be achieved both by working to the minimum possible resolution and by using a compression algorithm such as the ubiquitous JPEG.

▼ **STUDIO SET-UP: PORTRAIT**
This shows a set-up for 8x10in portraiture. The camera is barely visible on the right, on a pillar stand; two builders' lights, diffused through a scrim, are set below the camera as a fill; the key is upper left; and there is a bounce to Frances's left (camera right). This sort of portraiture demands a *lot* of light.

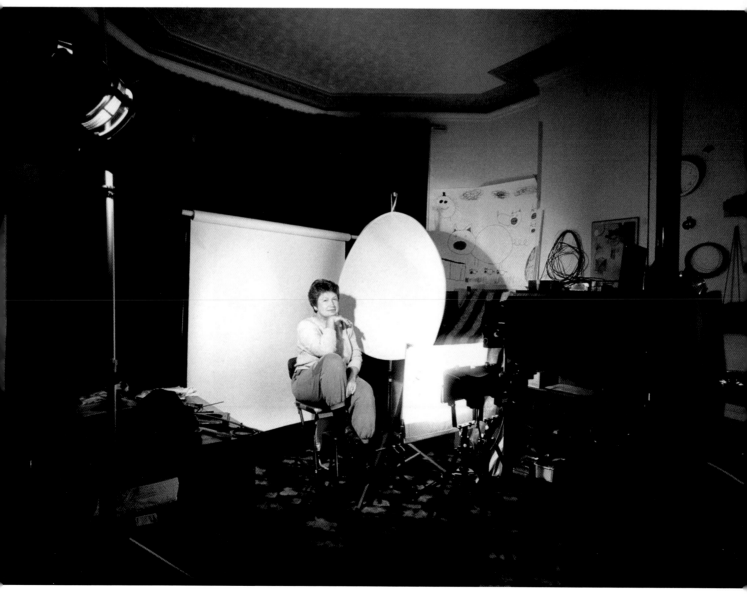

PICTURES FOR REPRODUCTION

The hybrid option – shooting on silver halide, then scanning – is particularly attractive for studio photography for reproduction, as it allows the possibility of easy retouching. This is all but essential for certain types of photography, such as 'exploded' pictures (pages 152–5), and it can be useful in portraiture when the subject has spots or other blemishes. And, of course, it is possible to 'comp' together multiple images.

Although one can do an enormous amount in Adobe Photoshop and similar programs, we have found that it is without question best to do as much as possible at the taking stage, rather than at the retouching stage. A dab of make-up; a little 'gardening' (page 27); really *looking* through the viewfinder – all of these save far more time than they take. At the most extreme, five minutes extra at the shooting stage can save an hour's retouching. The only things we willingly do in Photoshop are the things that are flatly impossible at the taking stage, such as removing the scaffolding in an exploded picture.

Scans for reproduction
The easiest high-quality option is normally to scan a transparency or negative with a high-resolution scanner: at least 2,500ppi of true optical resolution (non-interpolated), and preferably more.

Scanning high-quality prints is often even better: there is the additional expense and time of making the print, but a good, modestly priced flat-bed scanner can deliver excellent quality. This route allows the full range of photographic image-manipulation techniques, and then the full range of electronic techniques as well.

It is rarely a good idea to scan commercial package prints. Most exhibit poor sharpness and excessive contrast, and (with many subjects) there are distinct colour biases.

If you make your own scans for photo-mechanical reproduction, sending them in on a CD-ROM or something similar, you will do best whenever possible to send a 'raw' scan file, in which the only corrections are retouching and spotting, and setting the resolution at the standard requested (normally 300ppi). Attempts to adjust brightness, contrast, saturation and so on, on the submitted scan are not usually a good idea.

Always send a reference print, with all necessary corrections so that the printer knows how you envisaged the final image, but don't save these corrections to the image file.

Prints for reproduction
Overwhelmingly the standard size of print for reproduction is 8x10in, often described as 20x25cm (actually 20.3x25.4cm). Smaller prints may be acceptable for small illustrations, but few if any publishers will thank you for anything bigger: handling is inconvenient, and a sharp print can be run 'half up' (1.5x) or even 'two up' (2x) while retaining excellent quality.

Black and white prints for reproduction should be less contrasty than exhibition prints, and lighter, especially in the darker areas, because both contrast and density tend to build in reproduction.

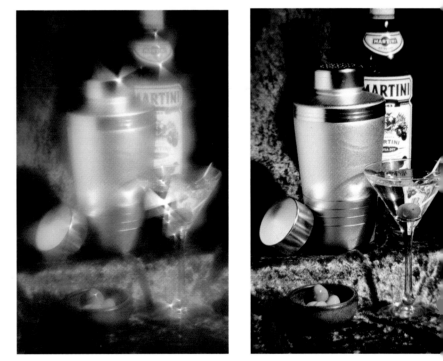

▲ ▶ **Martini**
The larger picture (*right*) is 'comped' together from the two smaller ones (*above*): the effect would be next to impossible to obtain in camera. The differences are subtle, but clearly visible: in the final image, the cocktail and the bowl of olives are from the sharp picture, while the rest of the image is from the soft picture. It would have been possible to shoot the two originals on a high-end digital camera with interchangeable lenses – the lens used was a Dreamagon – but an easier, cheaper route was to shoot transparencies, scan them, and comp the two together. The position of the single light is clear enough from the shadows: it was to camera right, quite close to the camera.

Nikon F, Kodak EBX. (RWH)

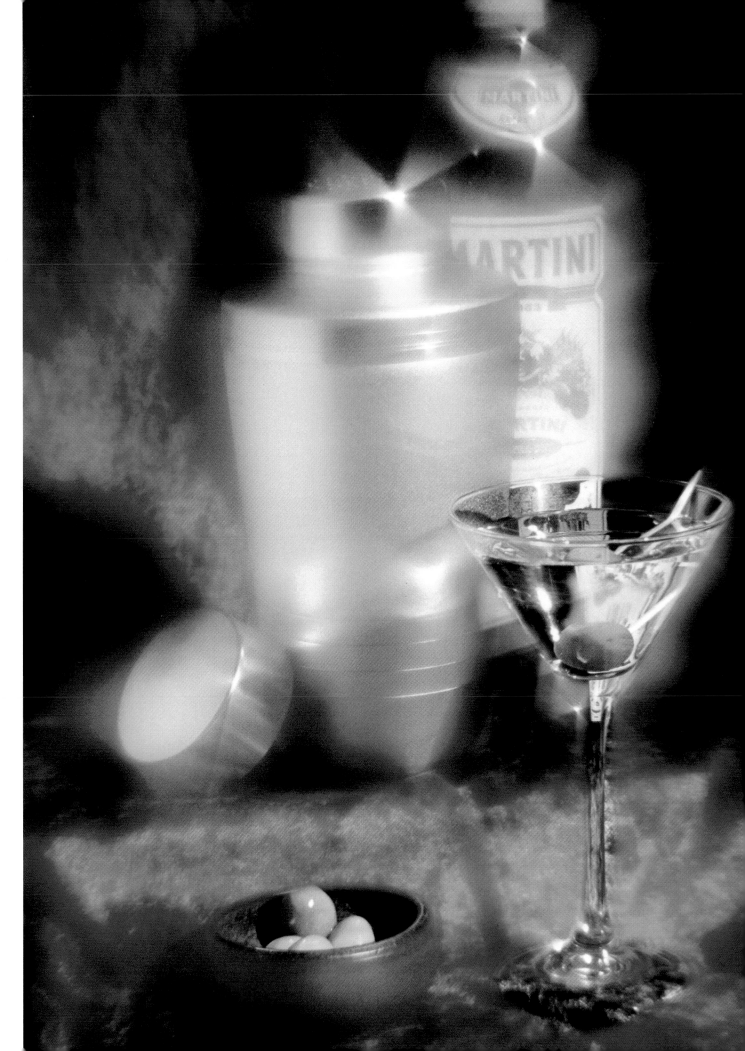

35MM

There is relatively little that you cannot do with a 35mm SLR, but there are three things worth considering if you are thinking about buying another camera, 35mm or no, SLR or no.

The first is that the lenses and accessories you need should be available. This should not be a problem with most modern cameras, but if you want to shoot extreme close-ups you will need either a macro lens or the kind of equipment that is described on pages 114–15. Some systems make this much easier (and more affordable) than others.

The second is that while the mirror blackout with an SLR is all but instantaneous, it nevertheless takes place at the most critical time. The subjects can blink, look away, or even (especially with children) stick their tongues out. Continuous viewing with a direct-vision camera (see below) removes this problem.

The third is that without camera movements, some still lifes will run you into the same sort of problem that you get when you angle a camera upwards to photograph a building and the verticals converge. If there are verticals in your still life, and you are looking down at the subject, you will get diverging verticals. An example appears overleaf.

You can reduce this effect by using a longer lens, but you can never get rid of it entirely at the taking stage unless you have a shift lens – and the problem here is that most shift lenses are of short focal lengths, while for most kinds of studio work, longer lenses are desirable, as described on page 112. This is one reason why some people prefer view cameras for still lifes. Of course, if you don't shoot this kind of still life, you don't need to worry – and even if you do, there's always the option of truing things up in Adobe Photoshop or a similar program.

Direct-vision cameras

For certain kinds of portraiture – especially reportage-style, or fashion, or of children – some

▼ ► SOPHIE
One of the great advantages of using 35mm is that you can try a wide variety of poses and lighting set-ups, quickly and at minimal expense. The three pictures shown on these two pages, and the ones on pages 44 and 50, were all shot during the same half-hour session, on a single roll of film. The nose shadows, in particular, greatly change the girl's apparent looks, and the poses change the mood.

NIKKORMAT FTN, 70–210/2.8 SIGMA APO, KODAK EBX. (MMK)

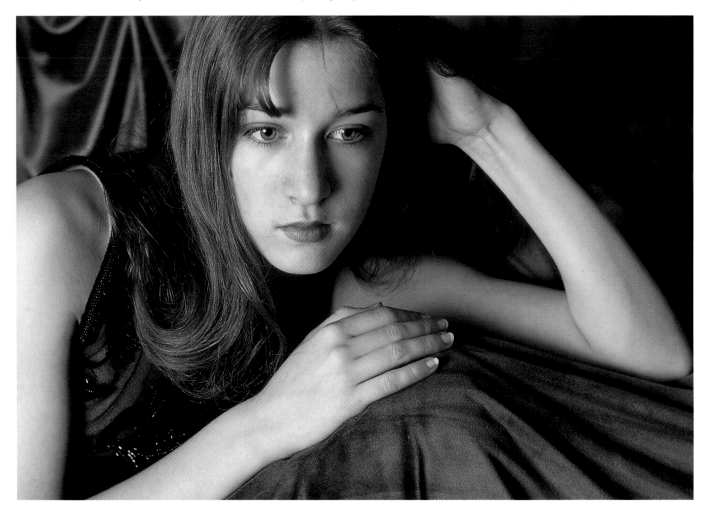

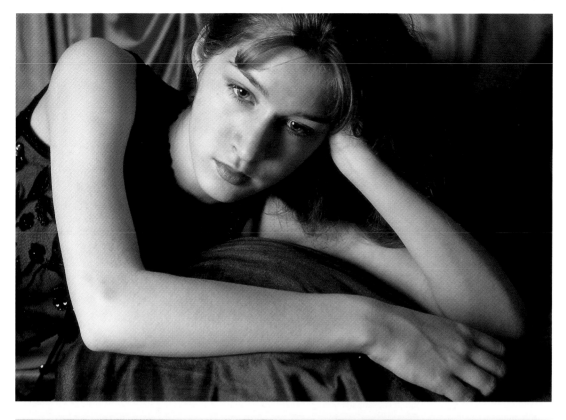

photographers prefer cameras with separate viewfinders, because they can check the subject's expression at the precise moment of exposure. There is also the point that a direct-vision camera normally has a much smaller time lag than a reflex between pressing the shutter release and taking the picture: typically $\frac{1}{60}$ second or less, rather than $\frac{1}{30}$ second or more, sometimes much more.

Of course there are parallax problems with direct-vision cameras, resulting from discrepancies between the viewpoint of the viewfinder and the viewpoint of the camera lens, but on high-end cameras these are minimized by parallax-compensating viewfinder frames. Even at 1m (3ft) the discrepancy should not be serious, and at anything beyond 1.5m (5ft) it should be trivial.

ROLL FILM AND LARGE FORMAT

Roll-film SLRs are subject to the same limitations as 35mm when it comes to mirror blackout, and most lack movements. Also, because the image is larger on the film, depth of field is less at a given aperture. This means you have to stop down more, increasing the risk of camera shake if you are using continuous lighting, or demanding more powerful flash equipment if that is the sort of lighting you are using.

For most types of high-quality portraiture, almost any roll-film camera is ideal, though you may wish to consider a direct-vision camera such as the Mamiya 7 instead of an SLR. For still lifes, or for any other kind of photography that involves close-ups, SLRs with bellows focusing are vastly more versatile and also convenient than are rigid-bodied cameras.

Large format

The one great advantage that most large-format (LF) cameras offer is that they have camera movements, which are extremely valuable when you are shooting still lifes. The two that are most useful in studio photography are a drop front, and swing/tilt.

The drop front enables you to get round the 'diverging verticals' problem illustrated here. Instead of tilting the camera, you keep the back parallel with the subject, so there is no 'keystoning', and then you either lower the front of the camera (drop front) or raise the back (rising rear standard).

Swing and tilt allow you to take advantage of the wonderfully named Scheimpflug rule, which states that everything will be in focus, without

▼ DROP FRONT

In the picture (*below left*), the camera is angled downwards and the candles splay out. In the picture (*below right*), a drop front has been used and the candles are parallel.

BACK PARALLEL WITH UPRIGHTS DROP FRONT

Drop front in use

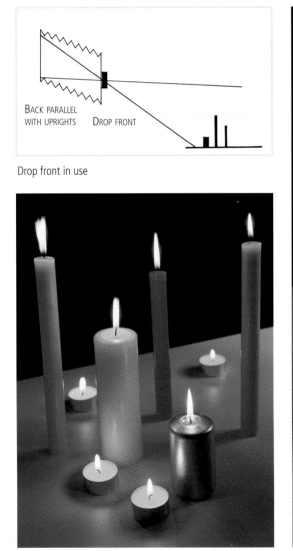

Without drop front

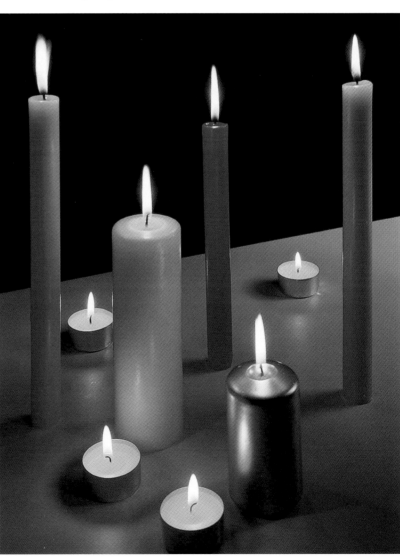

With drop front

THE SCHEIMPFLUG RULE

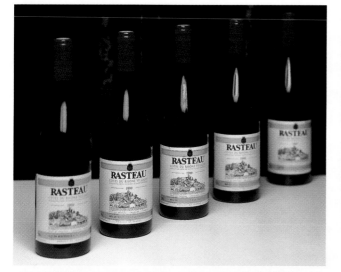

Shot at f/8 without Scheimpflug

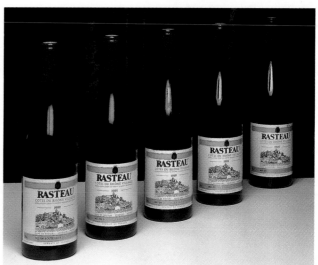

Shot at f/22 without Scheimpflug

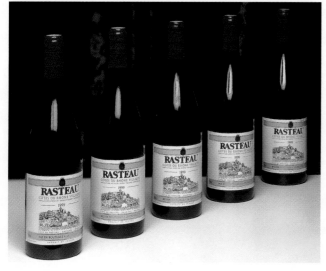

Shot at f/8 with Scheimpflug

In the picture with no movements (*above left*), only the centre bottle is sharp, even at f/8. Stopping down to f/22 (*above*) still does not bring both the front and rear bottles into focus, and demands a 1,000 watt-second flash instead of 125 watt-second. In the picture (*left*), the Scheimpflug rule has been applied and all five bottles are sharp at f/8.

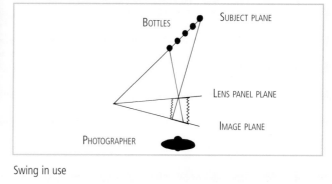

Swing in use

stopping down, when three planes coincide at a single line: the subject plane, the lens panel plane, and the image plane.

The 'nodding' movement, for holding a receding horizontal plane in focus, is known as 'tilt' or 'vertical swing'. The 'looking side-to-side' movement, for receding vertical planes, is known as 'swing' or 'horizontal swing'. The illustration shown here – the wine bottles – uses swing, not tilt.

Front and rear movements

An important point about using camera movements is that while front swing and tilt change the plane of focus without changing the shape of the image, rear swing and tilt will also change the shape of the image, thanks to

'keystoning' on the ground glass. This is normally used to exaggerate perspective: for example, making a car look longer and lower, and more aggressive, than it is.

Roll film on LF cameras

Modern lenses and film are so good that ever fewer professionals use 4x5in/9x12cm cameras or larger. It is entirely possible, however, to fit a roll-film back onto most 4x5in/9x12cm cameras, and many of the illustrations in this book (including the ones on these two pages) were taken with a 6x7cm roll-film back on a 4x5in/9x12cm Linhof Technikardan, so that we could take advantage of both movements and Polaroids (see next page).

POLAROIDS

Unless you are shooting digital, one of the greatest blessings you can have in many kinds of studio photography is Polaroid instant pictures: the old-fashioned peel-apart variety, not the 'integral' version that has replaced it for amateur use. There are both colour and monochrome versions, which have the same sort of response as slide films: ISO 100 is the most popular speed for test shots.

Polaroids are normally used for two purposes, before taking the final picture on transparency film (or more rarely, on black and white). The first is to check exposure and lighting. Seeing that the lighting ratio is correct – that there are no unwanted 'hot spots' or pools of darkness – can be as important as confirming that you have read the meter correctly. The other is to make sure that the picture itself looks right. Everyone has had the experience of checking the viewfinder carefully and taking the picture, only to discover when they look at the final transparency that they have left the meter in shot, or that the background is leaning over at a funny angle. Somehow, such things are always easier to see in a picture than they are in the viewfinder, and a Polaroid gives you the picture to look at.

There is actually a third use. When you are shooting a picture with a lot of input from the client, it is not unknown for the client to complain, on seeing the final picture, that this isn't what he or she wanted. Get the art director to sign the Polaroid before you shoot the final tranny, and it's a lot harder for them to argue.

Most professional medium- and large-format cameras can accept interchangeable Polaroid backs that snap on and off in the same way as roll-film backs, and for those that can't, NPC makes backs with fibre-optic transfer plates. You can even get Polaroid backs for 35mm cameras: we have one for our Nikon Fs.

Another way to take Polaroids is with a purpose-made Polaroid camera, preferably the NPC 195. This is a fully manual camera, with rangefinder focus, apertures from f/4.7 to f/32, and a shutter speeded from 1 second to 1/500 second. This is not quite as convenient as a Polaroid back, and of course you have to assume that the shutter on the film camera delivers the

same speeds as the shutter on the Polaroid camera, but it is undoubtedly better than nothing.

The bigger the Polaroid the better, though even a 35mm Polaroid can tell you more than you would think possible. The biggest common size (for 4x5in and 9x12cm cameras) has an image area of about 9x12cm (3¼x4¾in): it is available in single sheets, and packs. The normal pack size is quarter-plate (3¼x4¼in/9x11cm) with an image area of about 75x95mm/3x3¾in, and smaller sizes are normally masked down from this.

► ABSINTH
Transilluminated pictures are always hard to meter, and when the only light is coming from behind and underneath, Polaroids make it much easier to check your exposure. The bottle was standing on a sheet of draughting film on top of a sliding glass door removed from a cupboard. A snooted spot below the glass provided the light.

LINHOF TECHNIKARDAN, 210/5.6 RODENSTOCK APO-SIRONAR-N, KODAK E100VS. (RWH)

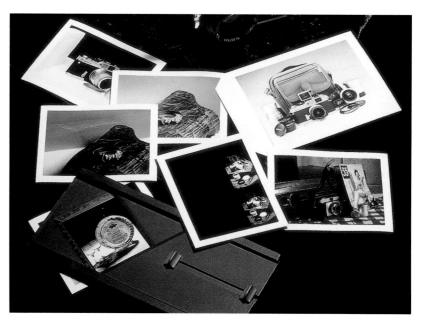

▲ POLAROIDS
Most of these are on quarter-plate pack film, but there is one 4x5in (the camera outfit, *top right*), and the two small images on a single sheet are from a Polaroid back for a Nikon F. The Kaiser adjustable mask (*front*) makes it easier to judge the crop if the Polaroid is not masked to the shape and size of the gate of the regular film back.

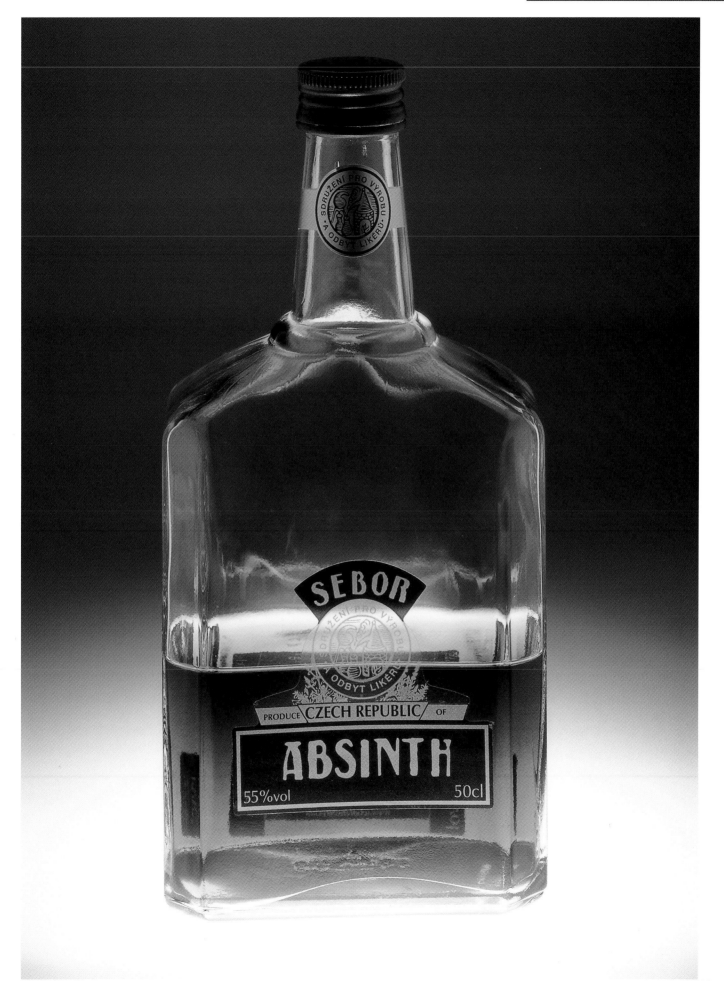

LENSES

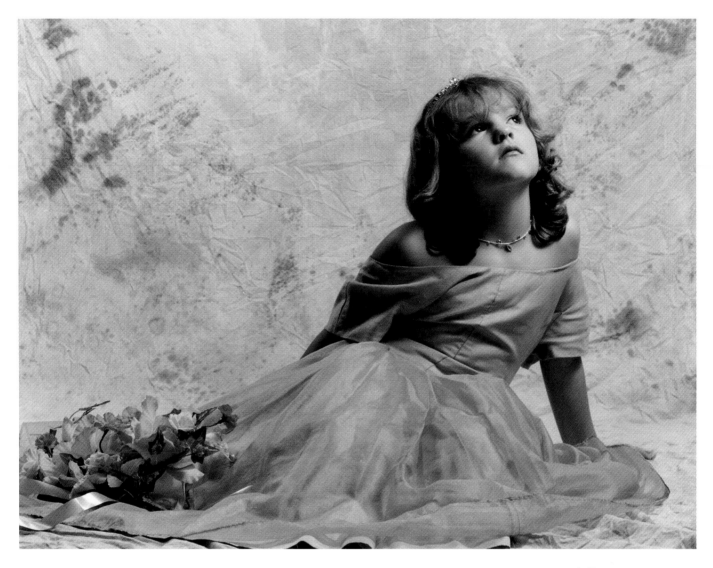

In portraiture, a slight loss of definition can be flattering, but with still lifes, you usually need the maximum possible resolution and sharpness. Often, too, you need close focusing.

Although zooms are vastly better than they used to be, even the very best can never be quite as sharp or contrasty or distortion-free as non-zooms – and as you move down the quality scale, the gap between zooms and non-zooms widens, especially if you go for a so-called 'macro zoom'.

Admittedly, this may not matter for small pictures, especially in reproduction, or for on-screen use. To recover lost contrast, use high-saturation films such as Kodak E100VS in colour, or give a little extra development in black and white, and don't enlarge the pictures more than 4x or 5x, except perhaps on screen. But for big, high-quality pictures, you need high-quality prime lenses.

Optical and digital zoom

Digital cameras generally have indifferent lenses, but then, the image chips are not too good either: they just don't have much resolving power. What is more important is the choice between an optical or true zoom and a digital zoom. The former works like a zoom lens on a film camera, magnifying the image more and more over the whole area of the chip. The latter uses less and less of the chip, while still filling the viewfinder (or monitor, or whatever). The inevitable result is a significant loss of quality at the longest end of the zoom range.

Soft-focus lenses

Soft-focus is generally far more successful in the studio, under controlled conditions, than on location. The traditional way to get soft-focus

▲ **Daisy**
Softness can be as much a matter of tonality as of lens quality: Marie's 50/2 Nikkor (on a Nikkormat FTn) is perfectly sharp, but the high-key exposure and soft-gradation film (Ilford XP2 Super) are still very flattering.

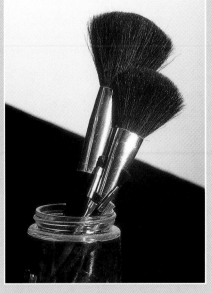

◄ **RUSTY AUGUR**

If you want to photograph this sort of thing – a dark subject against a transilluminated background – it is highly advisable to use a very contrasty prime lens such as the 210/5.6 Rodenstock Apo-Sironar-N that Roger used here on Kodak E100VS.

▼ **MAKE-UP BRUSHES**

The difference that flare can make is well illustrated here. This was shot with a 90–180/4.5 Vivitar Series 1 macro lens, to this day one of the sharpest zooms ever made. But flare in the white-background shots meant that it was impossible to match both the brush heads and the jar to the dark-background shot. As these shots show, Roger could match one or the other, but not both.

NIKON F, KODAK EBX.

effects was with a large-format camera and a purpose-made soft-focus lens. In general, the smaller the format, the less successful the soft-focus, though the German-made Dreamagon is successful even with 35mm.

Two other possibilities are simply to use a very old or very bad lens, or to use a soft-focus attachment on a normal, sharp lens. The best soft-focus attachments are probably the ones with the little lenticles moulded into the glass. The Zeiss Softar is the best known, but there are others: we use one from B+W. Another good soft-focus attachment comes from Pro-4 and consists of a sheet of optical resin with holes drilled in it.

Each and every kind of soft-focus lens and lens attachment has a unique look, and the only way to find out which look suits you best is to try them – always buy on approval if you can!

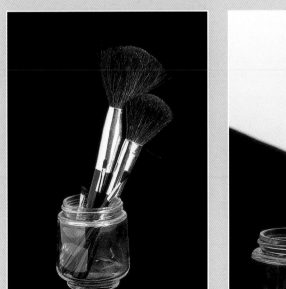

Dark background shot with the jar clean against the background

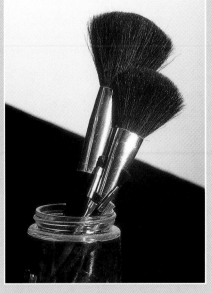

Brush heads matched to the dark background shot means the jar is darker

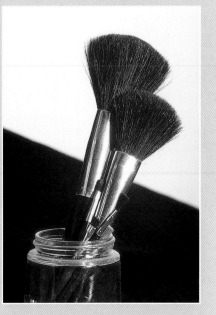

Matching the jar to the black background shot means that the background goes lighter

CHOOSING A CAMERA

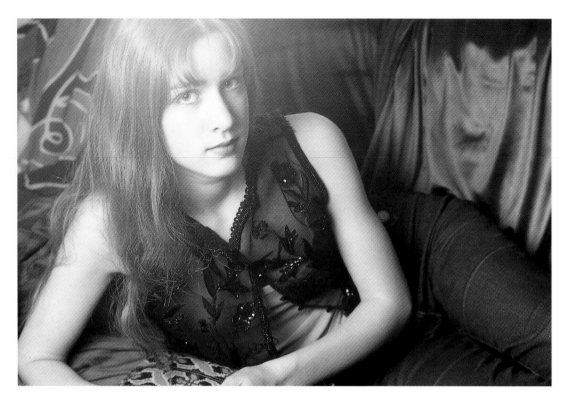

◀ **Sophie**

Even flare can be used creatively, but you really need a camera with through-lens viewing (Marie used her trusty Nikkormat) if you are not to rely completely on chance.

70–210/2.8 Sigma Apo, Kodak EBX.

Regardless of what format you choose, and whether you go for digital or silver halide, there are a number of basic considerations which range from indispensable for almost all applications to extremely useful for some applications. These are considered here in turn.

Manual exposure control

Studio photography often involves extremes of light and shade, and dramatic lighting contrasts. These can completely fool automated metering systems, typically leading to burned-out subjects against a dark, muddy background or to semi-silhouettes against overly bright backgrounds. Only manual exposure control can overcome all of these problems.

Standard flash synchronization

Unless you rely only on continuous lighting, you will need flash synchronization. The standard PC (Prontor/Compur) connector may be an abomination in the sight of the Lord, and hateful in His sight, but at least it is standard – and at least it allows you to connect any standardized studio flash gun. It is also possible to buy converters which allow you to take PC connections off hot-shoes, but they are a pretty nasty compromise and an admission that the camera in question is hardly professional quality.

Interchangeable, manual-focus lenses

The single most useful lens for most kinds of studio photography is somewhat longer than 'standard', with a good close-focusing capability: something like 85mm or 90mm on 35mm, or maybe 127mm on 6x7cm, or 210mm on 4x5in. A fixed zoom can be an acceptable alternative for small degrees of enlargement.

Often, precise focus on one specific part of the image is critical, and manual focus is generally quicker and easier than autofocus.

Depth-of-field preview

Depth-of-field preview (manual stop-down) gives no more than an approximation to what is in focus. But if you lack experience, or are shooting still lifes that have to be sharp from back to front, even an approximation is a lot better than nothing.

More than one camera system?

No one camera type or system is ideal for

◀ **Swan Leaf**
For maximum resolution, contrast and sharpness, plus the option of camera movements, Frances used a 210/5.6 Rodenstock Apo-Sironar-N on 6x7cm Kodak E100VS in a roll-film back on a 4x5in Linhof Technikardan.

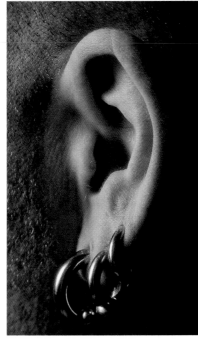

◀ **Ear**
Most good pictures depend less on technical quality than on composition and showing people something that they would not normally notice or perhaps even see. A 35mm camera (like Marie's Nikkormat, here used with an 85/1.8 Nikkor and Kodak EBX) is all you need for this.

everything, so you may do best to consider two (or more) different systems, each optimized for a particular application.

The 35mm SLR, as noted, is the most versatile, and should be regarded as a 'base' system, though you may find that a rangefinder is preferable for some kinds of portraits.

For general commercial work, a roll-film SLR is probably best, though for still lifes (where movements are required) a roll-film back on a 4x5in camera is preferable.

For 'quick and dirty' work, or for website illustration, a digital camera is unbeatable.

For fine art, the choice must be dictated by your personal vision: Roger prefers a 5x7in view camera (Gandolfi), Frances a 6x7cm back on a 4x5in camera (Linhof).

STUDIO
LIGHTING

Lighting – buying it, let alone using it – is where many photographers lose their nerve. It is not hard to see why. Few camera stores carry lighting. Even fewer can give good advice. Most photographers have never seen anyone using lighting, and don't know where to start. Even the vocabulary can be intimidating: inkies, scrims, snoots, flags. But really, there's not that much to learn.

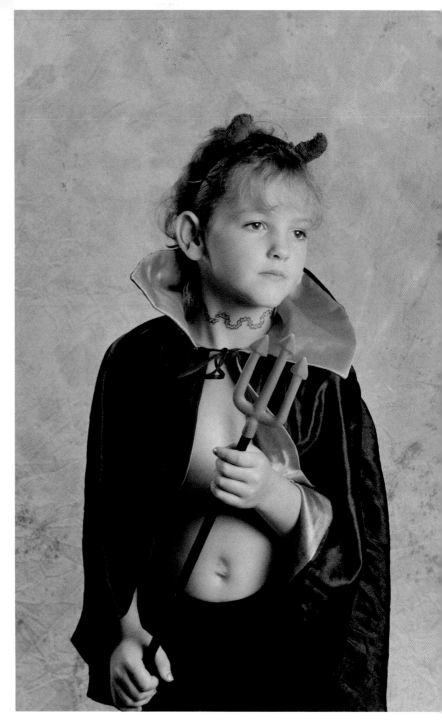

ANGELIC DEVIL
Quite honestly, this could have been shot using almost any camera. What makes the difference is the availability of controlled studio lighting – see page 59.

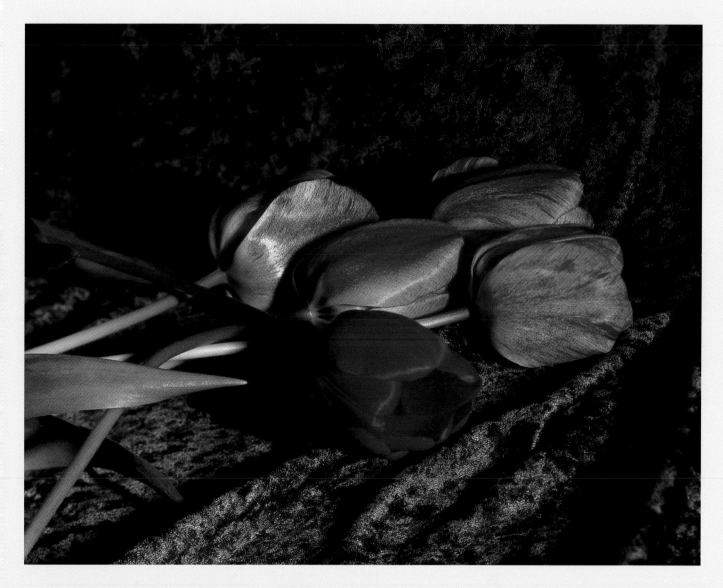

TULIPS

Frances shot these tulips on Kodak E100VS with a single, snooted flash head, using a
210/5.6 Rodenstock Apo-Sironar-N on a 4x5in Linhof Technikardan with a 6x7cm roll-
film back. She used the Scheimpflug Rule (page 39) to keep everything in focus.

REALITY AND ILLUSION

The basic premise of studio lighting is that there should be a single main light source. After that, it's a matter of contrast control and of using light (and shadow) to create the effects we want.

Key and fill

The main light, the one that casts the shadows, is known as the 'key'. You can use a key on its own, or you can add a subsidiary, softer light, the 'fill', in order to fill the shadows with light to a greater or lesser extent.

Bounces

Instead of using a second light as a fill, you can use a big, diffuse reflector or 'bounce' to reflect light from the key back into the shadows. Common bounces include white-painted plywood; expanded polystyrene panels; and commercially produced bounces such as are made by Lastolite. A bounce is normally held as close as possible to the subject, just out of shot.

By the same token, you can use a 'black bounce' to absorb light and stop it being reflected back. Again, this is held as close to the subject as possible, just out of shot. Plywood painted with blackboard paint makes a good bounce. Many studios paint their bounces white on one side, matt black on the other.

Intensity of shadows

For hard shadows, use a small, bright light source, preferably tightly focused. For soft shadows, use a big, diffused light, as close to the subject as possible. The terms 'key' and 'fill' can become a bit meaningless if there are no real shadows. If there is only one light, then by definition it is the key, but if it is diffuse enough, it is effectively providing its own fill.

▼ ► DEBBIE
We wanted a light, ethereal effect in the final shot (*right*), so we fairly poured the light on. This was shot in Marie's studio using a Nikon F and a 70–210/2.8 Sigma Apo zoom.

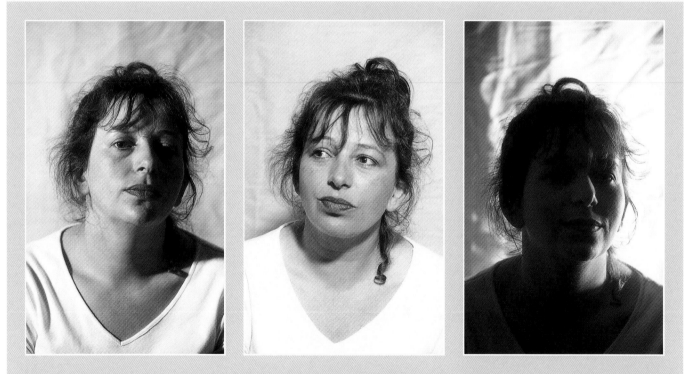

KEY ONLY
With only the key light on, from camera left, Debbie's face is half shadowed: the only light on the dark side comes from 'spill' bounced back from the light walls of the room.

FILL ONLY
The fill is a much softer light to camera right: a Lastolite UmbrellaBox. Normally, if the key is on the right, the fill is on the left, and vice versa.

HAIR LIGHT ONLY
The hair light makes very little difference in the final picture, but you can see how it can have quite an impact in many portraits – not least for differentiating hair from a dark background. Hair lights are normally tightly snooted. This is strictly an effects light, as described on page 50.

Balancing key and fill

If the fill is too strong, so that it casts shadows in its own right, the effect is ugly and unnatural: 'crossed shadows' are a common fault among novices when they start to learn to light.

Although the fill is normally weaker than the key, it is surprisingly often possible to use a key and fill of the same strength – 500W each, say – if the key is highly directional and the fill is well diffused. It may even be possible to use a key of lower output than the fill, if the key is tightly focused and the fill is very diffuse.

CREATING OTHER EFFECTS

◄ **SOPHIE**
Do not get carried away with lighting. Generally, simplest is best: otherwise you get all kinds of hot spots and crossed shadows and general confusion. The (single, large, soft) light source used in this shot can be seen in the reflections in Sophie's eyes.

NIKKORMAT FT3, 70–210/2.8 SIGMA APO, KODAK EBX. (MMK)

Effects (or 'FX') lights are neither key nor fill, and they do not really correspond to anything normally found in nature. Rather, they are a way of forcing the camera to 'see' in the same way as the human eye.

The human eye, after all, views its subjects intelligently, lingering upon points that the brain finds interesting, and ignoring other parts. As it scans the subject, it also works at a constantly varying aperture, opening up for darker areas, closing down for brighter ones.

A camera, on the other hand, records everything at once, at a single aperture. Effects lights are used to lighten specific parts of the image, in order to emphasize them in the picture so that they draw the eye in the same way that they would in the original scene.

The classic effects light is the hair light. In sunlight, it is almost impossible to photograph backlit hair without the subject's face looking flat, dull and (often) slightly blue. The classic remedy is fill-flash, using on-camera flash to put colour into the face and add sparkle to the eyes. At this point, the flash arguably isn't fill at all: it's the key. The sun is functioning as an effects light, and the sky is the fill.

In the studio, you can adjust the relative brightnesses of the key, the fill, and as many effects lights as you like: as well as a hair light, you can add lights to emphasize (say) jewellery and a handbag, or a belt buckle. You can make the effects lights as obvious or as subtle as you like, anything from a spotlight effect to a slight added sparkle.

Flags, gobos and cookies

A flag (or French flag) is a panel – it can be as simple as a piece of cardboard – that shades or 'flags off' a part of the subject. A 'gobo' or 'cookie' is a flag with holes in, so that the light that falls through it is dappled.

The term 'gobo' is also used for a shaped mask that is used in a projection spot, to project a pattern of light (or of course to create a pattern of shadows, which is the same thing). Projection spots are so expensive that we have not considered them in this book, though you can use a slide projector to similar ends.

◄ **FRANCES**
'This takes ten years off your age,' said Frances, referring to the TriFlector which 'wraps' the subject in light. And this was with a sharp lens, the 70–210/2.8 Sigma Apo, on a (relatively) high-saturation film, Kodachrome 25. Use soft focus and a gentler film and it is even more flattering.

(RWH)

The TriFlector/TriLite

This is a unique accessory from Lastolite which deserves its own brief entry. It is a three-'winged' reflector, and it can be used to create a wrap-around light. The key (and only) light is a big, diffuse source, typically overhead. The central part of the TriFlector (TriLite in the USA) acts as a simple bounce, under the face, opposite the key, while the angle of the two wings can be adjusted to throw light onto the sides of the subject.

COLOUR OF LIGHT

The human eye can accept a wide range of colours as 'white'; however, film is not able to adjust like this. Almost all film is balanced for daylight, which it records as white, and it therefore records tungsten light as yellow.

To make the tungsten light record as white, it must be filtered, either at source (with a filter in front of the lamp), or at the camera (with a filter in front of the lens). It does not matter which approach you use – sometimes one will be more convenient, sometimes the other – but you always need to use one. If you use both, of course, you will over-correct and the light will record as blue.

It is possible to buy tungsten-balance films, which work very well indeed; but, of course, if you use them to shoot in daylight (or under electronic flash, which is matched to daylight, around 5,500K) they will give a very blue effect. It is also worth noting that whereas in the past tungsten-balance films were often Type A, matched to the old, short-lived Photoflood lamps (which ran at 3,400K, close to the melting point of the tungsten filament), almost all that are used today are Type B, matched to the 3,200K of modern studio tungsten lighting (page 56).

Domestic lamps run still cooler, typically 2,600–2,900K, and will give a slightly yellow effect even with tungsten-balance film: 110V lamps run at a lower colour temperature than 240V, and low-wattage lamps run at a lower colour temperature than high-wattage.

Colour negative film

You can shoot colour negatives under tungsten light, then apply the filtration at the printing stage. A lot depends on the film, though, and often you will get better results if you apply the correction at the shooting stage.

The same is true of digital cameras. Even where 'white balance' can be manually selected, you will normally get far better results with daylight-balance light than with tungsten. Because so few digital cameras are equipped to accept filters, it is a much better idea to filter the lights themselves.

Filters

All but the cheapest and nastiest on-camera filters are of more than adequate quality, and will not degrade image quality detectably in the real world. This is true even of 'optical resin' filters ('plastic', if you're being rude). Suitable filters can be bought from any decent camera store, or by mail order. Often they are known by their Wratten designation (a Kodak company) as '80B'.

If you want to filter the lights instead of the camera lens, it is slightly harder to find big sheets of 'gel' filter material – short for 'gelatine', though they are actually acetate nowadays. Any professional camera store should be able to order them for you, though. Probably the best known filter company is Lee: a British firm, though they have major offices in Hollywood (surprise, surprise) and elsewhere.

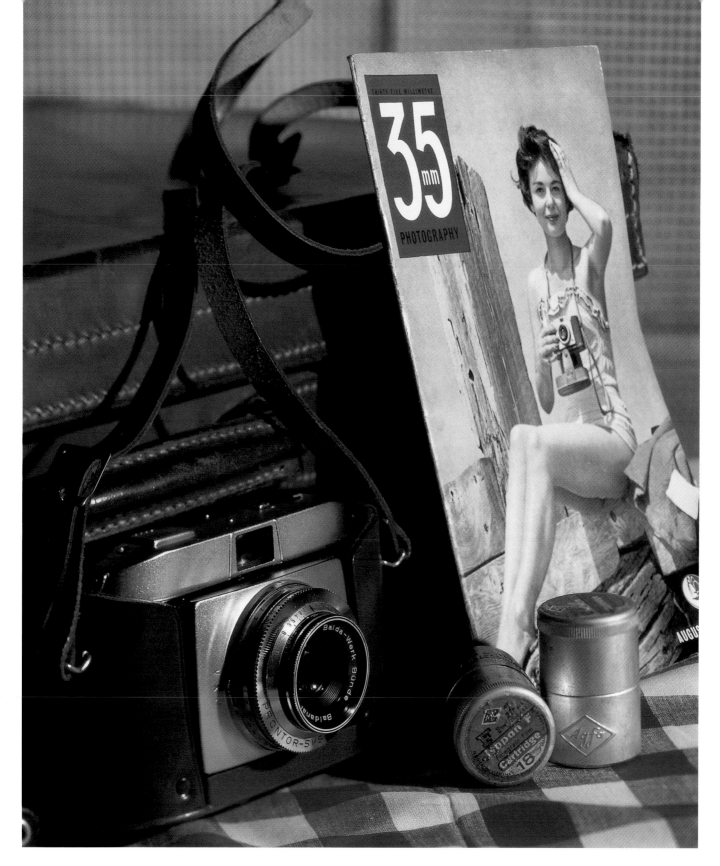

◄▲ OFF ON OUR HOLS

One of these was shot using flash (a snooted Paterson 1200), and the other with tungsten (an 800W Beard focusing spot) in exactly the same position. Both were shot on daylight-balance slide film. Although the flash version (the smaller, blue picture) is more 'correct', the tungsten version (the big yellow picture) suits the mood better: it is as close as you can get to sepia while still working in colour. The magazine dates from the late 1950s, a similar period to the camera; the suitcase came from a Salvation Army store; and the 'tablecloth' and 'curtains' are fabric offcuts.

Linhof Technikardan, 210/5.6 Rodenstock Apo-Sironar-N, Kodak E100VS. (RWH)

BUYING LIGHTING

The prestige value of owning lights is negligible: people don't show off lighting gear in the same way they do cameras. But any professional who owns a studio will own (or rent) lights.

Buying lighting is an absolute refutation of the popular viewpoint that you can't buy success. Countless magazine articles, and numerous books, make the point that it's the person behind the camera, not the brand of camera, that makes the picture. True enough: but you have to have a camera to be behind.

Likewise, it's not the brand or type of lighting you own, be it flash or tungsten or anything else, that makes the picture: it's the person using the lights. But you have to have the lights to use. For a given level of investment, buying lighting can do more for your photography than just about any other expenditure.

Buy used lights, and improvise, and you can build a basic lighting set-up for the price of 20 or 30 rolls of process-paid slide film. Go for the very best, and you are looking at maybe one-quarter to one-half the price of a new small car. Compared with the price of cameras, this still looks uncommonly like a bargain.

Of course you can live without lights. But if you do, there are whole areas of photography that are either out of bounds, or severely circumscribed. That is the cost of not buying lighting. Decide which you want to pay.

Choosing lights

The two main choices are tungsten (or 'hot') lights and flash, which are dealt on pages 56–59; however there are a few other options that are worth mentioning briefly.

Flicker-free fluorescents are best suited to broad, soft light sources or strip lights: they are highly efficient (in terms of lumens per watt) and fairly expensive.

HMIs are normally used for enormously powerful focused spotlights. They have a very high luminous

▼ **STARFISH**
If you buy a single lamp and (preferably) a soft box as well, you can accomplish a great deal. Two lamps will see off the vast majority of work; more lamps are a luxury and can be added as needed. Marie used a single soft box for this still life, relying on colour contrasts for the composition.

NIKKORMAT FT3, 80MM ENLARGER LENS ON BELLOWS, KODAK EBX.

efficiency, but are very expensive indeed: to buy, or to hire, think of buying or hiring a mid-range motor car.

Carbon arcs were once popular, but as well as demanding impressive current draws they are tricky, noisy, and can also be dangerous: the very high ultraviolet (UV) output can even lead to sunburn of the eye.

Mercury vapour lamps are sometimes referred to with approval in the old books, but we have only ever seen one in private hands: handling mercury in those quantities, in relatively fragile glass envelopes, is not to be recommended.

Improvisation can work wonders, especially in black and white where you are not too worried about colour balance.

CONTROLLING CABLES

Ideally, you should have numerous power sockets all around the wall, so that cable runs to lights are short and neither the model nor the photographer has to step over the cables, with the risk of tripping or bringing down the lights. If you don't have sockets like this, use two or three high capacity extension cables with multi-socket ends, and run them round the edges of the room as far as possible. Another useful trick is to keep small rugs, or carpet off-cuts, to cover cables that do run across places where people may walk.

▲ **SUZIE AND HER FAITHFUL PIGLETS AT SUNSET**
Frances used two lights, a (flash) soft box overhead and a tungsten spot to camera left to create the impression of the setting sun; under-exposing slightly added to the evening mood.

NIKON F, 90–180/4.5 VIVITAR SERIES 1, KODAK EBX.

TUNGSTEN

The smallest, simplest lights you can use for still lifes are no more than desk lamps. They are really only suitable for black and white, though, because of the low colour temperature (page 52).

The next step up is simple, but purpose-made, tungsten lighting such as the Paterson Interfit series with 500W Photopearl lamps. A deep, bright-polished reflector gives a fairly hard light: a broad, white-painted reflector gives a much softer light. We use a 'bowl and spoon' a lot – this is a big reflector (the 'bowl') with a small cap (the 'spoon') over the bulb to even out the light and avoid a 'hot spot'.

Photopearls do not put out as much light as Photofloods of the same wattage, but last many times as long. You can use Photopearls in lamps designed for Photofloods, but not Photofloods in lamps designed for Photopearls, as they may melt parts of the lamp.

The drawback with low-cost tungsten is that you can't get a really hard, directional light; but there are several ways around this.

One is to scour the camera fairs for old slide projectors. These can be found very cheaply – often for less than the cost of a replacement bulb – and they make extremely powerful focusing spots. You can even use them to project shapes onto backgrounds: draw a church window on a piece of glass, put it slightly out of focus, and the result can be very effective. Or use an actual slide.

Another way is to go to a builder's merchant and buy the sort of light that is used for lighting building sites at night, or interiors of buildings under construction. These typically use 500W tungsten-halogen lamps in small reflectors, and are surprisingly cheap: ours cost a little over £10, under $20/€20, each, complete with (admittedly crude) lighting stands.

After this, you are into buying proper focusing spots, new or used. Modern versions, often known

▲ **KEYS**
This formal pattern was lit with a desk lamp: in actual fact, Roger's bedside reading lamp.

NIKON F, 90–180 VIVITAR SERIES 1, ILFORD HP5 PLUS

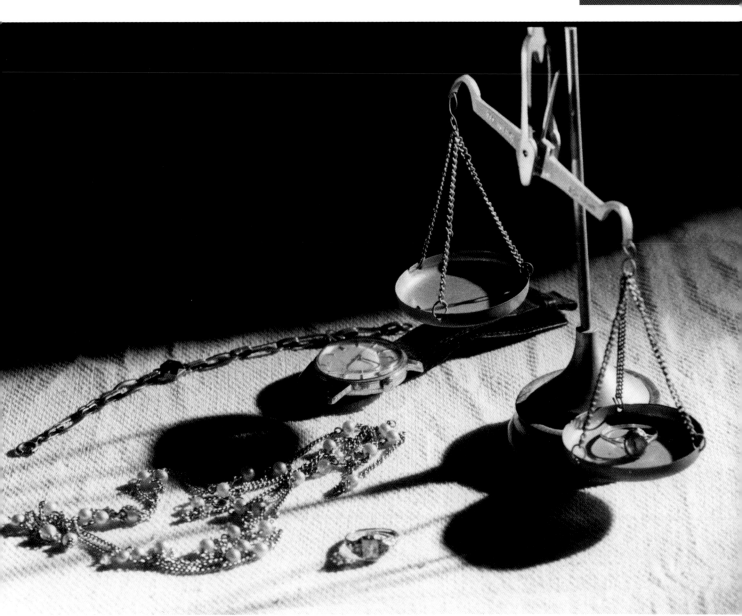

as 'Redheads' after a leading brand (Ianero), typically have an 800W bulb that can be moved relative to a small, deep reflector.

The older type is still available new, at a price, but is quite often encountered on the used market, often in deplorable condition requiring complete rewiring and refinishing. The bulb can be moved relative to a Fresnel lens in front of the lamp, and this provides the focus. The quality of light is rather different from that delivered by the modern type, and rather better focused. The smallest ones you find are typically 250W or 300W; 500W and 1,000W are relatively common; and they exist at 2,000W and beyond. Bulbs are alarmingly expensive, especially in the larger sizes, but generally last for a very long time, especially if you are careful not to move them while the filament is hot.

REFURBISHING LIGHTS

Refurbishing old lights is the sort of thing people were happy to do in the past, when basic common sense and familiarity with simple tools was assumed. Nowadays, it comes with all kinds of health warnings. Make sure the paints and cables you use are heat-proof; take great care with wiring, especially earthing (grounding); if you wash anything with soapy water (ideal for Fresnel lenses) make sure everything is dry before you reconnect the supply; and unless you are confident that you can do it without endangering yourself or others, don't try it.

▲ **Take it or leave it**
Roger wanted to show a part of what it means to be a refugee: the point when you sell the last few things you can, for whatever you can get. The hard, directional light of a slide projector added to the harshness of the image.

Nikon F, 90–180 Vivitar Series 1, Ilford HP5 Plus

FLASH

Most people today use 'monobloc' heads, with the power pack and the head in a single unit: if you need more lights, you buy more monoblocs. The alternative is separate power packs that can power two or more heads. Monoblocs range from around 150W-s (Joules) to around 1,500W-s, while separate packs range from 200W-s or less (for digital) to 5,000W-s or more (big studio packs).

The power you need will depend on what you want to do. You will need more power if you plan to use soft boxes, snoots and other light modifiers that greatly reduce the light, or to shoot medium and large format, or less if you plan on using simple reflectors and use only 35mm. For still lifes on large format, you might need 2,000W-s or more (2x1,000W-s); for portraiture on 35mm, as little as 400W-s (250+150W-s); and for digital table-tops, 200W-s or less, split two or three ways.

The greater the power, the bigger the switching range you should look for: at 1,000W-s and above, $\frac{1}{32}$ power is sometimes needed, but at 150 W-s, $\frac{1}{2}$ power is normally all you need.

Always keep a spare modelling light on hand. Some are standard domestic bulbs; some, Photopearls; and some, alas, rare and expensive specialist bulbs.

Power and light output

Flash units vary widely in efficiency, by a factor of as much as 2:1, and some manufacturers take advantage of this to quote their power in 'equivalent watt-seconds'. Thus, a unit sold as an '1800' may actually be 1,200 or even 900W-s, because the manufacturer reckons that his super-efficient 900W-s unit delivers the same power as someone else's unusually inefficient (and possibly discontinued) 1,800W-s unit. Always try to learn actual W-s ratings before you buy.

Don't mix and match

Sticking with a single manufacturer's lights not only means that the light modifiers are interchangeable (overleaf): it also makes it much easier to judge the final result. Different makers use different powers of modelling light, and run them at different intensities, so the modelling light may not always show you what you get. Intelligent choice of wattages can get around this problem to a large extent, and experience can get around much of the rest; but it's as well to be aware of the problem.

Remote control

The controls on monobloc heads can sometimes be hard to reach. If you can possibly get a remote control, whether this is via cables (cheaper and arguably more reliable) or cordless, then we would heartily recommend it.

▲ Mushrooms

These mushrooms are about half life size on the film, which meant an extra 1 stop of exposure. They were shot on 6x7cm Kodak E100VS (in a roll-film back on a 4x5in Linhof Technikardan), and the 210/5.6 Rodenstock Apo-Sironar-N had to be stopped down well for depth of field, even though the Scheimpflug Rule (page 38) was used. This meant that plenty of light was needed: a 1,200W-s snooted head used at about ¾ power.

(RWH)

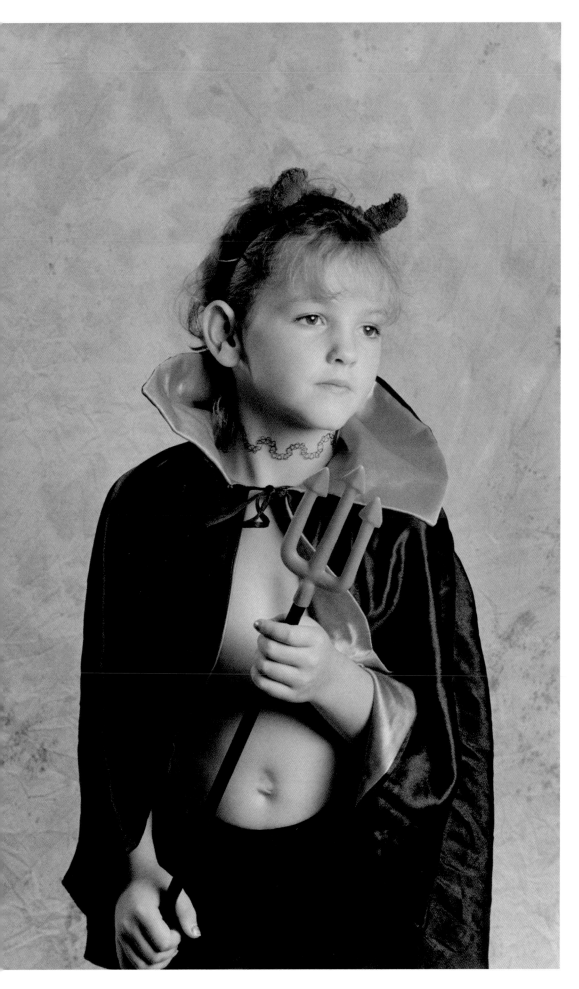

◄ **ANGELIC DEVIL**

Key light is an old 300W-s
Courtenay in a bounce
umbrella to camera right and
slightly above Daisy's eye
level – look at the reflections
in the eyes and the shadow
of the arm – but there is also
a weak fill (a shoot-through
umbrella) to camera left: look
at the highlights on Daisy's
right arm. A reasonably fast
film (Ilford XP2 Super) and a
fast lens (85/1.8 Nikkor on
a Nikkormat FTn) mean that
these relatively low-powered
units deliver plenty of light
for the purposes of this
picture.

(MMK)

LIGHTING ACCESSORIES

◀ **BAY TWIG**
This twig of dried bay exhibits wonderful textures, and is lit obliquely with a flash head: barn doors control the spill, and create a narrow slot of light. The background is separately lit with another flash head, snooted to give a circular patch of light.

LINHOF TECHNIKARDAN 4x5IN WITH 6x7CM BACK, 210/5.6 RODENSTOCK APO-SIRONAR-N, KODAK E100VS. (RWH)

The depth and finish of a reflector, the simplest light modifier, can greatly affect the quality of the light. The smallest reflectors are often known as 'spill kills', because they do little more than limit the sideways 'spill' of light from the source.

Many lights (though not the cheapest) can also be fitted with 'barn doors' – a self-explanatory term – to further limit those areas where the light can escape. Barn doors are used with both tungsten lights and flash.

Snoots are truncated cones: the wide end fits on the flash head, the smaller end restricts the light. Even a flash modelling light soon makes the snoot too hot to touch: with a more powerful tungsten light, it would be dangerously hot.

'Honeycombs' are metal grids resembling their namesakes, and are clipped to the front of a reflector. They make light 'harder' and more directional. They are more common with flash than with tungsten, but can be used with either.

Umbrellas resemble their civilian namesakes and may be either 'shoot-through', in which case they function as diffusers, or 'bounce', in which case they function as reflectors. They are more commonly used with flash than with tungsten, and in professional use they are normally replaced by soft boxes.

A **soft box** (or north light) is in effect a big reflector with a diffuser stretched across the side opposite the light. The biggest soft boxes in everyday use in most studios are typically up to 1.5x2m (60x90in), and the smallest we have ever found useful is about 0.5m (20in) square.

Most soft boxes nowadays are made of fabric erected on a frame of springy rods, and can be collapsed for storage. A locking collar secures them to the flash head: they are seldom used with tungsten, because of the heat build-up.

Finally, **scrims** are fabric screens that are used to soften, reduce and diffuse light. They vary in effect according to whether they are black or white, and they may be used at any distance from the light, from draped over it (in which case they need to be fireproof), to arranged on a frame just out of shot, where they can be used to soften or reduce the light falling on part of the subject without cutting out the light altogether.

◄ **DRIED FLOWERS**
The choice of whether to use hard or soft light will always depend on the subject matter, the colours, the contrast, the background and of course personal preference; but unless you have an umbrella or soft box or some other means of diffusion (Lastolite makes a combination 'UmbrellaBox') you will never be able to check soft light to see how it looks.

NIKKORMAT FTN, 50/2 NIKKOR, FUJICHROME 100. (MMK)

▼ **GRADUATES**
This picture has no claims to artistic merit – it just illustrates a point – but it is a trick worth knowing about.

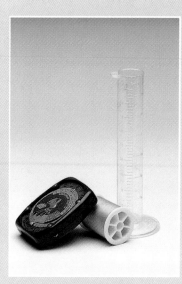

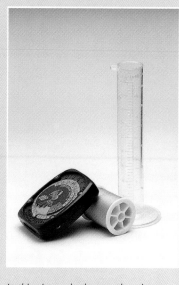

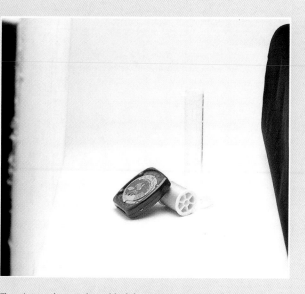

The edge of the graduate is very poorly differentiated from the background, and the face of the meter is dark.

In this picture, both are rather clearer..

The picture shows why: a black bounce on one side, and a white bounce on the other.

LIGHTING STANDS AND LIGHT METERS

The most usual form of lighting stand is a tripod with a telescopic centre column that can be extended in two or three sections. These vary enormously in quality, height and stability: to a very large extent, you get what you pay for. You can often find very solid old stands at camera fairs, but they are bulky and heavy, and they do not fold up: if space is a consideration (as it will be for most people), then modern folding stands are a much better bet.

For overhead lighting you need a boom arm, normally sold as an accessory for a lighting stand. There is a clamp in the middle of the arm: the light goes on one end, a counterweight on the other. You need a pretty substantial lighting stand, and cheap boom arms can droop and flex. You also need a lot of space. If you want to hang a light 1m (3ft) from the lighting stand, you need another 1m (3ft) on the other side for the counterweight.

We use a wall-mounted boom arm, which requires no counterweight. In some ways, it is harder to handle – the absence of a counterweight means that you have to lift the full weight of the light, plus the weight of the boom arm – but the absence of the overhang on the other end of a lighting stand can greatly increase the versatility of your studio.

Light meters

Because so much studio work is about the precise control of light, it makes sense to be able to meter specific areas. One reading determines the correct exposure for the principal subject, while other(s) determine whether you want to change the lighting on other areas of the scene.

For colour, an incident light meter is easiest, and generally gives entirely adequate results. A spot meter gives the ultimate in control, but requires more experience.

You do not, unless you are very foolish, base your exposure on either a mid-tone or a grey card. Mid-tones are notoriously hard to judge, and grey cards are a complete waste of time: an incident light reading is vastly easier and more reliable.

Most modern, high-quality meters can read flash as well as continuous lighting. A few 'do-it-all' meters allow a choice of spot, broad-area reflected and incident light metering, including flat-receptor

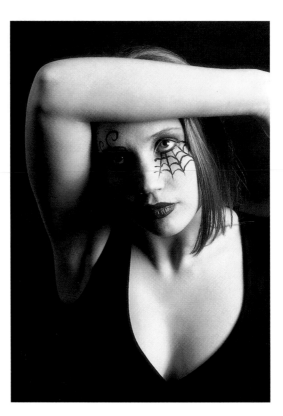

metering which is invaluable for determining lighting ratios. We have used Gossen meters for years: their 'do-it-all' model is the Starlite.

◄ ► COBWEB EYE
No matter how good your meter and metering technique, there is always the question of preference. The skin tone in one of these pictures is significantly lighter than in the other – around ½ stop – but both are arguably the best possible exposure for the subject and pose: if the one with the arm across the brow were any darker, the differentiation of the body and the background would disappear altogether.

NIKKORMAT FT3, 70–210/2.8 SIGMA APO, KODAK EBX. (MMK)

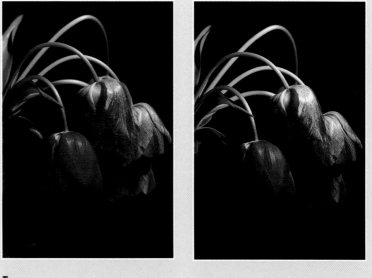

TULIPS
The difference between these two pictures is subtle, but clear enough once you know what you are looking for. Both have received the same exposure, but in one, the light was much closer to the subject and the highlights are therefore 'hotter'.

LINHOF TECHNIKARDAN 4x5IN WITH 6x7CM BACK, 210/5.6 RODENSTOCK APO-SIRONAR-N, KODAK E100VS. (RWH)

ACCESSORIES, **BACKGROUNDS** AND PROPS

5

Most studio photographers are perforce pack-rats. They collect all kinds of junk, because they never know when it will come in useful. Some accessories are essential, or all but; some are unexpectedly useful, and almost constitute 'professional secrets'; some are a waste of money; and then there are the ones that are personal, that define your personal style of photography.

TIPA
This is from a series of pictures shot at the Tibetan Institute of Performing Arts (TIPA) in Dharamsala. The costumes were lost in a disastrous fire some years ago – see also page 73.

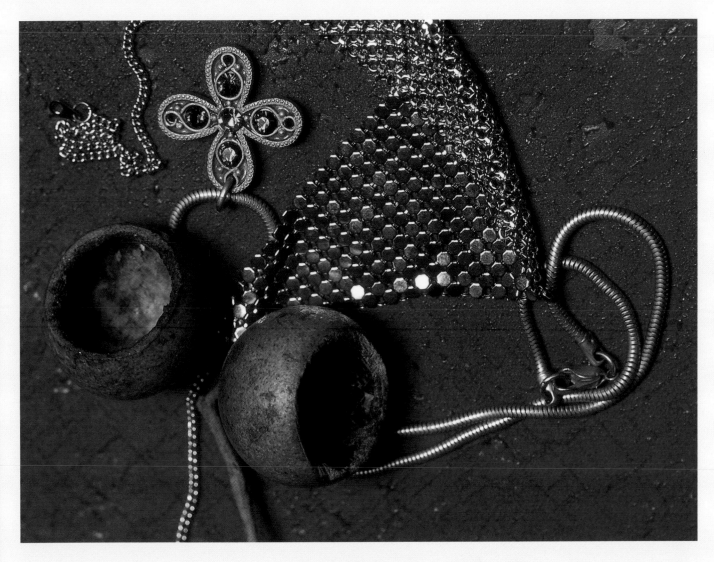

Autumn jewels

Marie shot this still-life with jewellery she had had for some years. The things that look like acorn cups came out of a pot-pourri, and the background is a piece of wallpaper. Ideally, this should have been shot on 6x7cm, but 35mm is cheaper. Besides, Kodak EBX is a sharp film and using an 80mm enlarger lens on a bellows (see page 114) on a Nikkormat FT3 allowed close focusing with admirable sharpness.

STUDIO ACCESSORIES

Camera supports are useful in general photography, and all but indispensable in the studio. Easily the most useful form of camera support, if you have the space, is the pillar-type stand. The pillar is up to 2.4m (8ft) tall, on a heavy cast-metal base with wheels. The camera is mounted on a cross-arm and can be moved from ground level to the full height in seconds. Compare this with the time you can spend fiddling with the legs of a tripod, and they are a godsend. They are horribly expensive new, and bulky and heavy, but they can be found secondhand. Ours can (just) be seen on page 33.

Among tripods, a big Benbo is useful, as the boom-arm construction allows the centre column to be used to place the camera almost as quickly and easily as a pillar stand.

After camera supports and meters, you are into the accessories that are specific to studio photography. As so often, these are a mixture of the off-the-shelf and the improvised. Before we go on to backgrounds and subject supports, it is worth looking at a handful of small, often unconsidered accessories that undoubtedly make life much easier.

Black aluminium foil Available in rolls from Lee (the filter manufacturer) and one or two other specialist suppliers, this has a thousand uses, especially when it comes to improvising snoots and flags and gobos. A roll is expensive, but lasts halfway to forever.

Cable ties As well as simply bundling cables together, these can be used to fasten them to anything that will keep them out of the way.

Filters In the studio, we mostly use Cromatek 'optical resin' filters. The most useful are the Wratten 80B, which corrects tungsten light for daylight film (page 52); Wratten 81-series warming filters, from a plain 81 through 81A, 81B, 81C and 81EF, for clients who like really warm pictures; a very pale blue, to re-create a vintage look in portraits (early materials were only blue-sensitive); and 'CC' (colour correction) filters that come in a range of densities for fine-tuning colour.

Leatherman tool These wonderful little American-made folding tools can almost supplant the Swiss Army knife (see below), though we prefer to carry both. The pliers are invaluable. There are a few good imitations and derivations made in the US and Switzerland, but cheap knock-offs, usually Chinese, are a waste of money.

Lens shades The self-supporting bellows variety, made under Lee patents, allow maximum shading and maximum ease of use. They are expensive but they are worth it.

Swiss Army knife As with the Leatherman, avoid cheap Chinese imitations.

◄ ▼ MARIE
We intended these to illustrate the lighting set-ups shown on pages 48–9 – full plot (big picture), key, fill, etc – but foolishly, Roger shot them freehand with a zoom lens (we were in Marie's studio rather than our own), and the viewpoint and framing are all over the place: he neglected to set a mark on the floor as a shooting position, and each time he put the lens down, he changed the zoom position. Far better to bolt the camera down, tape the zoom setting (if you are using a zoom, and need a constant reproduction ratio), and leave everything that you don't need to change where it is, rather than changing all the variables, all the time.

NIKKORMAT FT3, 70–210/2.8 SIGMA APO, KODAK EBX.

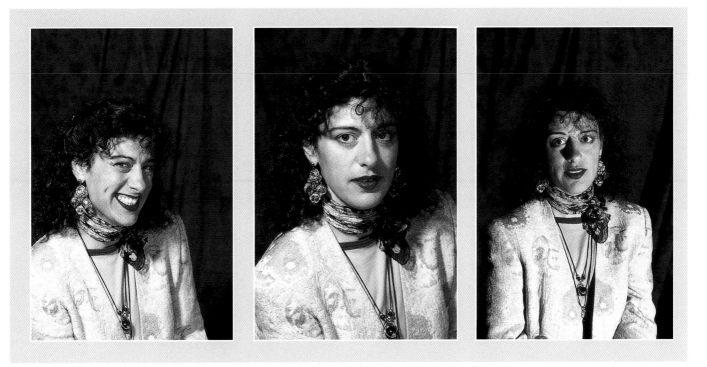

BACKGROUNDS

Whether you shoot portraits or widgets, you need something behind your subject. What you choose depends partly on your personal vision, and partly on fashion, but it must either complement the principal subject, or it must be unobtrusive: a background must never command more interest than the main subject.

The painted-out 'coved' studio has already been mentioned, but few photographers can afford this approach. The same objections are true of built sets, whether permanent – the kind of bookshelves we described on page 23 – or built like theatre sets.

If you intend to make a commercial go of photographing children, there are several companies (such as Off The Wall Productions) who sell ready-made sets, slightly twee perhaps, but often very effective: they have titles such as 'The Secret Garden' and 'Grandma's Attic'.

A rather simpler option is seamless background paper, known generically as 'Colorama' after the leading manufacturer. It is traditionally sold in 2.75m (9ft) widths, in lengths up to about 30m (100ft). You can buy half-width rolls, or you can buy a full-width roll and saw it asymmetrically: for example, a 90cm (3ft) roll for really small subjects, and 180cm (6ft) for bigger ones. Any professional

dealer can order seamless paper, though few carry significant stocks.

It can, however, look sterile with many subjects. At this point, backgrounds for portraits and still lifes tend to diverge somewhat.

Portrait backgrounds

Numerous suppliers offer fabric backgrounds with a random pattern of blotches, in a variety of colours. These avoid the absolute sterility of background paper, and are gratifyingly easy to retouch, but they are something of a cliché and they can have a sterility all of their own. It is quite easy to make them yourself, from builders' drop-cloths (look for cotton rather than synthetics) daubed with fabric dyes on a sponge: paints tend to be rather rigid and can crack if rolled. Store backgrounds crumpled up, in a stuff bag: if you attempt to fold them neatly, the folds will usually be painfully obvious in your pictures.

There are several variations on this sort of fabric backdrop, including traditional Victorian-style painted scenes, and swags of fabric of many kinds, preferably bought cheaply from remnant shops, or even from sari shops. The painted scenes are expensive to buy and difficult to make for yourself: even if you are a sufficiently skilled artist,

▶ **SLASHER**
With a subject this striking, you need either a built set (as seen on page 109) or some kind of fairly neutral background. The drawback to bought backgrounds is that they are mostly fairly uniform – the mottling is relatively even, the colours subdued – whereas with home-made grounds you can introduce more variation.

Nikkormat FTn, 85/1.8 Nikkor, Kodak Portra 400VC. (MMK)

◀ **PAUL AND GUITAR**
A novice might omit the second swatch of fabric on the right of the picture as distracting, but without it, the deep red background is too uniform, too dull. Look at Hollywood portraits from the golden age and you will see that they often do something similar. Marie should, however, have set the main background slightly higher: the clip that secures it to the pole had to be cropped out. To Allah alone belongs perfection!

Nikkormat FTn, 85/1.8 Nikkor, Kodak Portra 400VC

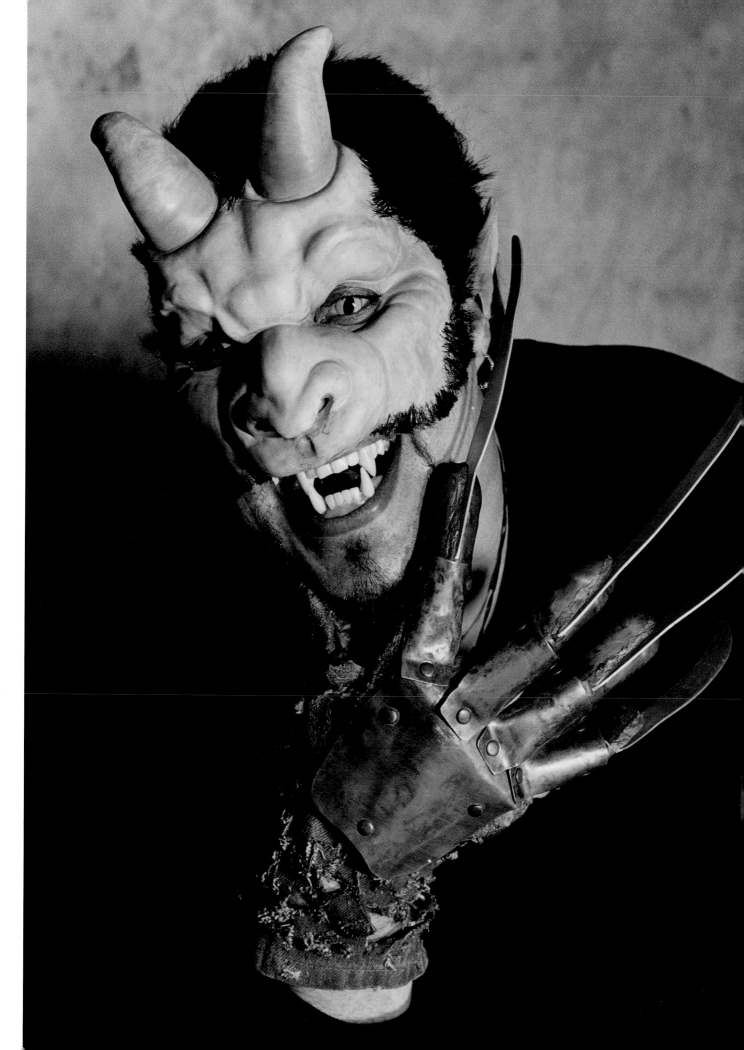

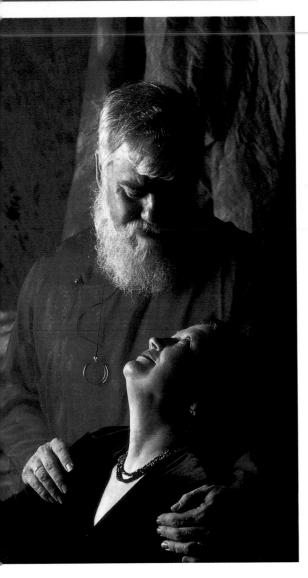

◀ **ROGER AND FRANCES**
The red-on-red-on-red-on-red (Roger's shirt, Frances's blouse, and the two backgrounds) was one of Roger's less successful suggestions when we were shooting at Marie's one evening. The two pictures do, however, illustrate the importance of positioning hands: in the smaller picture (*near left*), it looks as if Roger is about to strangle Frances.

NIKON F, 135/2.3 VIVITAR SERIES 1, KODAK EBX.

you can have problems finding enough room to work. Swags can be unexpectedly successful: Marie uses all kinds of rich-looking fabrics in the same shot, in both portraiture and still life.

The easiest way to support either seamless paper backgrounds or fabric backgrounds is with two stands and a cross-pole. Lighting stands (page 62) are ideal, and you can buy cross-poles that fit onto them; but for years, our main background support was a couple of telescoping display stands bought at a clothes shop that was going out of business, with a length of 50mm (2in) PVC drainpipe across the top, linking the two. Background paper was simply threaded onto the cross-pole; for holding fabrics, big bulldog clips are extremely useful.

With any background, a great deal can be done with lighting. Look at Hollywood portraits to see how they deliberately cast shadows on their backgrounds, or used pools of light and shadow, to add unobtrusive interest.

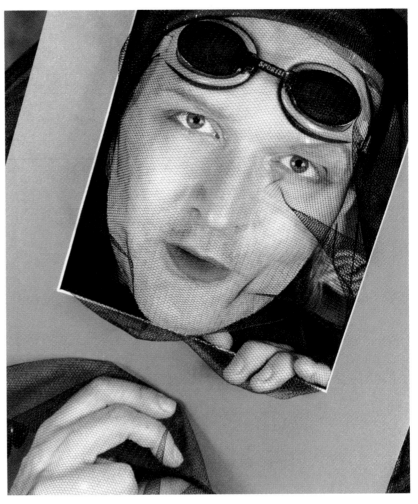

▲ **PAUL AND MATT**
As we say repeatedly, the easiest way to solve the problem of backgrounds is to come in so close that they are barely visible. There is a tiny bit of background in the upper left-hand corner, once again made from a builder's drop-cloth, but you would never know what it was.

NIKKORMAT FTN, 85/1.8 NIKKOR, PATERSON ACUPAN 200, HAND-COLOURED PRINT ON ILFORD MULTIGRADE IV. (MMK)

Still-life backgrounds

The only limits here are your imagination, your budget and the storage space available to you. In the early 1970s, the studio where Roger worked in London borrowed £100,000 in banknotes as a background. At the other extreme, brown paper has been used to good effect, as have old bedsheets. As already mentioned, Marie uses rich fabrics; we have a weakness for crushed velvet.

Stacked against our studio wall are sheets of black acrylic, mirrored acrylic and painted plywood (given a texture by mixing sawdust with the paint), pine shelves (two can be pushed together to create a convincing pine table-top), an old veneered table-top (the legs went for firewood), a wardrobe door (ditto the wardrobe), two marble tops from Victorian

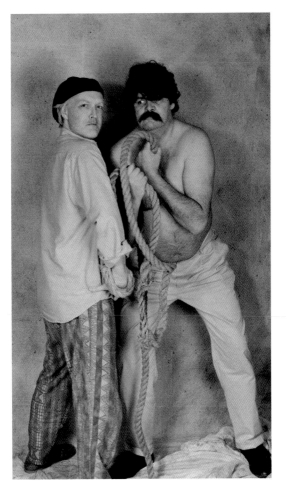

▲ **Paul and Roy**
The builder's drop-cloth is pressed into service once again. The shadows on the background are slightly awkward – one goes in one direction, the other in the other – but in a way they add to the cartoon-like pose and clothing: the overall effect is reminiscent of Popeye and Bluto.

Nikkormat FTn, 50/1.8 Nikkor, Paterson Acupan 200. (MMK)

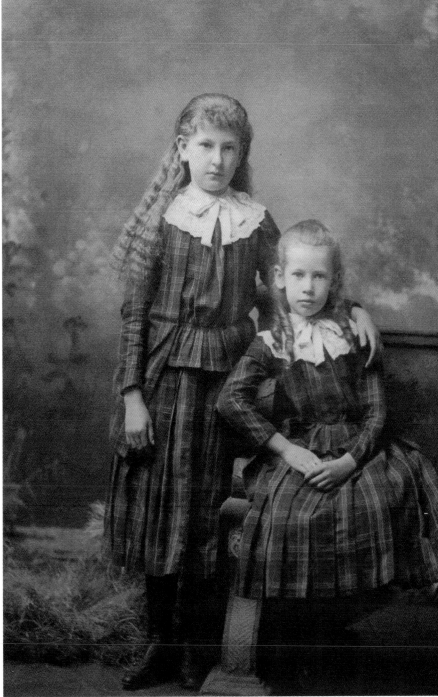

washstands (one white, the other 'corned beef'), a roll of black flocked plastic (even better than black velvet for a dead black) and more. Beware of plastic laminates: they almost never photograph well, and often have a nasty bluish sheen.

For a background to a shot of some seafood, we gathered a couple of bushels of flints from the beach near us; and we bought our kitchen table because its rough, uneven timbers make a wonderful background for other food shots. At this point, you are coming close to set-building.

▲ **Lovina and Almira Cosman**
This was probably shot in the late 1880s. The girl on the right, Almira, was Frances's maternal grandmother. As so often, the elaborate painted backdrop has been supplemented by some real (if slightly elderly) natural grass. Surprisingly, such backgrounds are still available today from a few specialist suppliers.

71

SUBJECT SUPPORTS

As is the case with backgrounds, regardless of your choice of subject, you (usually) need something that will keep it off the floor.

With portraits, supports can be surprisingly obtrusive or inappropriate (go to any camera-club exhibition if you doubt us) and it is worth thinking hard about stools, sofas and chairs. Marie Muscat-King uses a lot of draperies to disguise what is underneath – though equally, when she gets the right chair, she knows how to make it a feature of the picture. She was fortunate in that for several years there was an antique furniture store a few doors away from her home-cum-studio.

We tend to prefer stools, sometimes low-backed. They force people to sit up straighter than chairs, making them look more alert. On the other hand, there is a good deal to be said for *chaises-longues*, on which the right sort of subject can recline languorously.

◀ HOLLY

When you are shooting 8x10in portraits – Roger used a De Vere monorail with a 21in/7.5 Ross, shooting on Ilford HP5 Plus – you need time to focus, close the shutter, insert the film holder, pull the dark slide and take the picture, without worrying about the subject moving out of focus. A firm support helps: look closely at most Hollywood portraits before about 1950 (when smaller cameras became more popular) and you will see that the subject is often all but nailed down.

▶ TIPA

This was taken in the early 1980s at the Tibetan Institute for the Performing Arts in Dharamsala: the props chest that Roger used as a support is very similar to the 'Hollywood coffin' mentioned on page 74. Light came from an open door to the left, which functioned as a soft box, with a 1m (3ft) Lastolite bounce on the right.

LINHOF TECHNIKA 70, 100/2.8 PLANAR, KODAK EPR.

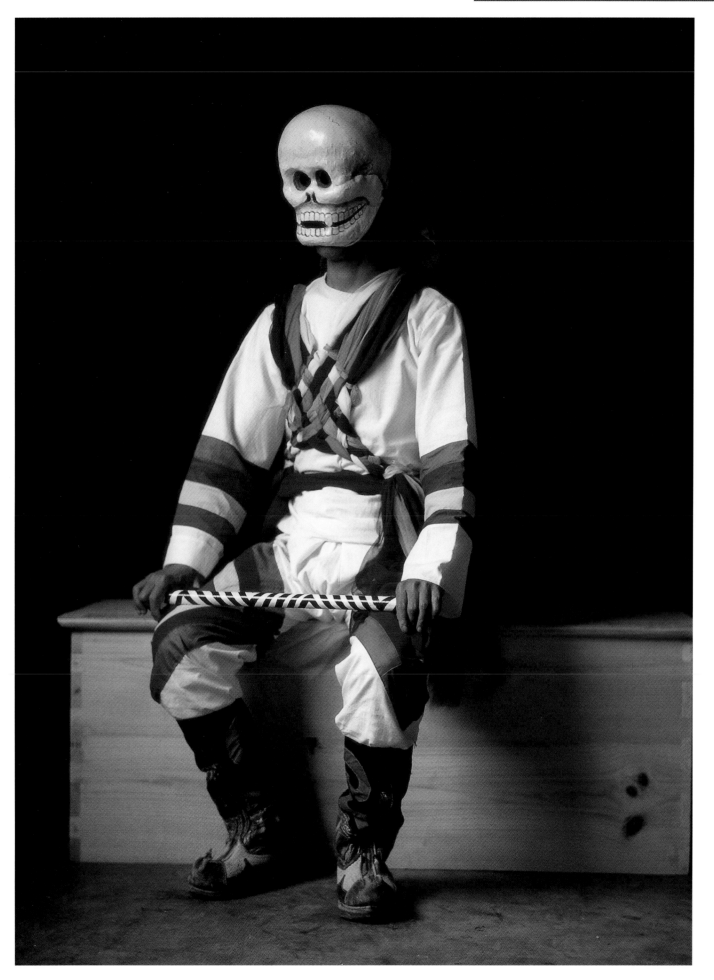

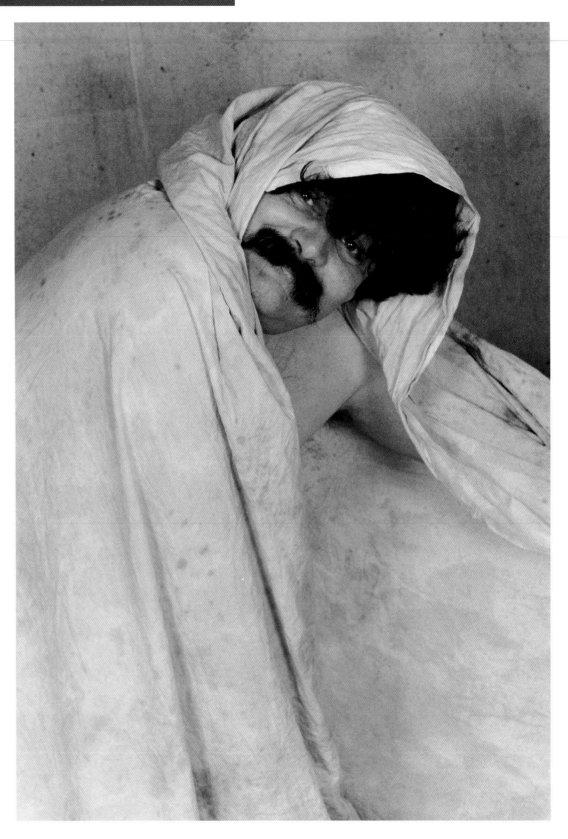

If your subject is not too worried about standing on his or her dignity, the floor makes a perfectly good support – though it can be a bit chilly and hard, so a cushion or even a piece of carpet is always welcome. Roy is wrapped in one drop-cloth and kneeling in front of another.

Nikkormat FTn, 85/1.9 Nikkor, Ilford XP2 Super. (MMK)

Specialist supports for portraiture

The ominously named 'Hollywood coffin' is a box, maybe 60cm (2ft) high by 60cm (2ft) deep by 120cm (4ft) long. Used draped or undraped, it provides a versatile and surprisingly unobtrusive support for a wide variety of portraits, though obviously it helps if your subject has some acting or modelling experience and can manage to look relaxed and 'at home' on anything.

The Multipose from Lastolite, alas out of production, is an ingenious, articulated, folding framework that can be made into a bench, a chair, a lectern or more. It is astonishingly rigid when it is properly locked (with simple screw

handles): the bench can easily support a heavy adult. It is ugly really incredibly ugly, but fortunately this doesn't show when it is draped.

Several companies sell 'baby chocks' into which small children, preferably too small to move under their own steam, can be wedged. For obvious reasons, it is desirable that these are waterproof and washable, as should anything with which they are draped.

For baby shots, one can also buy wickerwork baskets and prams, too insubstantial for sustained use, but adequate for photography. At this point, however, we are veering more into props than into supports.

Sports teams and the like are often supported on a precarious collage of benches and beer crates, but you can also buy lightweight benches that can be assembled and disassembled in a matter of minutes.

Still-life tables

The ideal studio table would be infinitely variable in area, as solid as the Rock of Ages, and compact enough when folded to go into a pocket. Unfortunately life ain't like this.

After many years' experimentation, we are convinced that the best approach is a pair of lightweight folding trestles – ours came from a DIY store – and two or three sizes of table-top. Whatever you are not using can be stacked against the wall. You don't have the convenience of adjustable height, but we find this a small price to pay for the small size of the disassembled tables. If the table is too high, we generally work straight on the floor, though if that is really too low, we stand four bricks on end and support one of the table-tops on those.

Subject supports

Often, you need the different parts of a still life to be at different heights. What we normally do is to use a draped fabric background, with empty Polaroid boxes underneath. A box of 20 4x5in Polaroids is about 19x24x5.6cm/7½x9¼x2¼in, and admirably rigid: it will support a weight of a few kilos (or 2.2 times as many pounds) perfectly satisfactorily. Like many professionals, we get through quite a lot of Polaroid, so the empty boxes are a cheap, easy solution.

If you don't use Polaroid, look at the boxes that other things come in, to see how they might be

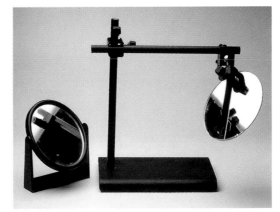

useful. We have also used gift boxes, 35mm film canisters, 4x5in film boxes, those cardboard tubes that are sometimes used to protect good bottles of whisky, and more.

Rather more of a problem is when you want to hold things up, or to stop them falling over, which is not quite the same thing. The traditional approach is to use bits of bamboo, bent wire, old coat-hangers, gaffer tape, double-sided carpet tape, Polaroid boxes (again), angle-iron and heaven knows what else; hot-melt glue guns are quite remarkably useful.

Although we still resort to all of the above from time to time, we save a great deal of both time and grief every year by using Climpex and Wobble Wedges, as illustrated.

◀ **CLIMPEX**
This is a mini-scaffold system, resembling a modular version of the sort of retort stand that most of us remember from studying science at all. As well as the bases and the uprights, there are all kinds of brackets, joints, clamps, clips and flexi-arms, and it is amazing what you can hold in place, and where. The 'Major' set that we use is frankly expensive – around £300 or $/€500 at the time of publication – but unless either you don't shoot many still lifes, or you value your time at nothing, it soon pays for itself in time saved. There are other gaffer clamp systems, but Climpex is easily the best we have ever found.

▲ **WOBBLE WEDGES**
Wobble Wedges are simply small wedges, about 50mm (2in) long and 20mm (¾in) wide, tapering from about 6mm (¼in) thick to a point. The really clever part is that they are ridged, so you can stack them point-to-point for a higher, steeper wedge, or point-to-thick-end for a support block 6mm (¼in) high, and they won't slip. We bought a 'candy-jar' of 75 of them, five or ten years ago: you do lose them slowly, but a box should last for decades if you are lucky, or careful, or both.

PROPS

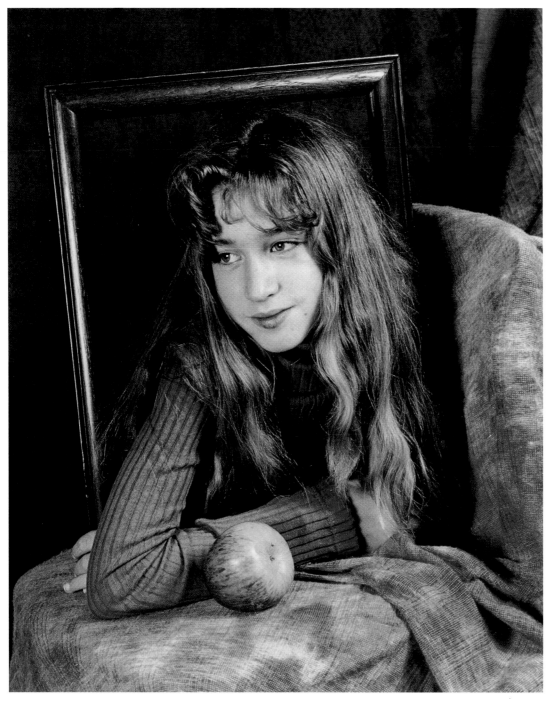

Many photographers never need props. They shoot only the subject, the whole subject, and nothing but the subject: some kinds of catalogue photography are a good example.

Others rely exclusively on props, especially those who shoot for their own pleasure, for competitions, or as fine art. Often, these photographers have a good idea of the sort of props that will make good pictures – or at least, they can recognize a good prop when they see it. Swap meets, car boot sales,

charity shops, thrift shops, local auctions, estate sales: all are happy hunting grounds.

In between, there are those whose need for props fluctuates, often involving unpredictable requests. In major centres such as London and New York, there are professional prop finders who service photographers shooting high-budget advertisements, and often, the hapless assistant is sent out to find and borrow or buy things. Roger still has unfond memories of trying to buy brightly

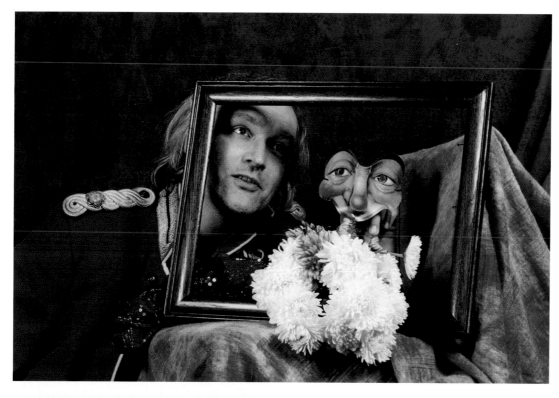

coloured beach towels in Wandsworth in January, and a friend of his, on being challenged as to why he was bringing two entire suitcases of Christmas ornaments home from Germany in June, replied, 'I am an eccentric millionaire.'

Whether or not he or she maintains an inventory of props, the studio photographer is well advised to keep a notebook of what is available where: it is all too easy to remember seeing precisely the right prop for a particular shoot, without remembering exactly where. It is a good idea, in many fields, to cultivate the acquaintance of antique shops and even junk shops. Surprisingly many are willing to lend even very valuable antiques against a cash deposit or credit-card imprint of the whole value of the item, and we have never had any trouble yet in returning the goods or getting our money back. The goods must be returned unharmed, of course, so you may wish to take out an insurance policy for

goods that are on loan: most professional photography policies offer this as an option.

If you do decide to maintain an inventory of props, the biggest problems tend to be storage, and finding things when you want them. We can't offer much help on either: that's how we know that they are the biggest problems. All we can say is, try to avoid getting carried away, and don't buy everything that catches your eye. Wherever possible, borrow things from friends: don't buy them unless you have to.

Personal props

The portrait photographer is well advised to watch his or her subjects, preferably on first meeting them before the portrait session, to see if there are any characteristic props that should be incorporated in the picture. A piece of jewellery; a pipe, a pair of glasses; even a particular garment, such as an opera scarf – any of these can make the difference between a so-so portrait and one that evokes the reaction 'Yes! It's just like him!'

If you can't spot such a personal prop, or if you don't meet the subject before the portrait session, explain the idea to them. Tell them that even if the prop is insignificant or invisible in the picture, it can still make an enormous difference. With it the sitter will be more at home, more comfortable: as the French say, *bien dans sa peau*, at home in their skin.

GETTING
THE SHOT
YOU WANT

The rest of this book is about specific techniques, topic by topic. We have used a lot of Marie Muscat-King's pictures, because we think that they are really good; and Marie herself would be the first to admit that much of what she knows, at least technically, we taught her.

If you see something you admire, don't be afraid to steal the idea and the technique. If you are good enough, it will be better than the original, and if you are not as good, there are few ways of learning that are as effective as trying to emulate someone who knows what they are doing.

Paradoxically, you can also learn a great deal by reacting against pictures that you don't like. You see a shot and think, 'No, it should have been tilted like *this*, and the point of focus should have been *here* and *that* shouldn't have been there at all. Fine. Go ahead and do it. And we hope, quite sincerely, that you will end up as a better photographer than we are, too.

MALE ADULT PORTRAITS

◄ ROGER

Generally, though it is pure prejudice, we prefer black and white portraits of men. Marie shot this 'head shot' for Roger to head his columns in *Amateur Photographer*; the monocle is the classic 'personal prop'.

NIKON F, 135/2.3 VIVITAR SERIES 1, ILFORD XP2 SUPER.

Once upon a time, the distinction between male and female portraits was very clear. Unless they were artists, musicians, writers, or other such morally dubious characters, men wore a collar and tie and their likenesses projected solidity, reliability, diligence and hard work. Women could wear more or less anything, and project more or less any image they liked.

Welcome to the twenty-first century. Since the 1960s, men have been less and less constrained by the older order. Many cannot remember the last time they wore a collar and tie. About the only reliable distinction between male and female portraits is that men seldom wear make-up – though even there, a little spot-concealing cream, and a dusting of translucent powder to dull down the shiniest highlights, will be accepted by the vast majority for photographic portraits.

Harsh lighting is a classic technique for bringing out character in a sitter's face – 'character' being the lines, wrinkles and general wear and tear caused by life, the universe and everything. More men than women seem willing to put up with 'character'.

This immediately brings to mind the point, however, that in order to photograph 'character', the face has to have some. Some people never seem to develop much, and the younger the subject, the less they are likely to have. This is why (for example) some young popstars look downright silly in hard side-lighting, like children pretending to be grown-ups.

Clothes and props

In the days of collars and ties, the code was clear but subtle. Double cuffs (with links) and regimental or old school ties told one story: button-down collars told another. Today, the likely variety in men's clothes is at least as great as in women's, and possibly even greater because fewer men than women are worried about looking foolish: they will wear almost anything.

The old advice to choose a characteristic personal possession as a prop – a pipe was the classical example – still holds good, but it is also worth considering the exact opposite, as well as complete neutrality.

The exact opposite would be to use a prop which the subject would never normally encounter. Good examples would be the Hollywood tough guy with a gun or a cigarette, both of which are ever rarer today. Surprisingly many men can look convincing if they think of impersonating a well-known actor of the past. The most difficult bit is often getting them to drop a facial expression that is a parody of the actor they are impersonating.

As for complete neutrality, there is a certain fascination in what amounts to a glorified passport picture, against a plain white background, with the subject staring unflinchingly at the camera. Choose clothes that say as little as possible – even a plain white T-shirt – and as neutral an expression as the subject can muster.

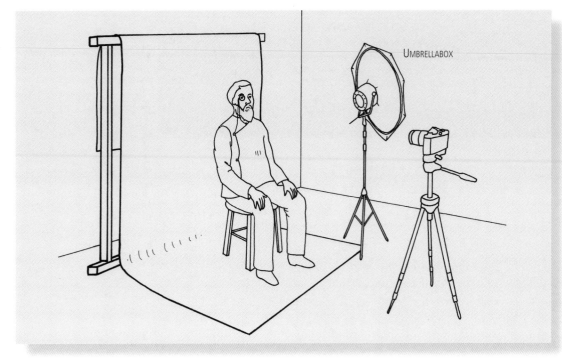

◄ **LIGHTING**
Directional light and harsh light are not always the same thing; here, after all, the lighting is very directional (a single source with no bounce) but comparatively soft. The light is a Lastolite Umbrellabox, effectively a bounce umbrella with a diffuser stretched across the open side of the umbrella.

◄ **PAUL AND CLASSICAL GUITAR**
The guitar is very much the 'personal prop' in this shot; Paul, Marie's husband, is an accomplished musician and guitarist. The pose clearly reflects his concentration and dedication.

NIKKORMAT FTN, 85/1.8 NIKKOR, KODAK E100VS. (MMK)

Lighting and backgrounds

Male portraits are well suited to the one-light portrait, with dramatic contrast, and you can do a great deal with just two lights, one used as a key and the other as a backlight-cum-hair-light. If you want a key, a fill and a hair light, the hair light need not be very strong, and even if you are shooting flash you can often use tungsten, provided it is not doing too much more than backlighting the hair and adding a bit of a halo. A small spot, even an old, fairly low-powered projector, can be adequate.

Tungsten is all you need for monochrome, though you can use flash. Generally, the key should be in a small reflector for a hard light – you can even use a small spot – and the fill should be in a larger reflector for a somewhat softer light, though there are plenty of changes you can ring: a big, soft reflector (or 'bowl and spoon'), or another hard light for a backlight, or even just a big, white bounce for a fill.

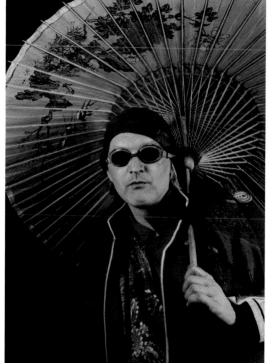

◄ **ARM**
Not all the best portraits are
of faces... This slightly
enigmatic pose says a great
deal about the subject.

NIKKORMAT FTN, 85/1.8 NIKKOR,
KODAK E100VS. (MMK)

◄◄ **PAUL WITH PAPER
UMBRELLA**
Compare this with the other
portrait of Paul opposite, and
the difference is obvious: he
is playing at a new persona,
or at least, a different aspect
of his personality.

NIKKORMAT FTN, 85/1.8 NIKKOR,
KODAK PORTRA 400VC. (MMK)

▼ **SCOTT**
Though not quite as neutral
as a passport picture, this
relies more on the subject
and his pose, and less on
clothes and backgrounds,
than most conventional
portraits. A plain black
T-shirt was, however, less
successful, as it was too
large an unrelieved area
of tone.

NIKKORMAT FTN, 85/1.8 NIKKOR,
KODAK E100VS. (MMK)

In colour, you can just about get away with tungsten if you use ISO 64 tungsten-balance films, but the speed losses engendered by using a conversion filter with daylight-balance films mean that you may need to choose between fast films (with concomitant grain) and dangerously long exposure times.

All but the lowest-powered studio flash units are likely to be powerful enough: the main difficulty is going to be getting a really hard light, which is most easily achieved with a snoot or even a bare bulb, with no reflector at all. Of course this reduces the amount of light available, but even so, a 600+600W-s kit should be enough for the majority of applications.

Unless you can run to the kind of 'built set' background that is described on page 23, the background should be as unobtrusive as possible – though this is not the same as saying it should be uniform. If you use a plain background, give it some texture or variety, either in the way that it is hung or in the way that it is lit: use a gobo, or anything else that casts a shadow, or 'shape' light with a snoot or focusing spot.

Equipment and materials

For maximum 'character', you want maximum sharpness, though grain is not necessarily a problem: gritty grain can complement 'character' in its own right.

The easiest ways to get maximum sharpness are with a sharp lens (this rules out many zooms), sharp film (such as Ilford 100 Delta) and the largest format you can muster: 35mm is often perfectly adequate, but roll film is better, and large format can have a charm all of its own. With a large enough format, you can even get away with a touch of diffusion, though you don't want to overdo it: the merest hint of soft focus is generally more than enough.

FEMALE ADULT PORTRAITS

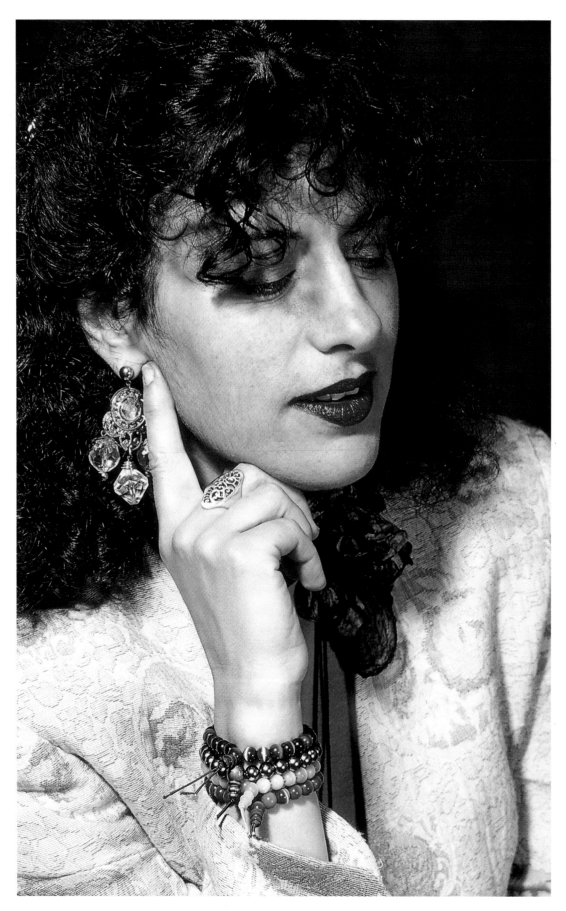

◄ **MARIE**

If you want to shoot something formal, look to the past for inspiration. Both the pose and the costume here are reminiscent of the late nineteenth or early twentieth century: a low viewpoint, and the head high in the frame, create an impression of sophistication, even haughtiness.

NIKKORMAT FT3, 70–210/2.8 SIGMA APO, KODAK EBX. (RWH)

Call us old-fashioned if you like, even sexist, but we firmly believe that the vast majority of women want to be flattered by their portraits. They may not want the kind of thing that once was the norm, with lashings of soft focus and every wrinkle retouched to oblivion, and those of a certain age may be more willing than once they were to accept that there is a limit to how far the camera can be made to lie and still look convincing; but at the very least, they certainly do not want their faults to be emphasized, and normally, they want them to be minimized.

There are exceptions, of course. A young enough woman can get away with almost anything, and laugh at it. And eventually, anyone who is neither terminally vain nor terminally stupid must come to accept that wrinkles are an inevitable part of life; that they can even be an attractive reminder of a long life well lived. But unflattering portraits are a good deal easier to shoot than flattering ones, and inevitably you will learn so much about unflattering ones in the course of learning to shoot flattering ones, that we need hardly concern ourselves with these exceptions.

In general, hard light is suitable only for very young women – from 15 to 25, say – and for those over 70 or thereabouts who are willing to accept their wrinkles as described above. For the majority, soft light is much more suitable. The trick lies in retaining modelling while still lighting softly.

The easiest way to do this is often to use both a soft key and a soft fill – though it is very easy to overdo this and to end up with something little better than copy lighting. A rather better approach is either to use a single soft key with no fill, or to use a fairly hard key and a very generous fill, so that the shadows are only a stop or two weaker than the highlights – especially in colour.

Slight over-exposure also helps, and you may even care to use a soft focus lens or soft focus attachment, though it is all too easy to overdo these – and besides, the bigger the format, the better they work. For portraiture, soft focus 35mm seldom works; medium format is marginal; 4x5in/9x12cm is where you may begin to see more successes than failures; and it is not until 5x7in/13x18cm and above that soft focus is more likely to succeed than not, even in the hands of a novice. And how many novices shoot formats that size nowadays?

Make-up

The biggest single drawback to striking make-up in the very latest fashion is that it can date extremely quickly. For a portrait that is supposed to have even a degree of timelessness to it, the more unobtrusive make-up is likely to be the most successful. In black and white, of course, make-up dates more slowly.

The same comments apply as were made regarding men on the subjects of spot-concealing cream and translucent powder.

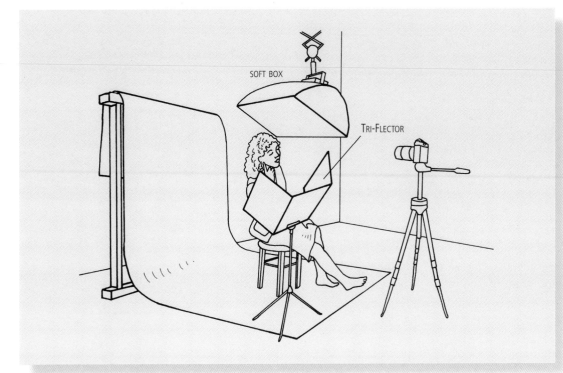

SOFT BOX

TRI-FLECTOR

◄ **LIGHTING**
This is a classic use of a Lastolite Tri-Flector (also known as a Tri-Lite) to surround the subject with light. Note that the soft box doesn't always have to be directly over the model's head: it can be more towards the camera or (as here) to one side. And, of course, the three panels of the Tri-Flector can be angled in many different ways: you can even push one 'wing' down so that it has no effect at all.

Check the make-up repeatedly through the session, refreshing it as necessary. If it proves a long session, and your subject gets thirsty, drinking through a straw preserves lipstick a great deal better than drinking from a glass or a bottle.

Clothes and props

As already noted in the section about photographing men, clothes and props are much more important today than they used to be. People express themselves much more through their clothes than they used to, and those clothes are for the most part much more casual. Also, there is far less distinction than there used to be between 'young' clothes and 'grown-up' clothes. Whereas the girls in high-school yearbooks in the 1950s and even early 1960s look far older than their years, there are plenty of women today who wear the same clothes in their forties as they did in their late teens.

Again as with men, it is a good idea to try to spot any 'props' that particularly characterize an individual: a favourite bracelet, say, or a weakness for jewellery in the shape of butterflies, or flamboyant hair ornaments. Don't just look: ask as well. Be prepared, however, to take pictures both with and without a favourite accessory, in case it comes to dominate the shot.

Lighting and backgrounds

Much the same basic considerations apply to female portraiture as to male, though rather than using two hard sources (or even just one) you will often do better with one light in a big, soft reflector (or 'bowl and spoon') and one smaller, harder reflector or even a small spotlight.

A 600+600W-s kit or even 600+300W-s should be more than adequate for key and fill, though there is the hair light to consider. As you rarely want really hard light, one light in a small reflector and one in a soft box should be enough.

High-key backgrounds can be very effective when photographing women, but you need a truly alarming amount of light to get even a plain white background to read as a bright white: a couple of 1,200W-s flash heads, or two 800W tungsten lights, are unlikely to be too much. If you are shooting high key, take care to use a contrasty lens and as deep a lens-shade as you can get away with, because flare can be a serious problem. If you can spot-meter the face and the

background, the latter need be no more than about 3 stops brighter than the former in order to read as a pure white. Any greater discrepancy will not make the background whiter and will merely add to the flare.

Because you need so much power to light bright backgrounds separately, you may do better to adopt the approach that Marie does and use rich, draped fabrics. Some of these are from the fabric remnant shop opposite where she lives; others are hand-dyed builders' drop-cloths, as described on page 68. Hanging these in swags seems to us to be much more effective than employing plain dappled backgrounds.

▲ CORSET

The black and deep red of the corset demand slight over-exposure if they are to retain texture: the model, already pale-skinned, is thereby rendered even paler and more ethereal, in keeping with the overall style of the picture.

NIKKORMAT FTN, 85/1.8 NIKKOR, FUJI ASTIA. (MMK)

◀ **EARTH GODDESS**
The classical accoutrements – the diadem and bouquet of the fruits of the earth – sit a little strangely with the gem in the nostril; but the truth is that this sort of setting is timeless. Marie made the diadem and bouquet herself, and used them in a number of her pictures.

NIKKORMAT FTN, 85/1.8 NIKKOR, FUJI ASTIA.

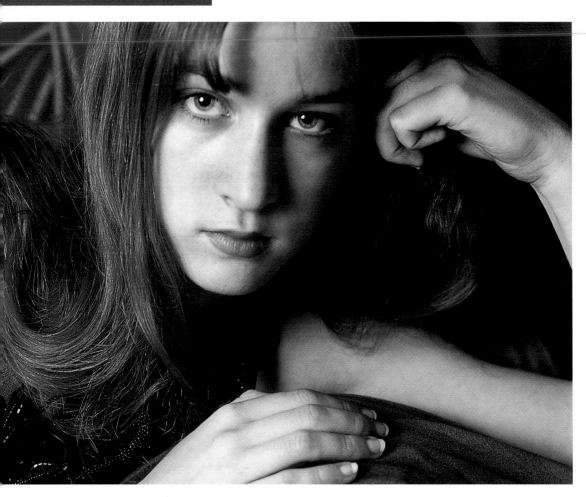

◄▼ SOPHIE

Sophie Muscat-King shows clearly how categories can and must change. Elsewhere in the book she appears substantially as a child; here, she is substantially an adult, a month or two before her sixteenth birthday.
Do not have too many preconceptions about what will look best: teenagers can be an adult one minute, a child the next, though few have as much control over which they wish to be as Sophie. We maintain that Marie has an unfair advantage, breeding her own model!

NIKKORMAT FT3, 70–210/2.8 SIGMA APO, KODAK EBX.

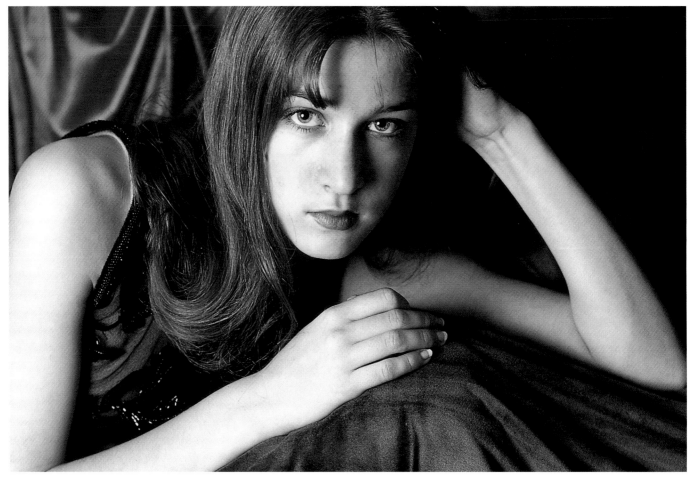

Equipment and materials

Grain is the thing to watch out for. If you are trying to portray a flawless complexion, young or old – especially if the flawlessness is artificially enhanced with a degree of diffusion – then grain will completely destroy the illusion. In general, we prefer either completely grain-free enlargements, or those in which the grain is big enough and clear enough to be a pictorial element in its own right. In black and white, this generally means up to about 5x, or over 10x; in colour, up to 8–10x or beyond 15x. In-between degrees of enlargement seem to us to be lacking in tonality.

Really big grain – the sort of thing you get from developing an ultra-high-speed film in paper developer (or Agfa Rodinal) – can have an ethereal quality all of its own, provided the image is not too contrasty: very soft lighting generally works best if you want to try this sort of approach.

For maximum versatility, we like medium format: 35mm is a bit limiting when it comes to fine grain, though slow, fine-grain materials such as Ilford Pan F are good, especially when developed in ultra-fine-grain developers, and chromogenic films are also well worth

considering. With Ilford XP2 Super you get the grain of an ISO 100 film or less, with excellent sharpness (though still not as high as a conventional film), while Kodak chromogenics are finer grained still, though detectably less sharp.

If you possibly can, contact prints from large-format negatives are wonderful.

▲ GAUZE
The only way to learn to use things like the gauze in which Marie has swathed her model in this picture is to experiment. Your early pictures may well include more than their fair share of failures, but there will be enough good shots (if the idea works at all) to allow you to increase your 'hit rate' next time.

NIKKORMAT FTN, 85/1.8 NIKKOR, FUJI ASTIA.

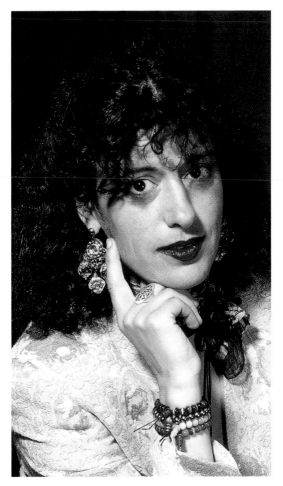

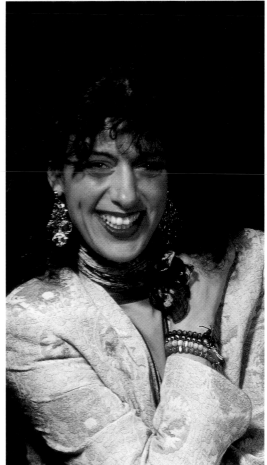

◄ MARIE
Marie Muscat-King is more often to be found behind the camera than in front of it, not least because she has great difficulty in holding a pose for more than half a second at a time: a basic problem with highly animated subjects is that much of their attractiveness lies in their animation. Various options are available: a high-speed motor drive, or (arguably better) a rapid-responding camera with the minimum possible delay between pressing the release and taking the picture – which lets out an awful lot of autofocus cameras.

NIKKORMAT FT3, 70–210/2.8 SIGMA APO, KODAK EBX. (RWH)

NUDES

Photographing nudes is an exercise complicated by a number of factors. First and foremost, technical skill is essential, or the results are tawdry: the 'Readers' Wives' look.

The subjects must be comfortable in their nudity, without being exhibitionists: failures here include the bored whores who feature in so many Victorian nude studies, and the overly predictable studies of fellow students that each new generation at art school is convinced is novel and daring.

The subject must be of age: the days when Lewis Carroll or Keith Dannatt could photograph little girls with no clothes on are long gone (see below), and although countless sculptors, painters and photographers have celebrated the beauties of adolescence, photographing teenagers nowadays can be a short route to the slammer.

We would argue, too, that the subject should be attractive, and preferably flattered. There are photographers who seem to delight in showing sagging, middle-aged flesh as cruelly as possible, every stretch-mark and varicose vein lovingly delineated. We fail to see the point.

With any model, remind them not to wear tight clothing, especially tight underwear, before the shoot: marks from elastic and straps can take a ridiculously long time to disappear.

In many sorts of picture, fashion plays an important part. To be sure, a 'classical' nude may be timeless, but even there, fashions change in backgrounds — plain wooden floors, seamless background paper, fabrics, whatever — and if the model's face is important, make-up and hairstyles can date a picture badly. One organization for freelance photographers has for decades been blowing its credibility by promoting itself with a nude who was clearly (from her make-up) photographed in the 1970s.

◄ TATTOOED NUDE WITH DRESS
Obviously from the same session as the full-figure study of the same subject, this photo illustrates very well the way in which clothing, nudity and eroticism are intimately intertwined.

NIKKORMAT FTN, 85/1.8 NIKKOR, FUJICHROME 100. (MMK)

► TATTOOED NUDE WITH DRAPE
Models for nude photography do not have to be waif-like; a more voluptuous model is far better suited to an opulent Victorian style with draperies and rich fabrics.

NIKKORMAT FTN, 85/1.8 NIKKOR, FUJICHROME 100. (MMK)

▼ LIGHTING
This was very simple, just a single tungsten light to camera right (look at the shadows): what little fill exists came from the opposite wall, bouncing light back into the picture.

AGE BEFORE BEAUTY

The age below which photography of the nude may automatically attract legal problems varies from country to country, and indeed within the US from state to state. The so-called 'Anglo-Saxon' nations (the UK and US) tend to lead the world in prudery, while the Catholic countries of southern Europe tend to be more relaxed. Your local photographic press will keep you up to date on this, but in the UK 16 was the break-point at the time of writing, while in the US we know photographers who will not shoot a nude under the age of 21.

TUNGSTEN LIGHT

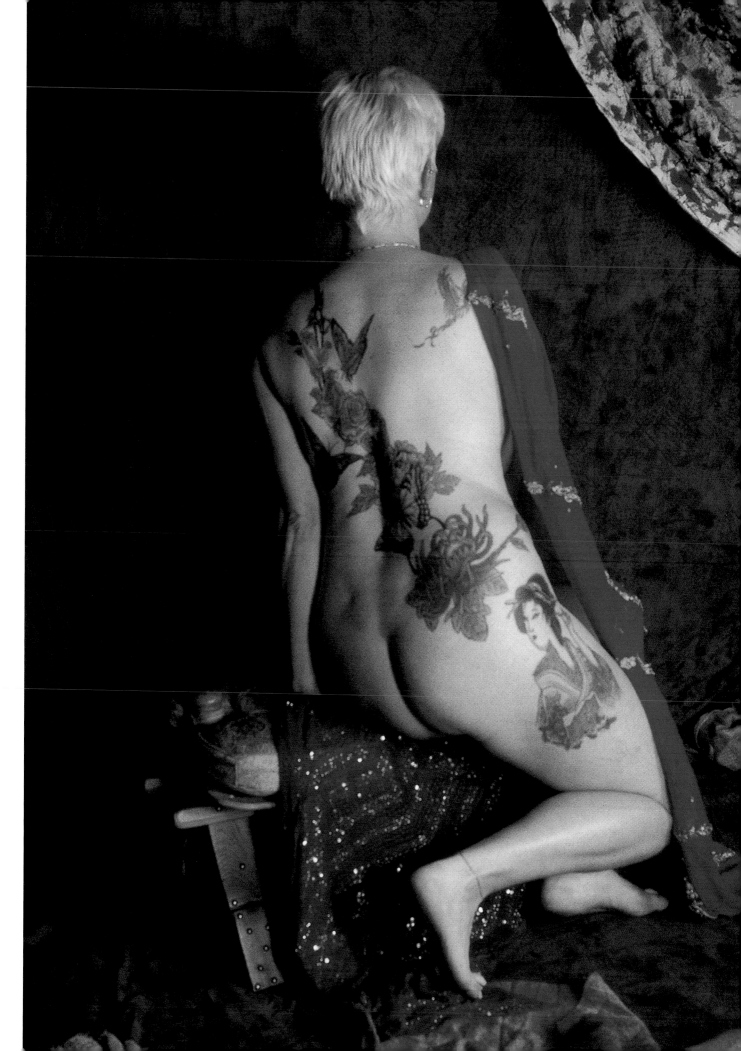

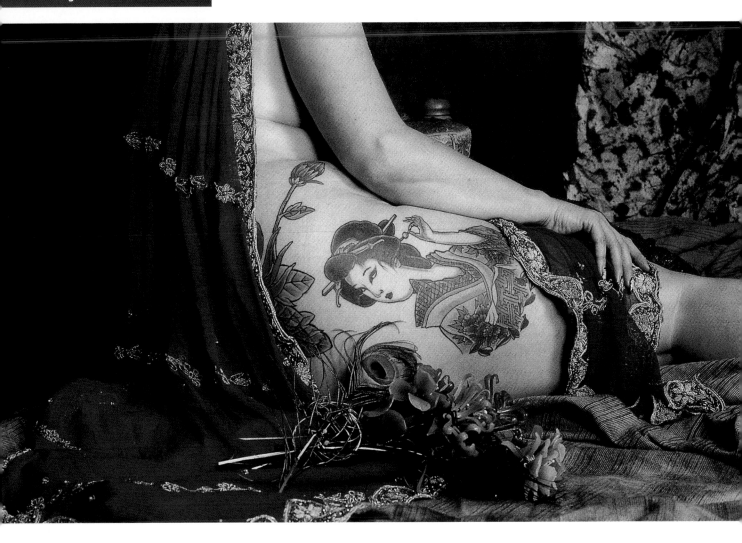

To return to the photographer, he or she must likewise be comfortable, even when the subject's attitude, reactions (and poses) turn out different from what is expected. You do not need to be a prude to feel uncomfortable with certain things; but equally, you need to be honest with yourself about what you do feel. If you care more about seeing the subject with no clothes on than you do about the final picture, it doesn't mean you can't take a good picture: it just makes it more difficult.

You need the right premises to shoot. Again, 'Readers' Wives' furnish plenty of ghastly examples, with cheap, ugly furniture, insufficient 'gardening' of the background (see page 27), and glaring flashback from shiny surfaces.

Finally, of course, the audience (for want of a better word) must be carefully considered: there are those who will condemn the slightest exposure of flesh as pornography, even in the tenderest nude, and at the other end of the scale those who will cry

▲ UKIYO-E

The focus of this picture is clearly the tattoo; but what raises it way beyond the level of a mere record, such as is seen in so many tattoo shots, is the attention to detail, and the use of props. Note the bunch of flowers with the peacock feathers, the draperies (sari shops are a happy hunting ground); and what appears to be an urn in the background, but which is in fact the horn of the camel saddle seen in the other pictures.

NIKKORMAT FTN, 85/1.8 NIKKOR, FUJICHROME 100. (MMK)

TATTOOING AND BODY PIERCING

People who go in for tattooing and body piercing often tend to be of an outgoing disposition, and many like good photographs of the artwork that adorns their bodies. A few pictures left with your local tattooing and piercing parlour may well result in a steady stream of models approaching you, instead of the other way around.

Much the same is true of devotees of fantasy and fetish wear. To those outside the 'scene' it comes as a surprise that there are numerous expensive and often poorly illustrated magazines dedicated to such interests. If you can produce a good set of pictures, your shots may well be welcome for paid publication. They do not pay a fortune, but it is a good source of models, and it's better than ending up out of pocket.

'Boring!' unless the pictures feature some sort of perversion, graphically depicted.

This raises the important point of how 'revealing' a nude should be. The days when pubic hair was anathema, and magazines and newspapers employed a retoucher whose unofficial title was the 'nipple obliterator', are long gone in most of the world. In general, though, we would argue that most people find it hard not to look at things that are concealed most of the time by most people, which means that genitals, in particular, tend to draw the eye – willy-nilly, one might say.

At the other extreme, there are nudes that reveal very little more than you might see on any beach in Europe, and indeed less than you would see on many. An artful combination of revelation and concealment lies at the heart of much art, and much eroticism.

On the subject of eroticism, there is no point in denying its importance in nude photography, or in trying to guess what is erotic or not to another person. The same picture can be a real turn-on to one person; actually repulsive to another; and a matter of supreme sexual indifference to a third – although the third may (or may not) be the one who appreciates it most as a picture.

With all this in mind, where do you start? First, with the studio itself. Privacy is essential, both for the shoot and for somewhere for the model to dress and undress: many are unhappy doing a striptease in front of the photographer. A useful tip, if there are windows that might allow you to be overlooked, is to pin or tape draughting film over them. Moreover, as noted elsewhere, a comfortable working temperature is essential.

Keep a little concealing cream to cover spots, and translucent powder to reduce the shininess of skin if needed. Note that in some American jurisdictions – ah for the Land of the Free – it is illegal for anyone but a licensed beautician (*sic*) to apply make-up to anyone else.

Lighting and backgrounds

You don't need much in the way of lights, and indeed, there is a school of nude photography that prides itself on using a single tungsten bulb. Together with Ilford Delta 3200, unparalleled for its tonality and very, very fast, this can give

wonderful results – grainy, moody and dramatic. In general, if you have a couple of lights, you will have enough to be going on with for the majority of nude photography; indeed, three will be a positive luxury.

For backgrounds and 'furniture', you can achieve an immense amount with fabric backdrops (page 68). Even an old crate, padded with a cushion (or a cheap pillow) and draped with fabric, can create a luxurious impression. A major advantage of this sort of thing over seamless paper is that it is warm: seamless paper on a plain floor can be damnably chilly.

▲ **FRAME**
The presence of apparently wind-blown gauze in so many classical nude paintings is almost a joke; but as this picture demonstrates, gauze can be the photographer's friend as well. Is the model nude, apart from the black velvet neckband? It is not clear from the picture. But the automatic assumption is that she is.

NIKKORMAT FTN, 85/1.8 NIKKOR, FUJICHROME 100. (MMK)

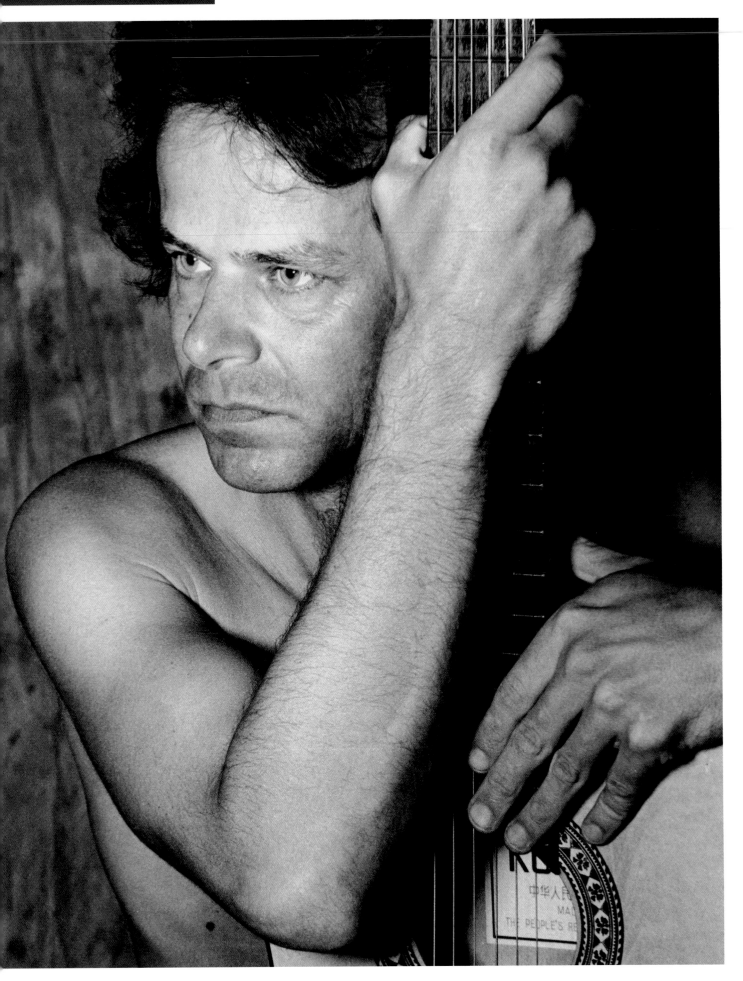

Equipment and materials

When it comes to cameras and lenses, pretty much anything goes, from 8x10in (or even bigger) down to 35mm (or even smaller), and with focal lengths ranging from very long to very short. It all depends on what you've got, and what you want.

Likewise with materials. We have already sung the praises of Delta 3200, and we have a great weakness for Kodak's super-saturated E100VS and EBX, which lend a positively Victorian richness reminiscent of Alma-Tadema in his heyday; but we have seen great infrared nudes, and first-class nudes shot on just about every other film stock ever made.

◀ **PETER**

Like the 'Frame' picture of Jane draped with gauze, this is another in which nudity is to a considerable extent in the eye of the beholder: a nude does not have to be particularly explicit or revealing to have a good deal of impact.

NIKKORMAT FTN, 85/1.8 NIKKOR, ILFORD XP2 SUPER. (MMK)

FINDING MODELS

Nude photography seems to be self-perpetuating. You shoot one or two good nudes, and suddenly, it's a lot easier to find models – especially nowadays, when more people seem to want to express their individuality with no clothes on, or with unusual but scanty clothing. Marie finds that more and more people approach her, rather than her having to ask them.

The most important thing, though, is not to pressure amateur models. Don't demand an answer immediately: give them your card (preferably properly printed, rather than from a money-in-the-slot machine) and ask them to get back to you. You may be surprised at how many do.

▲ **COUPLE, NUDE**

If you are exploring the shapes and interactions of two nude bodies – or even the shape of a single figure – you may often find that anonymity works well in its own right, quite apart from being a useful way of persuading people to be more relaxed the next time they do a nude session in the studio for you .

NIKKORMAT FTN, 85/1.8 NIKKOR, KONICA VX400. (MMK)

COUPLES, FRIENDS AND GROUPS

As soon as you photograph two or more people together, you raise the question of how they relate to one another. Are they lovers? Strangers? Members of the same family? Business associates? Of course, you can refuse to provide the answer to this question, but if you do, anyone looking at the picture will place their own interpretation upon it. Far better to try to answer it, whether honestly or misleadingly. After all, what is a movie love scene if not (usually) misleading?

Perhaps the most fundamental point, and one of the least immediately obvious, is that for people to look convincingly close in a photograph, they must often be physically closer to one another than they would be in real life. Even lovers can look awkwardly distant from one another, and it is all too easy for business associates to look like two people who merely happen to be in the same room and standing a few feet apart.

What is more, the closeness must look unforced. Think of the typical party snapshot, with two (or more) people leaning towards one another, clearly strained. Their heads may be craned together, but their body language tells a different story. Quite heavy stage-direction is often required to achieve a natural-looking closeness. The easiest thing is often to tell people exactly what we have just said: that a photograph is not real life, and that to look natural in a photograph, they have to be closer together. This is often the best approach with business associates.

If they are similarly dressed, it is easier to see them as related in some way, or as sharing something in common: this, after all, is one of the things that uniforms are for. The same is true with props: if they are carrying musical instruments, for example, the assumption is likely to be that they play together. If they are differently dressed – a father in a business suit, a son in the height of current teenage fashion – then you will have to work all the harder to make it look as if they are not total strangers.

If they are touching one another, it must look convincing. Many men, in particular, can put their arm around another man's shoulders when asked to do so, but will then lean their heads away from the other person so as to avoid even the possibility of cheek touching cheek. If you have this problem,

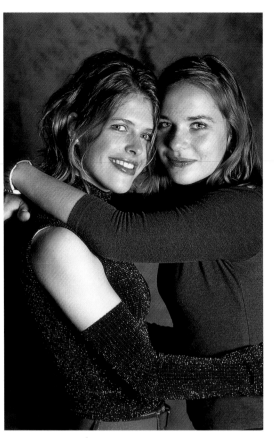

it often works to make a joke of it: tell them you're not expecting a passionate clinch, but that the way things stand, both look as if they are poised to run away at a moment's notice. Tell them to imagine that one of them is drunk, and that the other is trying to help him home. After a moment of parody, they will be much more relaxed.

◄► SISTERS

In the small picture (*left*), the girls are close enough (just) but by tilting the camera Marie has managed to create a much more intimate, informal portrait (*right*) – though the crop is closer, and the pose is happier too (look at the hands).

NIKKORMAT FTN, 85/1.8 NIKKOR, FUJI ASTIA.

▼ LIGHTING

An adjustable focusing spot set to 'flood', or even a light in a middle-sized reflector, can look surprisingly soft in the final picture: lighting doesn't get much simpler than this. Buy a single lamp, and you may be amazed at what you can do.

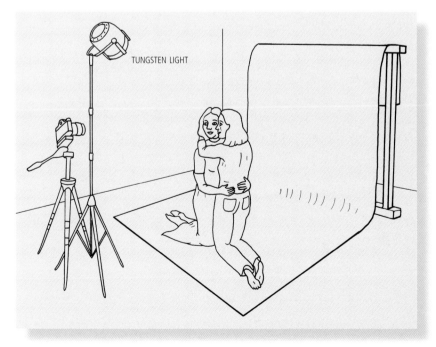

TUNGSTEN LIGHT

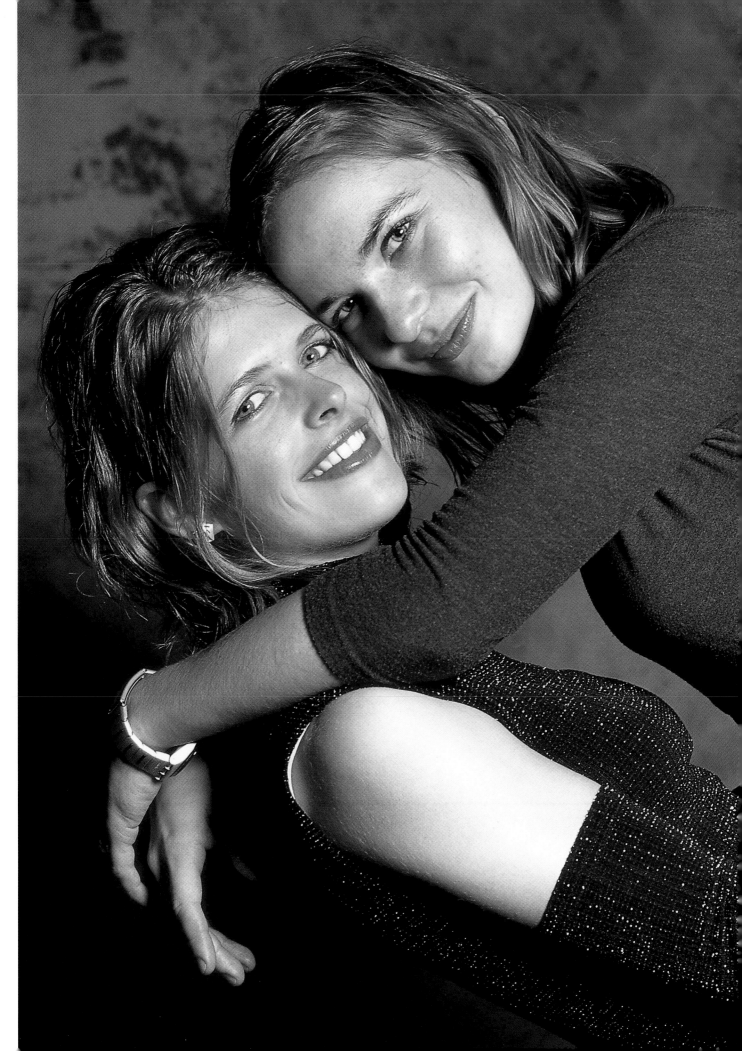

◄ ROB AND SARAH I

In a pose like this, the intimacy (past and present) of the subjects is clear. This is a very old-fashioned picture in some ways, brought bang up to date by the tattoos and the body piercing.

NIKKORMAT FTN, 85/1.8 NIKKOR, FUJI ASTIA. (MMK)

With lovers who look unconvincing, tell them to remember a time when they were particularly happy together. Tell one to nibble the other's ear: even if they don't do it, they'll laugh and that will help them relax. With business associates, tell them to imagine they've just been offered a million in venture capital to expand the business, and don't be afraid to use clichés, such as the Hollywood handshake (right hands gripping, left hand on the other's elbow or forearm).

Before you even get your subjects into the studio, you should have a pretty good idea of the shot(s) you want to take. With a couple, for instance, you might want the classic Victorian pose, one sitting, one standing, though an important point to note is that the Victorians normally had

the man sitting and the wife standing. This may offend the chivalrous, but it reflects the simple truth that most men are taller than most women. This makes for a much happier composition. The eyes of a man of 1.8m (5ft 11in) tall, seated, are likely to be around 110cm (43in) above the floor. If his wife is 1.65m tall (5ft 5in), her eye level is going to be about 150cm (59in) above the floor, or within 40cm (16in) of his. Sit her down, and stand him up, and their eye levels are likely to be a good 60cm (2ft) different.

Equally, you may decide that you would prefer something completely different: sitting on the floor with his head in her lap, or vice versa. That's fine, too. You just have to have something – anything – in mind, so it doesn't come down to their running the show, usually ineffectually. To be sure, you can shoot the pictures they want, and there is often a lot of creative benefit in bouncing ideas off one another; but ultimately, as noted elsewhere, you have to be in charge, and it's easier to lose the initiative when you are dealing with more than one person in a session.

Lighting and backgrounds

If two people are close enough together, you can treat them effectively as one subject for lighting, so you can use much the same lighting equipment as for individuals. You may have some difficulty in doing two hair lights unless you have three or four

◄ **ROB AND SARAH II**
The pose is formal, high Victoriana, but it is subverted by the subjects' attire and tattoos. Having Sarah seated and Rob standing makes for a very long picture: Marie got around this by filling the lower part of the frame (which would otherwise be a large expanse of clothing or bare skin) with the bouquet.

NIKKORMAT FTN, 85/1.8 NIKKOR, FUJI ASTIA.

lights – but equally, how often do you want two hair lights?

At least one soft box or umbrella is useful to light larger areas, and you may often need more power than you would with an individual, because the lights are likely to be working at a greater distance: a light that is just out of shot may illuminate one person adequately, but fall-off will mean that the other person may not be well

◄ **ROB AND SARAH III**
Unlike the picture of the pregnancy, or the formal pose, this shot introduces a lot of tension by having the two subjects looking in opposite directions. On the other hand, the body piercings unite the two of them, as does the way she leans against him.

NIKKORMAT FTN, 85/1.8 NIKKOR, FUJI ASTIA. (MMK)

enough lit. For the same reason, fill can become increasingly important.

If you decide to light two people separately, it generally looks best if the light is coming from the same direction, and you need to pay particular attention to spill from what amounts to two key lights, so that you do not end up with awkward crossed shadows.

Unless you have a fairly elaborate built set, you will generally do best with quite simple backgrounds. Otherwise, the background can compete with the subject.

Equipment and materials

We have no compunction about shooting 35mm colour slide, but in black and white or with colour negative we generally prefer roll film or even large format, simply on the grounds of smooth tonality – unless, of course, we are deliberately looking for a grainy effect.

Space limitations with anything other than tight shots of couples will often mean that you cannot use very long focal lengths: often, a 'standard' lens (80mm on 6x6cm, for instance) will be all you can get away with. Fortunately, the further away you have to stand, the shorter the focal length you can get away with: even as short as 35mm on 35mm, if the group is big enough.

Remember, though, that a wide-angle lens may mean that your background is not wide enough: as shown in the two diagrams opposite, a longer lens makes it possible to use a narrower background. If you can find one, a lens very slightly longer than 'standard' is ideal. If you are lucky, and use an old 35mm camera, you may be able to find a 58mm, which equates roughly to 100mm on 645 or 6x6cm. Other good lengths are 65mm (120mm on 645/6x6) and even 75mm (140mm/150mm).

Because you can control the lighting, you do not

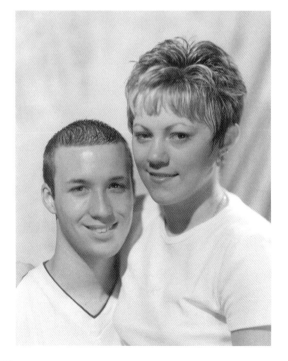

BACKGROUNDS AND LENSES

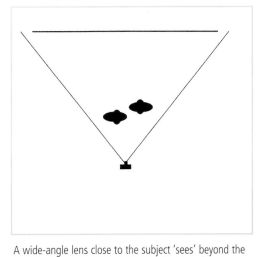

A wide-angle lens close to the subject 'sees' beyond the edges of the background even when there is little room either side of the subject.

A longer lens allows plenty of room either side of the subject while still remaining inside the backdrop.

▼ PETER AND EMMA
If you are going to shoot with 35mm, as Marie did here, then use either a fine-grain conventional film such as Ilford 100 Delta, or a chromogenic film such as Ilford XP2 Super.

NIKKORMAT FTN, 85/1.8 NIKKOR.

need the kind of low-contrast films that are normally used for weddings, and unless you are deliberately looking for rich colours and high complexions you will generally do better to avoid high-saturation films such as Fuji Velvia and Kodak EBX.

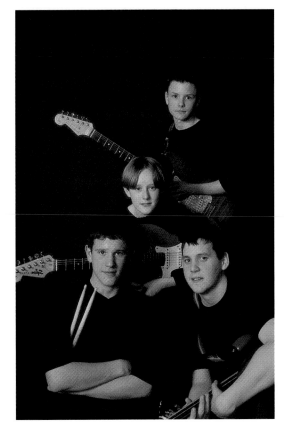

▲ BAND
The pyramidal composition, the near-identical shirts, and of course the musical instruments all tie these four together as members of a band.

NIKKORMAT FTN, 85/1.8 NIKKOR, FUJI ASTIA. (MMK)

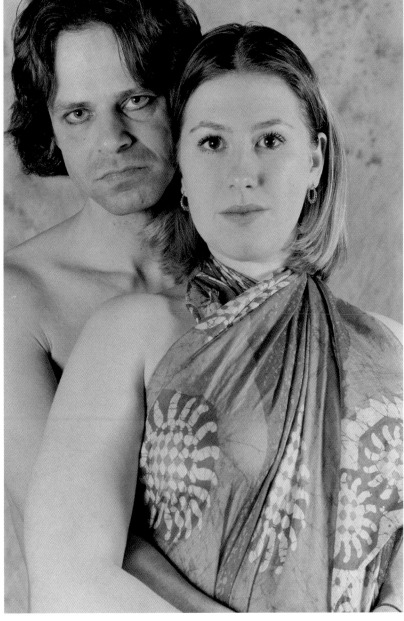

101

CHILDREN AND YOUNG PEOPLE

Stop. Remember what it was like to be a child. Remember being ordered about; told to sit still; told to stop fidgeting. Remember a golden afternoon that stretched away forever but was stolen from you, ebbing away as you sat, waiting, waiting, waiting for something the grown-ups wanted to do. Remember the scratchy new clothes, with their distinctive new smell, that you were told looked so smart.

Remember too the games you played: dressing up, standing on tiptoe, spinning round and round until you were dizzy, laughing so hard your sides ached. Now ask yourself how to get a good picture of a child.

Child portraiture is a powerful reminder that all studio portraiture is a question of people management – and of the often-forgotten fact that children are people, too. The big difference between (most) children and (most) adults is that children generally think in an even shorter time-span than dotcom investors, and they get bored even faster than currency derivatives dealers.

A child's viewpoint

Something that cannot be over-emphasized is the need to shoot from the child's eye level, or even below. Shooting from too high a viewpoint is always unflattering, the more so as most children have disproportionately large heads as compared with adults, and a high viewpoint will make this worse. Shooting from well below the child's eye level can result in some very interesting portraits.

Being aware of the child's viewpoint is merely a specific example of treating children with respect. If you started ordering adults around the way that many people order children around, and made a habit of disregarding adults' views the way that children's views are often disregarded, you'd be asking for a knuckle sandwich. But if you treat them as equals, and make a game of it, you will get a much better response.

Most children are realistic enough to know that not all games are good games, and they will go along with your game even if they are not enjoying it very much, as long as there is nothing better to do.

KEEPING CHILDREN'S INTEREST

- Polaroids (page 40) are unparalleled for keeping all but the youngest children interested. Don't let them handle the prints until they are dry, and don't let them peel the pictures apart unless they are old enough to understand just how nasty the processing chemicals are.
- Take some of the pictures that *they* want, as well as the pictures that *you* want – even if you don't like the pictures they want, or the poses they adopt. And make sure they see the prints as soon as possible. Again, Polaroids are wonderful.
- If they are old enough, let them take some pictures of you. Shoot some of them first; then ask them to shoot some of you, issuing the same sort of directions that you did; then shoot some more of them. You may be surprised at how they take on your style of direction. Again, Polaroids are wonderful: you may even wish to buy an 'integral' Polaroid camera just for their shots.

▶ **DAISY AND SOPHIE**
This is the sort of picture that makes grandparents go 'Aaaah' – and it was not particularly difficult to take. To start with, the background is home-made (page 68). Shooting in black and white removed colour discrepancies between the two dresses, rendering them both as similar light tones, and the flowers and jewellery were an essential part of the dressing up that stopped the girls getting bored.

A useful trick is to use an older (and more reasonable) child as an intermediary when you are dealing with another that is smaller and rather more fractious.

NIKKORMAT FTN, 85/1.8 NIKKOR, ILFORD XP2 SUPER. (MMK)

▼ **LIGHTING**
The lighting is two umbrellas, the one to camera right bounced and slightly closer as a key light, the one on the left shoot-through for diffusion.

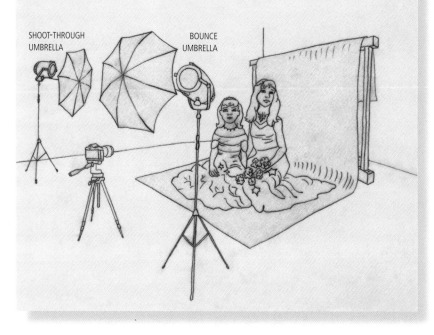

SHOOT-THROUGH UMBRELLA

BOUNCE UMBRELLA

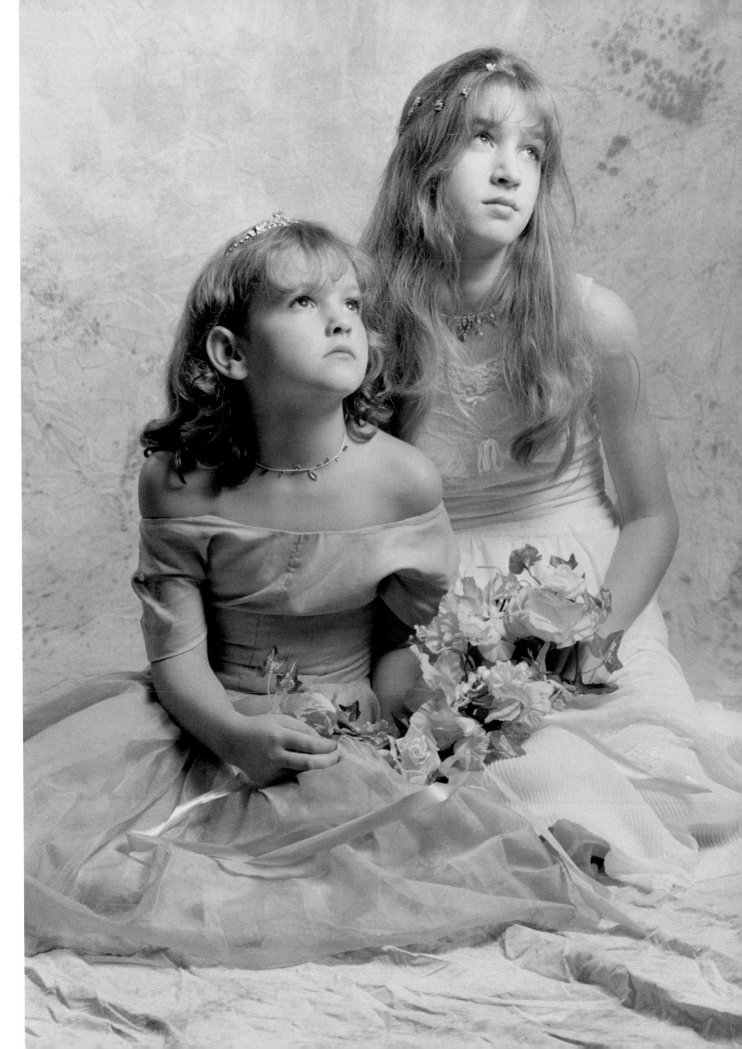

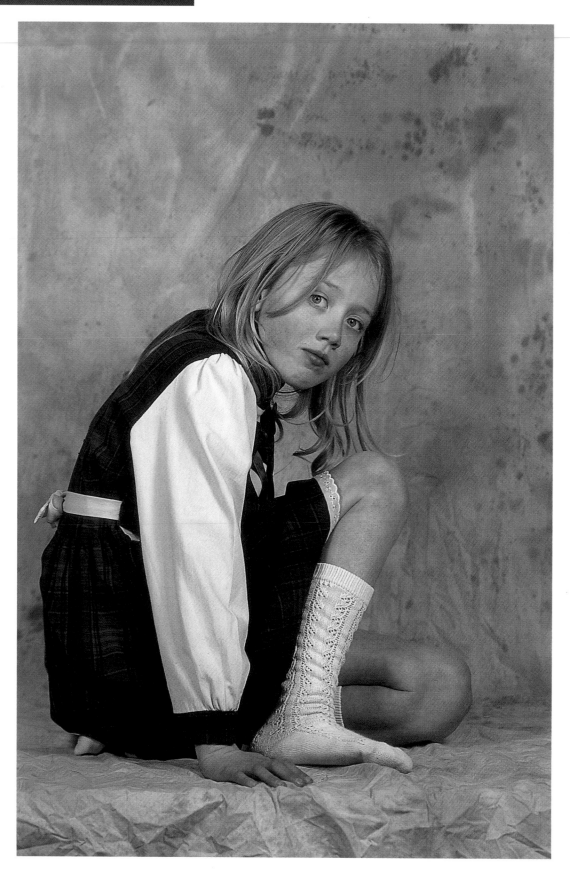

◄ **GOOD THINGS IN SMALL BOXES**

Often you can get striking and unexpected poses by asking children to imagine things – such as 'Imagine that you are in a box. How would you fit in?' Work from the poses they adopt, suggesting changes until you are both happy. The very soft light here is from two flash heads bounced off a white ceiling.

NIKKORMAT, 85/1.8 NIKKOR, HOME-MADE BACKGROUND, FUJI VELVIA (WHICH ACCOUNTS FOR THE SLIGHTLY MAGENTA SKIN TONES). (MMK)

Backgrounds and materials

Because lighting and equipment are covered below, according to the age of the child, the structure of this section is slightly different from most of the others in this book.

Regardless of age, backgrounds are for the most part best kept simple, but not sterile: fabric is fine. Elaborate built sets such as those described on page 68 have a high 'Aaaah!' quotient with the visually unsophisticated but are often dismissed as

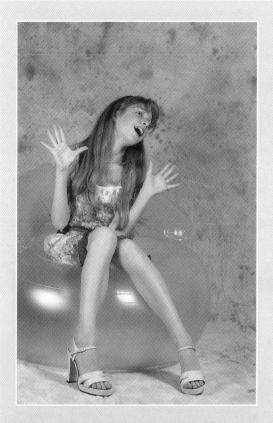

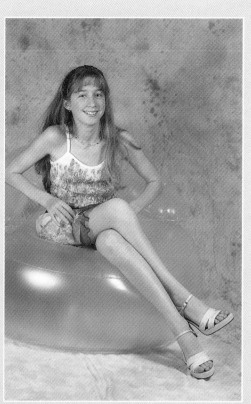

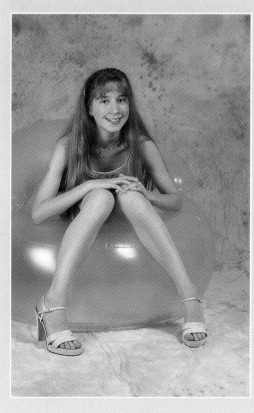

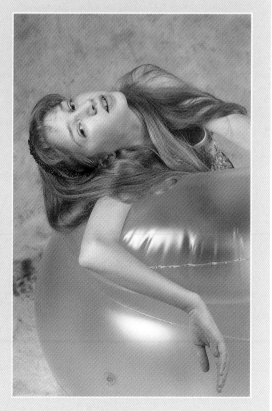

◄ **SOPHIE**

The inflatable chair had a 1960s look to it, which Marie decided to exploit by asking Sophie to adopt over-the-top 1960s poses; a slight difficulty, given that Sophie was born in 1985, but a clear demonstration of the advantages of an intelligent model who was willing to look at pictures from the period, such as Bailey's famous 'Goodbye Baby and Amen'. The series would have been more successful with a less magenta-coloured background, which reacted unfavourably with the Fujichrome 100 film used: plain background paper might have been more successful. Two flash heads were used, one with a bounce umbrella and one with a shoot-through.

NIKKORMAT FTN, 85/1.8 NIKKOR.

tacky by more up-to-date parents. With toddlers, waterproof backgrounds may be highly desirable.

In colour, even quite high-saturation films can capture childish complexions well, where they merely make adults look as if they are suffering from high blood pressure. In black and white, we (and Marie) have a great weakness for Ilford XP2 Super for child portraits.

If you want a very high 'Aaah!' quotient, hand colouring can be very effective. Let the children try hand colouring some reject prints, too.

Babes in arms

Such personality as very small children have is generally apparent only to their immediate relatives. We prefer to photograph babies with their mothers, but if you insist on shooting them on their own, it is mainly a question of wedging them as gently as possible into a position where they can't roll over, and shooting fast before they start crying. If you have the magic touch that means you can work some other way, then we can teach you nothing.

Soft lighting generally looks best, to capture those delicate skin tones, but you need enough modelling to capture the chubby cheeks and rounded limbs as well: try two umbrellas, one bounce for a key, one shoot-through for a fill. Because babies don't move about much, medium format is as much use as 35mm.

Toddlers

Two- and three-year-olds can move with altogether unbelievable speed, and cause expensive havoc in a studio in seconds. Unless they are unusually well behaved, we would strongly recommend that they be photographed out of doors in playgrounds, tank-proving courses and other hard-to-destroy environments. The only way you can normally keep them in one place long enough to take a studio picture (barring strong adhesives) is if you can get them really engrossed with a favourite toy – and even then, you had better have the mother handy to tackle them and bring them down as soon as they make a break for it.

From an equipment point of view, 35mm is virtually essential to capture fast-changing expressions and poses, and although the lighting should cover a large enough area to allow for reasonable movement, the child's face and body is beginning to demonstrate somewhat more

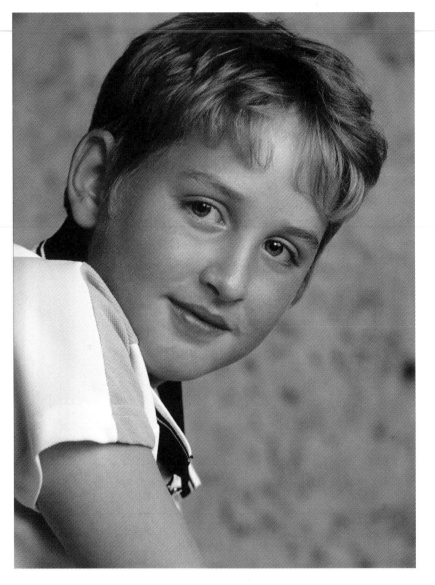

▲ **OMEIVER**

A besetting problem with small boys is scratches, scrapes and bruises. Omeiver had quite a bad scratch on his face – the result, by all appearances, of a disagreement with a cat. The easiest way around this was a repair in Adobe Photoshop, a trick worth remembering.

NIKKORMAT FT3, 70–210/2.8 SIGMA APO, KODAK EBX. (MMK)

◄ **SPIKE**

Is this an attractive picture? No. But it is the picture that Spike wanted – and wasting a frame or two of film is a small price to pay for the picture that you (or the parents) want.

NIKKORMAT FT3, 70–210/2.8 SIGMA APO, KODAK EBX. (MMK)

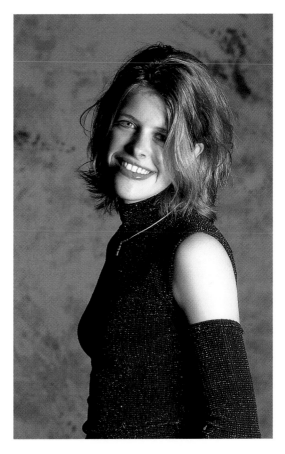

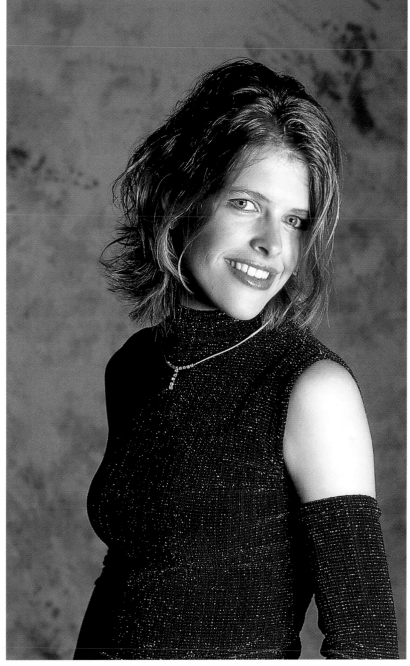

individuality, so stronger directional lighting can be surprisingly effective. Try a bounce umbrella on one side of the child, and a big, flat reflector on the other side.

Small children

From four or five to ten or eleven is often the easiest age for photographing children. If you are lucky, they are reasonably biddable, and they love dressing up and role playing.

This means that you can try an enormous range of techniques. For instance, try very harsh adult-style lighting on a small boy in a cowboy outfit; or high key for a young ballerina; or low key for a little girl wrapped in rich-coloured fabrics. Looked at in this context, it really is a game for both of you. The main thing is to do all your preparation beforehand, so that the child does not have to sit around waiting for you.

Young people

Some children remain as amicable at 12 or 14 as they were at eight or ten, but many tend to become much moodier, more easily bored, and generally harder to deal with.

One important thing is to remember that they are not there for your benefit, any more than you

are there for their benefit: both parties have to get something out of it. Simple bribery often works wonders, and provided you consider the bribe carefully (and stick to your side of the bargain), there is nothing wrong with this.

As they change from children to adolescents, they will become more and more concerned with their appearance and perceived attractiveness. A pimple can be a catastrophe, the wrong clothes, even worse. Make them look good on their terms, and you will be surprised how often that will make them look good on your terms, too; and you can also trade pictures of the way they want to be seen with the way you want to see them.

▲ **GIRL IN BLACK**
You will seldom lose the co-operation of your subjects by treating them as older than their actual age. Shoot plenty of pictures, and select the ones that look best: this is far and away the best way to capture mercurial expressions. A single light to camera right, with a plain reflector, may be harsh to some tastes but it is also dramatic.

NIKKORMAT FTN, 85/1.8 NIKKOR, FUJICHROME 100. (MMK)

FANTASY AND FASHION

Fashions change fast enough, but to make life worse, there are fashions in fashion photography. Grainy black and white; over-exposed colour; under-exposed colour; ultra-wides; 300mm telephotos; underwater; tungsten-light film exposed by daylight; strong chiaroscuro; high key; complex sets, laden with props; bare background paper – everything has had its day, sometimes more than once. Then there are fashions in models, though since the 1960s most have been very thin indeed and many have been unusually tall. Almost by definition, they are beautiful, because increasingly, beauty is defined by how models look; but there are more types of beauty than one.

To make life still more interesting, by the time a style (of clothes, of models or of photography) is fashionable, it is on its way out. What you must do, therefore, is to cultivate your own style, and try to get it in front of the right people. This is a book about photography, rather than about marketing, but it is fair to say that if you are going to succeed in fashion photography, you already know the fashion scene: what magazines are influential (and who their editors are) and which designers are up-and-coming, which are on the way down, and which are established for the foreseeable future.

Because the styles are so evanescent, the main thing you need to learn is how to deal with people, and how to put your personal vision together. Rather than dealing with cutting-edge fashion, we have used what we call 'fantasy' pictures. These are closely allied to fashion, in that they are essentially a version of dressing up and creating a persona and image for the model; the only real differences are first, that the styles chosen are less 'here today, gone tomorrow', and second, that your model is likely to be more enthusiastic – which always helps.

In what follows we have concentrated on photographing young women, but much of what we have said is applicable, *mutatis mutandis*, to photographing young men. The difficulties inherent in finding models (page 110) will be slightly different, but less so than you might think.

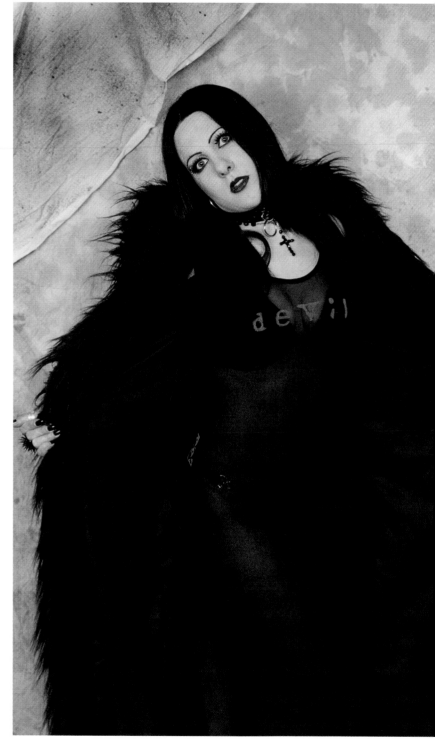

▲ **FUR COAT**

You have to be open to what the world brings, if you want to succeed in fashion and fantasy photography. You cannot fully control what appears in front of your lens: you can only control how you record it. This is Sharlene again: by trying to show a number of different moods or aspects of your model, you can broaden your skills and photographic horizons.

NIKKORMAT FTN, 85/1.8 NIKKOR, KODAK GOLD 100. (MMK)

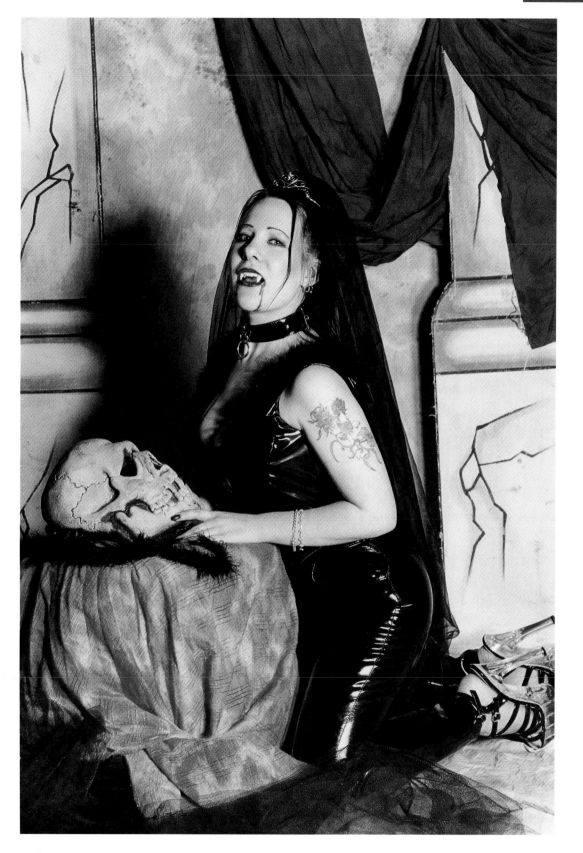

▲ **SKULL**

The pillars in this elaborate-looking built set were rescued from a discarded shop window display: they are painted on plywood. The fabrics came from the remnant shop across the road. Sharlene provided the costume, fangs and skull herself. Helping someone else to create their fantasy can teach you a great deal about fantasy in general and the techniques needed for fashion in particular. The key light is a Paterson flash head in a reflector to camera right (look at the shadow) with a weak fill from a shoot-through umbrella to camera left.

NIKKORMAT FTN, 85/1.8 NIKKOR, KODAK GOLD 100. (MMK)

Finding models

Your portfolio shots do not necessarily have to feature the sort of models that are themselves the height of fashion. Sharlene, who features heavily in this section and appears elsewhere in the book, is very striking and very much her own woman; her beauty goes beyond the flavour of the month. Find a model like her, with whom you can work and explore, and you are halfway to success. Your model may even become the next Face.

Finding new models is trickier for male photographers than for women, and the older the photographer gets, the harder it can be to persuade attractive young women that your intentions are honourable – unless, of course, you can cultivate an avuncular persona which they find non-threatening. There is no doubt, though, that it is easiest for a male fashion photographer to become established young, after which, finding a supply of models is a self-solving problem.

The only reliable approach, for both male and female photographers, is to have cards printed and to hand them to any likely prospects. They should be well printed on good paper: a card on cheap stock, with the printing slightly off centre and running up or down hill, is seedier than no card at all. And they should not try to be overly clever: logos are all very well, but off-the-shelf symbols such as a camera and tripod usually look cheap and nasty. Do not take rejections too hard: an acceptance rate of one in three is excellent, while one in ten is not too bad.

Lighting and backgrounds

Electronic flash is generally the preferred form of lighting, because it does not overheat the studio – fashion modelling can be hot work, even without tungsten lights – and because it allows motion to be 'frozen' by the duration of the flash. For rapid shooting with a motor drive, location shooting by available light is widely used. But there are no rules: if the budget runs to it, hire HMIs by all means.

As for backgrounds, anything goes. Shock value is highly prized: meat markets, desolate factories... And then someone comes along with Colorama all over again, as if it were the first time.

Equipment and materials

Since Terence Donovan, Brian Duffy and David Bailey rewrote the rules in the 1960s, 35mm and roll film have been the accepted norm: the days of 8x10in fashion are gone. Or are they? Maybe the time is ripe for someone to reintroduce large format fashion.

Materials can be anything, and are routinely abused: cross-processing, outdated stocks, Polaroid technical films, anything goes. Experiment.

▶ **FANGS AND BLOOD**
Sharlene again, and the principle is clear. When you sell clothes, you are selling a lifestyle: props and make-up matter. This is as true in fashion as in fantasy.

NIKKORMAT FTN, 50/2 NIKKOR, KODAK EBX. (MMK)

◀ **TROUSERS**
◀ **SHIRT**
Do not neglect the possibilities of shooting fashions *sans* models. This is pretty much the opposite of the school that photographs models in such a way that you can see nothing of the clothes, in that all you can see is the clothes. You cannot see the drape, and the cut is not seen in the same way as it would be on a model; but the colours, the detailing, and much of the style can be presented attractively, relatively easily, and rather more cheaply than is possible with a live model shoot – a point which may certainly commend itself to some clients.

NIKKORMAT FTN, 50/2 NIKKOR, KODAK EBX. (MMK)

CLOSE-UP AND COPYING

Close-up and copying provide the foundation for the more interesting subjects that follow: still lifes, flowers, food, even 'how-to' and 'exploded' pictures. Most involve close focusing, or even macro. Strictly, 'macro' photography is life size (1:1) or larger on the film, but this is not really a very useful distinction, which is why in popular usage 'macro' simply means 'unusually close focusing'.

The normal close-focusing limit of most lenses is around one-tenth life size on the film. There are three reasons for this. One is that at this size, you start needing to consider extra exposure to compensate for the extra extension, though this problem has been substantially solved by through-lens metering. The second is that extended-throw focusing mounts are bigger, heavier and more expensive than the usual variety. And the third is that the performance of many (though far from all) lenses deteriorates badly in the close-up range.

One of the great disadvantages of autofocus is that it is much harder to adapt modern cameras and lenses for close-up work, so the only easy option is to buy a new, autofocus macro lens. On the other hand, if your camera can accept manual-focus lenses (and most can, via adaptors if need be), you may find it cheaper, easier and quicker to take this route. With close-ups, we find it easier to focus manually in any case.

Macro lenses

If you can afford it, the best option for the vast majority of close-up applications is undoubtedly a purpose-made prime macro lens in a long-throw focusing mount. Not only can you focus down to 1:2 or even 1:1, but you also get excellent image quality in this range.

Short (50mm and 55mm) lenses are ideal for copying, but something in the 85mm to 125mm range allows greater stand-off between you and the subject. This reduces the likelihood of scaring off live subjects, and gives more working space in the studio for lighting.

Prime macro lenses are normally fairly slow in order to allow the maximum possible image quality, and they tend to be expensive because not many are sold relative to their general-application cousins. They can, however, be found on the used market, sometimes in excellent condition.

Macro zooms

The vast majority of so-called macro zooms are general-purpose lenses with a close-focusing facility added pretty much as an afterthought. Some do not even allow continuous focusing: there is a 'macro' setting that allows a limited close-up range, quite separate from the normal focusing range. The best macro zooms cannot approach the quality of a purpose-designed prime macro lens; the worst of them are abysmal, and should not be used for anything that is going to be enlarged more than about 2x.

Such a tiny enlargement may seem useless, but it is more than adequate for many 'how-to' and step-by-step shots and for small catalogue illustrations. As noted elsewhere, image quality requirements for web illustration are so low that even a bad lens is likely to be adequate.

Some macro zooms are, of course, much better than others, such as our 90–180/4.5 Vivitar Series 1 Flat Field, but this is a lens that rarely appears on the secondhand market and cannot really be considered as a possibility for most people. Carefully test any macro zoom, new or used, before you buy it.

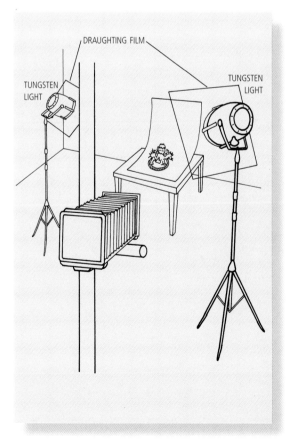

► **HAYAGRIVA**
A 'baby' Linhof with a 6x7cm back was used to capture this stunning *rupa* (religious statue) of a *yab-yum* (male/female sexual congress) manifestation of Rudra: a 105/4.5 Apo Lanthar helped with the colours, even on Kodak EPR, a film well below the standards of modern emulsions. 'Copy' (45 degree) lighting was well diffused with draughtsman's film; the film was under-exposed to 'pop' the colours; and black velvet, slightly under-exposed, delivered the pure jet black of the background.

(RWH)

◄ **LIGHTING**
The two tungsten lights are essentially in 'copy' formation' at 45 degrees either side of the subject–camera axis, and they are well diffused with draughting film – which must be kept well away from the hots lights, or it will melt.

DRAUGHTING FILM

TUNGSTEN LIGHT

TUNGSTEN LIGHT

◄ **BLUE**

Marie used an 80mm enlarger lens on an old BDB bellows (no longer made) to photograph this close-up study at about one-quarter life size: the lighting was a single diffused flash head to one side.

NIKKORMAT FT3, KODAK EBX.

True macro lenses

True macro lenses, designed for 1:1 and larger, are normally of very short focal length, anything from 25mm to 10mm: surprisingly fast, often f/2 or faster; and have no focusing mounts, but are designed to be used on bellows. The short focal lengths are so that you get a high degree of magnification with modest bellows extension, and the high speeds are because of diffraction limitations on resolution. An f/2 lens at a magnification of 3:1 (three times life size) is working at an effective f/8, and an f/5.6 lens would be working at an effective f/22, where the diffraction-limited resolution would be between 45lp/mm and 70lp/mm at any useful contrast.

Other close-focusing lenses

A few lenses that are not advertised as 'macro' can nevertheless be used in the extreme close-up range. One (elderly) example that we have is a 135/2.3

◄ **FUNERAL SERVICE**

Miniscule depth of field characterizes this evocative miniature still life by Marie, incidentally illustrating why copying must be done square-on to keep everything in focus. She used an 80mm enlarger lens on a bellows, which allows continuous focusing from infinity to rather over life size. Daylight-balance film under tungsten lighting creates an 'instant sepia' effect, adding a degree of nostalgia that would not be present in a shot with the usual colour balance.

NIKKORMAT FT3, KODAK EBX.

◄ **GOSSEN MAKROGERÄT**
This macro light was discontinued when no one could afford it any longer – German precision does not come cheap – but other, similar light sources are made by various manufacturers from time to time. The arms contain glass-fibre bundles: at their tips are tiny lenses that allow each arm to be focused from flood to spot. Inside the box is both a tungsten light source and a flash unit.

Vivitar Series 1, which focuses to about 1:3. This is more than close enough for many applications, and the image quality is remarkably good.

Other lens options

Supplementary close-up (dioptre) lenses entail an inevitable loss of image quality, but this can be kept to a minimum by choosing a high-quality prime lens to begin with, and working at a modest aperture: f/8, say, for an f/2.8 lens. As a general rule, slower lenses will perform better than faster, especially among standard and wide-angle lenses, and longer lenses will perform better than shorter. Zooms will be worst of all.

Ideally, the close-up lens should be a cemented doublet rather than a single glass, but such lenses are almost impossible to find nowadays. Close-up lenses are not just small, light (fairly) cheap and easy to use: they have the further advantage that they do not entail any loss of speed, so the marked apertures still hold good.

Extension tubes and bellows

Another option is to increase the extension, and once again, loss of image quality can be minimized by choosing the same sort of lens described above as being suitable for use with close-up (dioptre) lenses. The choice of tubes or bellows will depend on the application. One of our best lenses for still life is an old 85/1.9 Pentax Super-Takumar on a very short extension tube,

while for true macro an old 50/2 Nikkor on a bellows is good.

We do not reverse either lens, because they don't need it, but some lenses perform better if they are reversed, in other words, if the filter ring is used to secure the lens to the camera via an appropriate adaptor. Some manufacturers publish recommendations on which lenses should and should not be reversed; in other cases, it's a matter of experiment.

Enlarger lenses

An unexpectedly useful option is an enlarger lens on a bellows. By definition, an enlarger lens is calculated to give its best performance in the close-up range, and if you use an 80mm or longer you can often get continuous focusing from infinity to life size. You can often find used bellows at camera fairs, and a specialist machinist such as SRB of Luton can make an adaptor for the enlarger lens.

Teleconverters

A teleconverter can be a good, cheap way into close-up photography, because it magnifies the image without changing the close-focusing distance. A lens that focuses down to (say) 1:8 can therefore be transformed with a 2x converter into one that focuses down to 1:4.

The only way to find out whether a particular lens will work well in this way is to test it. There is an inevitable loss of speed – 2 stops with a 2x

▲ **THE ROAR OF THE GREASEPAINT**

Two arms from the Gossen Makrogerät were used for this, tight spots lighting the lid and the cracked, dried-up greasepaint. The tin is maybe 35mm (1½in) in diameter.

NIKON F, 90–180/4.5 VIVITAR SERIES , KODAK EBX. (RWH)

◄ **REVOLUTION IN THE USA**

For this shot, all three arms of the Gossen Makrogerät were set to 'flood'. The badge is maybe 20mm (⅘in) in diameter; the combination of two such potent symbols was irresistible. Both are so familiar that it takes a moment or two to realize that they do not belong together like this.

NIKON F, 90–180/4.5 VIVITAR SERIES 1, KODAK EBX. (RWH)

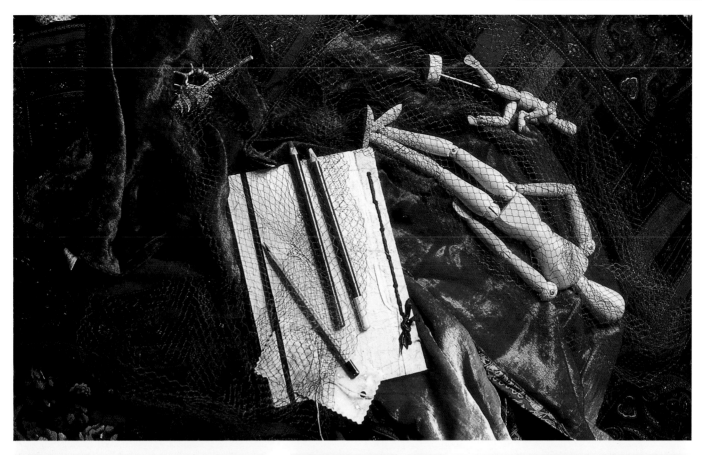

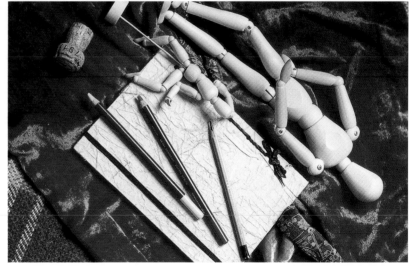

▲ **LAY FIGURE**
The smaller lay figure shot is the sort of thing that anyone might take, but (as ever) Marie continued to explore the theme and came up with the version that is here printed larger. A spirit of play is the only practical approach here. In both cases the light is a single soft box.

NIKKORMAT FT3, 80MM ENLARGER LENS ON BELLOWS, KODAK EBX.

converter, so that an f/2.8 lens becomes f/5.6 – and it is generally a good idea to work a couple of stops down from even this modest aperture, at f/11; but a quick test will show which stop, f/8, f/11 or f/16, delivers the best quality.

Digital cameras

Surprisingly, many digital cameras focus very close indeed, but it is worth checking to make sure that the focusing is continuous and does not involve a 'macro mode' that is quite separate from the normal focusing range.

▲ **MUSEUM OF THE REVOLUTION**
This is not quite as easy as it looks. As well as focusing very close and avoiding reflections, a glancing light had to be used to bring out the word MOCKBA (Moskva) cast in the metal. The 90–180/4.5 Vivitar Series 1 lens was at its closest focusing distance, allowing one-half life size at 180mm.

NIKON F, KODAK EBX. (RWH)

117

Medium format (MF)

Years ago, we moved from Hasselblad to Mamiya RB67 in order to get the bellows focusing. Today, our standard MF cameras for still lifes are always bellows cameras: either a 'baby' (6x9cm) Linhof with a 6x7cm back, or a 4x5in camera with a roll-film back (6x7cm or 6x9cm). After all, most studio pictures other than of people are not going anywhere, so ground-glass focusing is no great drawback, and with these cameras, we have the advantage of camera movements for optimum focus (see page 38).

Large format (LF)

For many kinds of still life, LF (4x5in/9x12cm and above) cannot be beaten. The image is easy to examine on the big ground glass; the quality is sublime; at 5x7in/13x18cm and above, you can make beautiful contact prints; and there is a contemplative side to using these cameras that many people find very attractive.

As professionals increasingly switch to roll film and even digital, used monorails appear on the market in ever greater numbers and at ever lower prices. Wooden field cameras still command a premium, and indeed represent a growing market, because they are lighter and more compact and more convenient for landscapes and the like; but in the studio, the extra weight and bulk of the monorail are no real disadvantage, and the movements are both more extensive and easier to use. Rather than going into any greater detail here, we would refer you to our book *Medium and Large Format Photography* (David & Charles/ Amphoto 2001).

Pinholes

A pinhole camera has infinite depth of field: everything is equally sharp (or unsharp). We are not wild about pinhole photography, and it is undeniable that you can never be entirely sure what you will get on the film, especially in close-up; but we have to admit that it has a certain charm, and we thought we would be remiss if we did not mention it.

Lighting

You rarely need very powerful lights for close-ups, unless you are shooting with large format at small apertures or using pinholes. Shadowless lighting

▲ ▶ MACRO BACKGROUNDS
Extreme close-ups allow all kinds of improbable things to be used as backgrounds. In these two shots, taken with an enlarger lens on a bellows, Marie used a seashell. Dead 'square' alignment allowed the background to be held in focus; a small aperture was needed to hold both the subject and the background.

NIKKORMAT FT3, KODAK EBX.

with a soft box (page 48) is often useful, sometimes with a 'mini-cove' (page 26), but frankly, just about any lighting set-up you can devise may suit a particular subject.

Mirrors really come into their own with small close-up set-ups. They function as lights, not as reflectors, being used to fill dark areas or highlight areas of importance.

Lighting for copying

As just about everyone knows, the best way to get an even light for copying is to have two lights at 45 degrees either side of the copying board – better still, four lights as two pairs.

Something that slightly fewer people know is the easiest way to make sure that the lighting truly is even. Hold a pencil, point down, on the copy board and see if the multiple shadows that it casts are equal in intensity. If they are, the light is even. If not, you should adjust the lights until they are.

Copying paintings

Increasingly, this is done digitally, with scanning backs on LF cameras. Traditionally, of course, it

was done on large format transparency film. The lighting is the same, no matter what format you use: essentially, it is the sort of copy lighting described above.

The big danger is 'flashback' from the impasto of the paint. The easiest way around this is to use polarizers on both the lights (which can be either tungsten or flash) and the camera lens. Camera filters can be bought at any decent camera store, but sheet polarizing filters are harder to come by: Lee makes them, and the ones we use come from Brandess Kalt Aetna (BKA).

Set the polarizers on the lights correctly (a matter of experiment, most easily done if you turn off first one side, then the other) and you can kill all reflections. The trouble is, this can look too saturated and a little 'dead', so it is often a good idea to turn one or both of the polarizers on the lamps so that they are slightly away from the point at which all reflections are suppressed.

If you are shooting a large number of paintings, sort them into batches so that you can shoot all those paintings of a similar size at a constant reproduction ratio, without having to move the camera stand or even refocus.

Slide copying

This is a dying art, as there is much less need for it than there used to be: the scanner has replaced the camera, as indeed it has to a very considerable extent for flat copying as well.

If you need to do much of it, the best approach is to use a purpose-made slide copier such as a Bowens Illumitran: once again, lack of demand means that these are available on the used market for quite modest prices. Another option is to buy an enlarger colour head and use it upside-down: this allows colour corrections to be dialled in, which is quite handy, but check before buying: some overheat in this position.

If you don't need to do much, then jury-rig

◄ **FILAMENT**
The lighting here was a surprise. The Gossen Makrogerät was used to light either side of the envelope, which reflected the light back onto the filament, making it sparkle. The background is black velvet. The same bulb is seen on page 142. A more adventurous photographer would probably have tilted the camera for a more dynamic diagonal composition.

NIKON F, 90–180/4.5 VIVITAR SERIES 1, KODAK EBX. (RWH)

◄ **WHISKY GLASS**
Depth of field is marginal in this shot, but the technique is interesting. A very bright, very tight, very small spot was directed straight down into the glass, and is the only light that was used.

NIKON F, 90–180/4.5 VIVITAR SERIES 1, KODAK EBX. (RWH)

some way of transilluminating a piece of opal acrylic sheet (Perspex or Lucite) with a small, on-camera flash. You will need to waste a few frames on the end of a roll to determine the optimum exposure. Alternatively, use tungsten lighting and tape a blue filter to the other side of the acrylic in order to correct the colour balance (or use tungsten-balance film). Daylight is not a good idea: the slides normally come out too blue, and the range of colour temperatures is too wide and too unpredictable to correct without access to a colour temperature meter.

Whatever set-up you use, a perennial problem is the way that contrast builds with each copied generation. One way around this is to use special copying film – check the manufacturers' catalogues – but a cheaper approach, and one which is just as good, is to use varying amounts of 'spill' around the image that is being copied. For maximum contrast, mask the image to the edges with black card; for minimum contrast, do not cover the area of white acrylic around the image. The white light that gets into the lens will cut the contrast impressively, even shockingly.

121

STILL LIFE

Almost anything can spark a still life: something seen in a secondhand shop, a chance arrangement of things on the kitchen table, a memory, an idea. There is a school that can make a semi-abstract still life from almost nothing: an arrangement of geometric shapes from a needle and thread and a piece of fabric. Another school meticulously assembles props to create a narrative, an evocation that may suggest a whole story or simply a time gone past. Yet another creates 'table-tops', whimsical little tableaux with dolls or glass animals. Then there are those who photograph the relentlessly everyday, concentrating on texture and shape, and showing the rest of us the utterly familiar as if it were for the first time.

One thing that all still lifes have in common, though, is that they generally require a great deal of playing around – with the subject, the lights, and the camera angle – until they come right. There are two great dangers in this, however. One is that you will shoot a dozen pictures that are so similar that no one but you knows (or cares) what the differences are. If you do this, have the grace to select the one you like best and show only that one to other people. The other danger is that you will spend so long playing about that the subject will lose its novelty: you will become indecisive or (worse still) decide that it isn't worth shooting anyway. You have to strike a balance between working towards a picture, and never actually taking it at all.

Another thing that all still lifes have in common, as a direct consequence of the above, is that they are in many ways the definitive form of studio photography. The photographer is in complete control. Oh, it may seem that inanimate objects have a life of their own – think of the way that the power cables on your lights tie

JUNK

Many photographers find that they create their best still lifes from junk bought at boot sales, swap meets and yard sales. When something is so worn out that its real usefulness is marginal or non-existent, it has usually acquired so much character that it makes a really wonderful subject. A lot of junk has strongly nostalgic connotations, too: this can be handy in 'narrative' still lifes.

► MEASURE AND KEY
The anodized aluminium measure was bought in Greece; the key, from a charity thrift shop, with a big bag of others. Both are precision-made in their different ways; this, and the contrast of textures, inspired the shot. The light was a desk lamp.

NIKON F, 90–180/4.5 VIVITAR SERIES 1, ILFORD HP5 PLUS. (RWH)

◄ LIGHTING
The 1950s Anglepoise reading lamp is not quite as big as it is drawn here, and it was actually on the table rather than on the floor – but drawing it like this makes it clearer how the shot was set up. Often, you don't even have to buy new lamps!

ANGLEPOISE LAMP

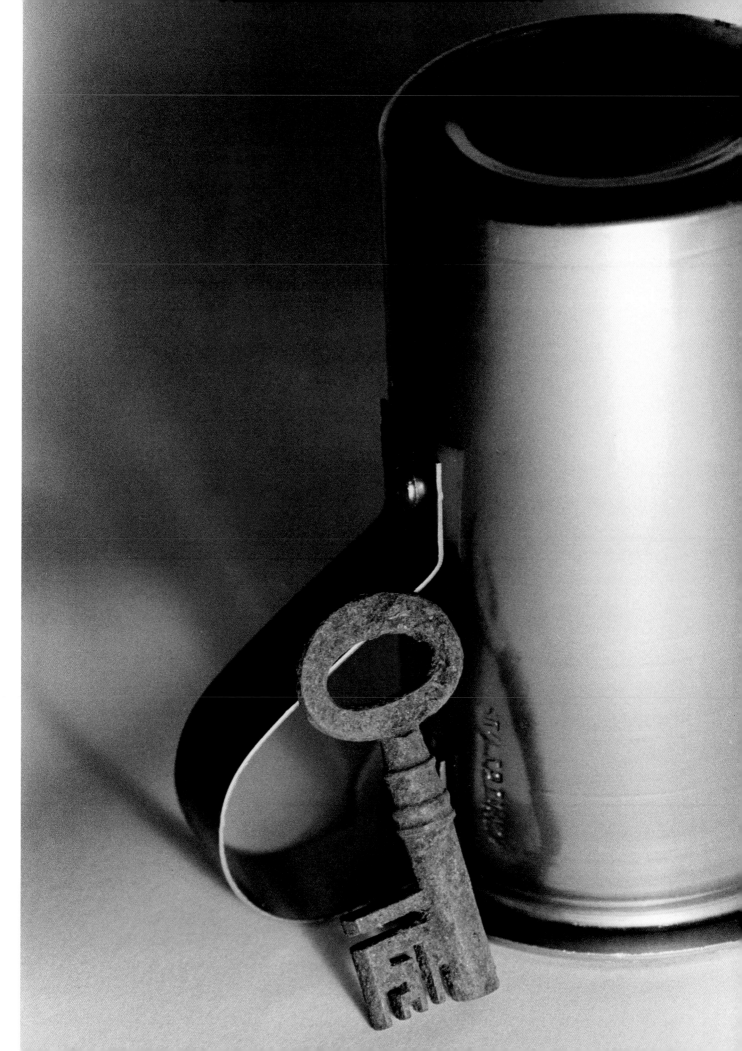

Lighting and backgrounds

themselves in knots, or a dropped piece of toast always lands buttered side down – but compared with the live subjects required for portraiture or nude photography, they are much more easily biddable.

This means that if you want to get accustomed to working in the studio, and to seeing what kind of lights produce what kind of highlights and shadows, still lifes are unbeatable. They also give you an ideal chance to learn how to work quickly and effortlessly with Polaroid backs, as well as lights, tripods, reflectors and so forth.

Yet another advantage of still lifes is that they teach you skills that are invaluable in commercial photography. Many top advertising photographers regularly shoot 'self-assigned' still lifes, to try out new techniques and ideas and to provide new pictures for their portfolios. Very few amateurs have any real grasp of how to shoot controlled still lifes in the studio, and those that do are often much better placed to make the transition from amateur to professional.

A great deal will depend upon the scale of your subject. At one extreme, still life is almost a branch of macro photography: we have spent many a happy hour playing with the Gossen Makrogerät illustrated on page 115, which effectively gives three independent focusing spotlights that can be used to create a tiny lighting world for an immense range of subjects. At the other, the biggest still life we ever shot was probably the entire contents of the back attic – and of course, car photography is a division of still life.

If your personal vision depends on hard lights and sharp shadows, one of the cheapest routes into still life is a slide projector, and as noted before, another way to get a hard light is to use a focusing spot at as great a distance as possible, but with the focusing movement turned unexpectedly to flood. It is a good deal more difficult to create really hard lighting with flash, unless you can afford a projection spot. Often, of

▲ ▶ BEADS AND LEATHER Marie decided to explore colours and textures in close-up using Kodak's ultra-saturated Elite Chrome Extra Color, the 'amateur' version of E100VS. A single flash head supplied the only light: you can see slightly 'hot' highlights in a couple of places, and it would have been possible to remove these with a single polarizing filter on the camera lens – though of course, you need extra power in the flash head to make up for the loss of light (1–2 stops) with the polarizer. When you try this sort of thing, try as wide a range of shapes, colours and compositions as you can, not just to see what 'works', but to see what doesn't.

NIKKORMAT FTN, 50/2 NIKKOR.

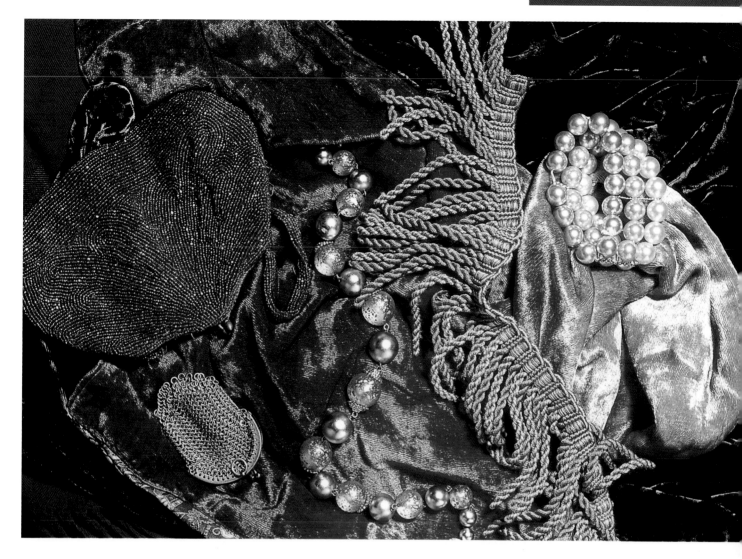

course, you don't need really hard light, and in that case, you can use either flash or tungsten, as you feel inclined.

Unlike pack and product shots, which are after all only a division of still life, 'artistic' or 'creative' still lifes seldom seem to call for shadowless lighting, though a useful trick we have found is to shoot on daylight-type film using both a big soft box (as 'sky' light) and a tungsten focusing spot, as warm 'sun' light, skimming in low. The colour temperature of a studio tungsten lamp, 3,200K, is just about identical to that of the setting sun.

The main thing with backgrounds is that they should be unobtrusive. A surprising number of still lifes are spoiled by being laid out on totally unsuitable surfaces, from the sterility of seamless background paper to the nasty bluish glow of plastic laminates.

The funny thing is that almost any textured surface can be successful, provided it is not too regular. Many fabrics are good, and some real

surprises work well, from old, ink-stained desktops to brown wrapping paper crumpled and then smoothed out.

Equipment and materials

How long is a piece of string? The only half-reliable route to failure, in either equipment or materials, is trying to re-create a particular style in completely the wrong way, and even then you have to try quite hard to get things wrong enough that they won't work.

Having said this, there is a certain pleasure in (for example) shooting 5x7in still lifes and making contact prints, whether on conventional paper or printing-out paper (POP), or even 'alternative processes' such as Argyrotype, salt prints, and so forth. 'Alternative' prints normally look awful in reproduction, like very inferior conventional prints, but as originals, they can be very attractive indeed.

Or again, you may care to try shooting modern ultra-saturated colour materials with a really sharp, contrasty lens. Use transparency film and

◄ ▲ PINS

Frances found the pin box in a junk shop for our usual £2/$3/€3. She loves Art Nouveau and this was just irresistible, even without considering it as a photo prop. Roger's first and second photos made a play on the idea of 'pin sharp', because the tin itself looked rather soft and unsharp on the focusing screen: he is unsure to this day whether the 'all in' shot is more successful, or the close-up. The background was a piece of crushed velvet from a fabric remnant shop, and Kodak Elite Chrome Extra Color made up for the lack of colour saturation that is always a risk when using a zoom, though the 90–180/4.5 Vivitar Series 1 (here used on a Nikon F) is to this day one of the finest close-focusing zooms ever made, 30 years and more after it was introduced.

◀ **PINS SOVIETS**
'Pin' in French is most commonly taken to mean what the English might call a 'badge' and this prompted the next stage of exploration. The inside of the box has the ornate printing seen here, and the pins were bought for a few kopeks each in GUM in the last days of the Soviet Union. As well as the obvious Lenin pins there are commemorations of the 1917 revolution ('Pobeda' means 'Victory'), of Sputnik, pins for museums, Aeroflot and more. They were taken with the same equipment as the pictures of the outside of the box.

◀ **BROWNIE DEVELOPING BOX**
The textures of the pin box reminded Roger of the lid of an old Kodak developing tank that hangs on the kitchen wall, concealing a flaw in the plaster. It is much shinier than the pin box, and the colour fairly glows in this picture. Using exactly the same equipment, he had to stop down well in the interests of depth of field: it might have made more sense to switch to a camera with movements in order to hold the receding plane in focus through application of the Scheimpflug Rule (see page 38–9).

under-expose slightly for intense, saturated colours. You should even consider using polarizers over the light, and over the camera lens, for maximum suppression of white-light reflections.

If you particularly admire a given photographer's style of still life, it is worth trying to find out what equipment and materials they favour, as this may make it a great deal easier to achieve the same sort of technical quality that they do, leaving you free to concentrate on content and composition.

FLOWERS

Flower photography, perhaps more than any other branch of studio photography, spans an enormous range from absolutely literal shots to pictures that are so abstracted or interpreted that the immediate response of most people will be, 'What is it?'

And yet, surprisingly many flower pictures rely on absolutely the same (rather limited) range of techniques. As a result, technical considerations are relatively quick and easy to master, leaving the photographer the maximum possible scope for aesthetic considerations.

The first thing you need to ask yourself is, what are the general implications of a particular kind of flower. Roses spell romance; orchids, exoticism; Easter lilies, death (and, improbably, Irish republicanism); daisies, freshness and innocence; and so forth. This should either help you decide which flowers to photograph, or how to photograph the ones you have. Remember, too, that you can always subvert the popular image via your choice of background, props, sharpness, lighting and exposure.

Select flowers with great care, so that they are flawless; transport them with equal care; and handle them as little as possible, and as gently as possible, once they are in the studio.

'Misting' with a fine spray to create water droplets on the petals and leaves is often a good idea, although it can be overdone. A perfume spray allows far more control than a plant mister.

Among props, fruits, wicker baskets and other 'rural' props create one mood: beads, a bottle of perfume, silk gloves, quite another.

Lighting and backgrounds

Many people advocate soft lighting for flowers, but drama demands contrasts of light and dark. You can do this by careful choice of background, or by dramatic lighting. Be careful not to be overly dramatic, though, or you will exceed the recording range of the film. Use bounces to reduce contrast.

Electronic flash is generally preferable to tungsten lighting, as too much heat will soon make most flowers wilt. Do not neglect backlighting, in conjunction with small shaving or make-up mirrors to throw light back onto the parts of the flowers nearest the camera.

Crumple aluminium foil, then smooth it out again, to make playing card-sized reflectors. Back them with a sheet of cardboard if necessary.

Backgrounds are often best when simplest. Sheets of cardboard are ideal. You should not need more than three or four sheets at most: black, white, dark grey and (if your personal vision calls for it) one colour.

▶ **FLEURS DU MAL**
This breaks one of the major rules given at the beginning of this section, as the flowers are actually dead. A bunch of budding roses never bloomed, but simply desiccated and died. The symbolism was irresistible; the choice of a black background, equally inevitable. Although it is not clear, the 'vase' is a shell case; the composition is tilted for more impact.

The wild flare and soft focus were achieved using a Dreamagon soft-focus lens on a Nikon F; Kodak E100VS boosted the saturation, which otherwise would have been lost because of the soft focus effect. As should be clear, the flowers are backlit (with a single, snooted Paterson flash head) from below. No bounces were used.
(RWH)

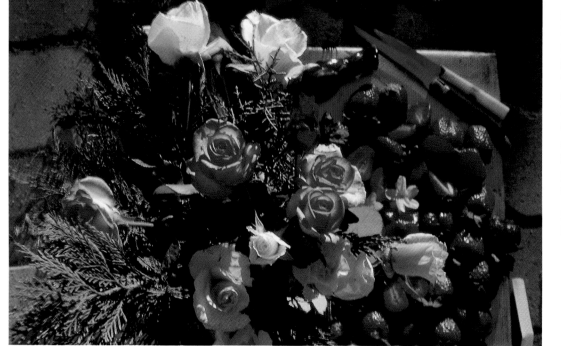

◀ **STRAWBERRIES AND FLOWERS**
Do not be afraid to mix other props with flowers. Here, the strawberries, the knives and the simple rustic background say a great deal about a lifestyle that most people would love to enjoy. Marie shot this by natural light in her 'outdoor studio' at her parents' house in the south of France.

NIKKORMAT FTN , 85/1.8 NIKKOR, KODAK E200.

◄ ▼ **Zoom flower**
The bigger picture (*below*)
is a double exposure with a
zoom lens, zooming between
the two exposures. Lighting
was a single electronic flash
head (Paterson). Paradoxically,
the flare and flattening of
contrast emphasize the colour
and the repetitive shape of
the flowers.

Canon Eos 5, 28–80mm zoom,
Fuji 100. (MMK)

Light backgrounds imply airiness, summer, sun, freshness, while dark backgounds are generally more dramatic and draw attention to the colour and structure of the flowers.

Fabric backgrounds are halfway to props, and all have their own moods: checks and ginghams for a little girl, and silks and satins for romance and sophistication.

Equipment and materials

You will normally need a close-focusing lens, possibly even into the realms of true macro. Poor quality may not matter if you want soft, romantic flower shots, but maximum quality is essential for crisp, sharp shots (which can also be very sensual). Razor sharpness tends to emphasize colour and structure: unsharpness (however achieved) is inclined to summon up more emotional reactions.

For maximum depth of field, stick with 35mm. Roll film and even large format can be stunning, but the pictures often have to rely on very shallow depth of field.

Some films are very much better than others at recording subtle colours. The classic problem is with pale blue flowers, which often record pinkish on film – though modern films are reducing this effect all the time. If you have a problem, try a different film.

High-saturation films such as Kodak E100VS or Fuji Velvia are normally more dramatic than 'ordinary' films, but they can be too vivid if you are trying to create a soft, dreamy ambiance. Underexpose by up to 1 stop for extra saturation and drama, or over-expose by 1 stop or even more for airiness and lightness.

The grain structure of very fast films can add materially to the impact of many flower pictures. If necessary, compose your picture in just a tiny part of the frame, and enlarge mercilessly.

Warming filters (Wratten 81-series) often enhance flower pictures, while polarizers can increase saturation by suppressing white light reflections. For maximum saturation, use polarized light sources as well as a polarizer on the camera.

▼ ROSES
The props – the beads, the scent bottle, the deep red background – are redolent of the boudoir. The hazy, desaturated colours are the result of under-exposure so extreme as to border on the unusable, but this reinforces the mood of a decadent night-time shot. The lighting was a Paterson flash head, shooting through an umbrella.

NIKON F, CHEAP ZOOM (BRAND FORGOTTEN), FUJI 100. (MMK)

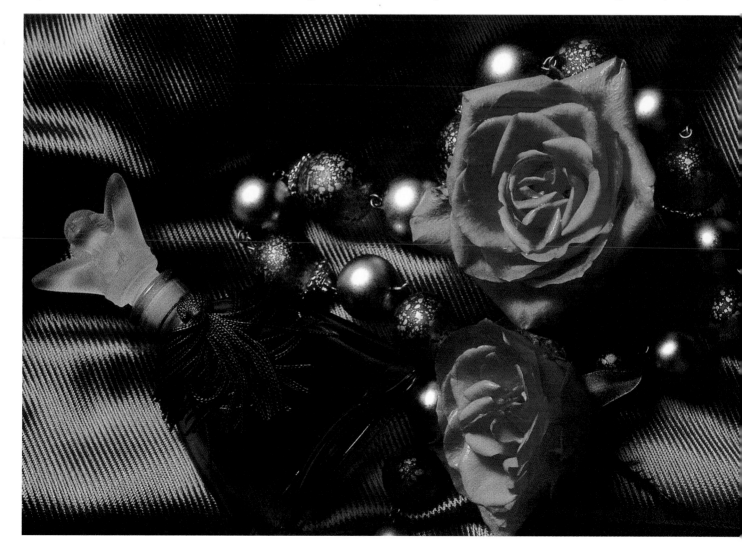

JEWELLERY

Jewellery is one of the hardest subjects to photograph. Many experienced professionals will simply turn down commissions that look too difficult, and the novice should never accept a commission to shoot jewellery without appreciating the difficulties. Of course, the bright side of this is that a skilled photographer of jewellery can turn out unusual work, and has a very saleable skill. What follows is the barest introduction to the subject. As ever, the only route to success is practice, practice and more practice.

The hardest thing of all is gemstones, especially diamonds and other clear stones that rely on 'fire' or 'sparkle'. This is because 'fire' depends upon movement. You move your head (or the stone) a tiny amount and the light is refracted and reflected differently: white light is split into vivid colours, and each tiny rainbow is what provides the 'fire'. The camera, of course, doesn't move, so there cannot be any 'fire' or sparkle.

'Fire' also explains why so many people, when they first try to photograph precious and semi-precious stones, use exactly the wrong sort of lighting. The best lighting to show 'fire' is highly directional, from almost point sources, which is why this kind of lighting is widely used in jewellers' shops. Only very rarely, though, is this the best light for photography. Often, a broad, soft light – the exact opposite of what you would expect to use – is the best bet.

With some kinds of jewellery, it is true, you can use highly directional light: enamel work, engravings, opaque (or substantially opaque) stones such as turquoise, coral, opal or tiger's-eye. But generally, shadowless lighting should be the first avenue of exploration for the would-be photographer of jewellery.

With any kind of jewellery that is not brand new, scratches, tarnishing and dirt can be a problem. Short of having the piece re-finished, there is not much you can do about scratches, but tarnishing and dirt are both best attacked with a soft brush such as an old toothbrush. With silver, you can normally use one of those products that dissolves tarnish, but with any solvent or chemical or abrasive cleaner, follow the instructions on the packet and think hard before you take any risks.

Backgrounds and lighting

The relative advantages of hard and soft lighting have already been discussed, but a fundamental problem with jewellery is backgrounds, which inevitably are magnified to the same degree as the jewellery, and therefore have to be able to withstand close examination. There's not much advice one can offer on this, except that it's a problem to be aware of. It does, however, explain why all kinds of unlikely supports appear in many jewellery advertisements: stones, driftwood, glossy PVC...

Notoriously, the photography of shiny surfaces is the photography of reflections, so it is a very good idea to have a selection of light and dark bounces that can be arrayed around the piece in order to create light and dark reflections in the right places, and an extremely useful trick is to use buff-coloured reflectors for gold: white can look cold and brassy, while buff looks warm and golden.

If you want to shoot jewellery being worn, remember that the model must have excellent skin but need not (unless their face is in shot) have film-star looks.

Equipment and materials

Most kinds of jewellery are very small, so you have to work in extreme close-up, even true macro at a scale of 1:1 or bigger. The only convenient way to

▶ *Drilbu* ring
These rings are normally made in pairs, *rdorje* (thunderbolt) and *drilbu* (bell). The wooden background is a piece of charred driftwood found on the shore in California; the blue is merely blue Colorama. Under-exposure kept the 24K *drilbu* and 22K ring rich and yellow.

Linhof Technikardan, 100/5.6 Schneider Apo-Symmar, Kodak E100VS. (RWH)

▼ Lighting
A snooted flash provided a highly directional light; another advantage of the snoot was that it stopped unwanted light striking the camera lens and possibly causing flare or reducing contrast. A flag could equally well be used for the latter purpose with an unsnooted light.

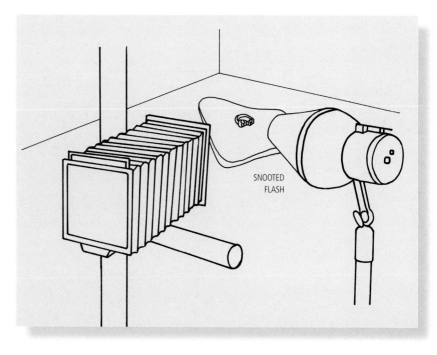

SNOOTED FLASH

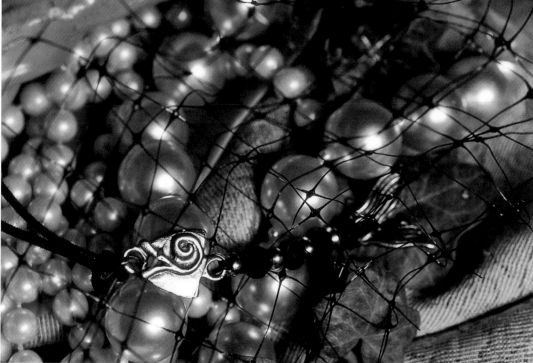

◄ **PEARL BEADS**

When in doubt – try it!
In one shot (*above*), these
pearl beads are used as a
backdrop for the fish charm;
in the other (*below*), the idea
of catching the fish in the
net makes for a richer, more
dramatic shot. Marie used an
enlarger lens on a bellows to
shoot these two shots with
her trusty Nikkormat FTn and
Kodak EBX.

do this in 35mm is with a macro lens, a bellows (or, less conveniently but still tolerably) with extension tubes.

Down to about 1.5x life size, even 2x, there is no great need for special short-focus lenses: a 50mm enlarger lens (page 115) or camera lens will do. For still greater magnifications, the very best option is a purpose-built bellows macro lens (page 114) but a surprisingly effective option is a short-focus cine lens in the 10mm to 20mm range. These can often be picked up surprisingly cheaply at camera fairs or from the 'junk drawers' of long-established dealers, and many give very good quality when used on a bellows. You will need to have an adaptor made up (most cine lenses are standardized, the so-called C-mount and D-mount) but this is not too expensive: ours was made by SRB of Luton.

Because of the extra extension, the lenses will be functioning as smaller effective apertures than at infinity, so you will need to increase exposure times. Through-lens metering should take care of this, but if your camera does not offer this (especially with flash) you can do a lot by rule of thumb: 1 stop extra for half life size (to be exact, 2.3x the exposure), 2 stops for life size, 3 stops for twice life size (to be exact, 9x). And if you are in doubt, bracket. To judge degrees of magnification, remember that the focusing screen on a 35mm camera is at most 24x36mm, and typically 23x35mm so as to allow for slide mounts, framing errors and also manufacturing variation.

If you are shooting in colour (as you normally would be), then a high-resolution, high-saturation film such as Kodak E100VS or its amateur cousin Elite Chrome Extra Color will normally give the most dramatic results. You may also care to try shooting daylight-balance film under tungsten lighting for a really warm effect – this is especially true with gold.

◄ HANDS OF FATIMA

If depth of field is important, try to arrange your subjects in as close to a single plane as possible, and unless your camera has movements (page 38) then shoot that flat plane square-on.

TECHNICAL INFORMATION AS FOR THE PEARL BEADS ON PAGE 134. (MMK)

◄ CLEF

Always think hard about possible backdrops for jewellery – and look at the ads in *Vogue* and other glossy magazines for further inspiration. The faded colours of torn paper complement the bright colours of the main subject.

TECHNICAL INFORMATION AS FOR THE PEARL BEADS ON PAGE 134. (MMK)

PACK AND PRODUCT SHOTS

Traditionally, pack shots are one of the first things that an assistant is assigned to do on his or her own, after the necessary period of making tea, sweeping the floor, running errands and otherwise being reminded that an assistant is not, by any stretch of the imagination, a photographer. Pack shots are exactly what the name suggests – pictures of packs, usually for catalogues but sometimes for advertisements, audio-visual presentations, and other applications – and small product shots are only slightly more exciting, consisting as their name implies of straight shots of small products.

Despite their lowly rank in the order of things, pack and small product shots are not to be despised. You can learn a very great deal from taking extremely boring pictures, and in the long run, some photographers find that they can make a good living from this sort of shot because they can work quickly and efficiently, turning out pictures rather better than the ones that assistants do.

It's a question of practice, and (to some extent) of equipment. The practice extends into many areas. At the very start, the skilled pack shot

◄► **MATCHBOX**
The smaller picture (*left*) is what you might call a 'standard' pack shot, though the use of hard light and a shadow is less conventional than the use of a soft box and near-shadowless lighting. The larger picture (*right*) is an attempt to match the pool of light to the illustration on the matchbox.

LINHOF TECHNIKARDAN 4x5IN WITH 6x7CM BACK, 210/5.6 RODENSTOCK APO-SIRONAR-N, KODAK E100VS. (RWH)

photographer can spot flaws that will loom large in the final shot, where the inexperienced photographer will kid him- or herself (and the client) that 'it won't show in the "chrome"' or 'we can touch it out in Photoshop'. Well, you can do an awful lot in Adobe Photoshop, and it has saved many a photographer's bacon; but often, five or ten minutes at the selection and shooting stages can save an hour or more in Photoshop.

Likewise, camera movements (page 38) are essential to ensure that the sides of boxes remain parallel, so you need to be able to operate these quickly and easily. Furthermore, you would be foolish if you did not invest in such things as a Climpex kit (pages 75) and a roll of matt black aluminium foil (page 67). And you learn all kinds of ridiculous little points, such as that if you try to use a polarizer to lose reflections in Cellophane packaging, there is a surprisingly good chance

CONSISTENCY

A particularly important thing if you are shooting a large number of packs or products against a single background – as is often the case in catalogue photography – is the maximum possible consistency in background colour and density. Although 1 stop brackets are often all that you need in outdoor photography, the ideal in this sort of work is ⅓ stop brackets, as this is the minimum that you can realistically expect to see in reproduction.

This sort of consistency is one of the few good reasons to buy 'pro' films, which are carefully matched for both colour and speed: in most kinds of photography, the variations will not matter, but here, they can. The films must, however, be kept chilled until a few hours before they are used, then processed promptly, or they will be no better than well-stored 'amateur' films.

▼ **LIGHTING**
The tightly shaped light on the main picture was achieved by rolling a supplementary home-made snoot out of black aluminium foil, and taping it onto the front of the normal snoot.

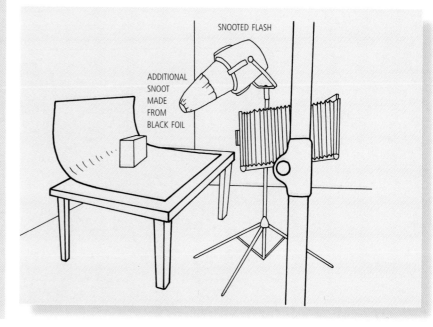

SNOOTED FLASH

ADDITIONAL SNOOT MADE FROM BLACK FOIL

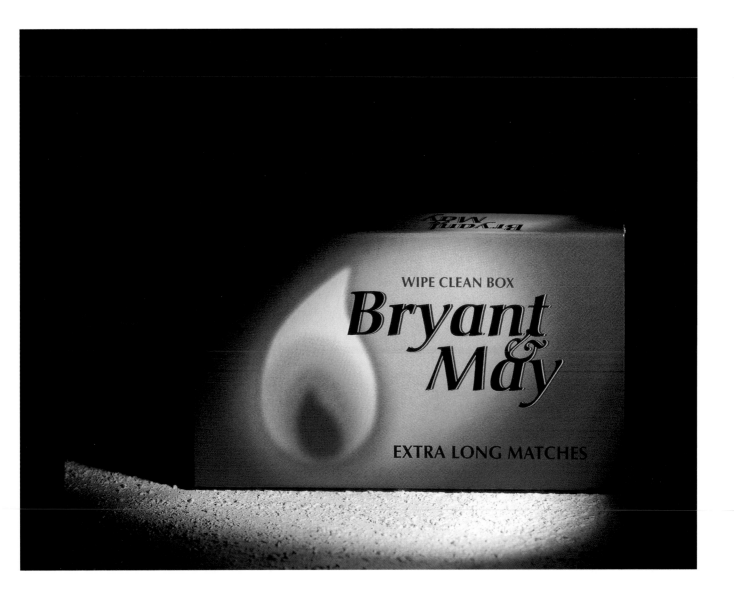

that you will end up with bright, unexpected 'oil slick' colours where the light has been plane polarized by reflection and then passes through the previously colourless wrapping.

Lighting and backgrounds

You need quite a variety of lighting – hard, soft, preferably even a projection spot – and if you are shooting at small apertures, in the interests of depth of field you may need rather more power than might seem reasonable, especially if you are using polarizers.

When it comes to backgrounds, you can never have too many. A good selection of different colours of Colorama or other background paper; a roll of black flock, for a 'dead' black background; and as much else as ingenuity and assiduous collecting of suitable materials can devise, from stone to fabric to mirrors to black acrylic sheeting to... well, you name it.

Equipment and materials

Unless you have a camera with movements, the only way to keep the sides of a pack adequately parallel is to shoot from as low as possible, with as long a lens as possible. Alternatively, if you are shooting digital (as catalogue photographers

▲ **TIGER BRAND SPICES**
It is a good idea to explore various approaches to a self-assignment, in order to test ideas that might be useful later in a commercial shot. The first picture is a straight pack shot of three tubs of spices on brown crushed velvet: the language, which will be unfamiliar to many, is Maltese. Roger shot all the pictures in this sequence with a Nikon F, 90–180/4.5 Vivitar Series 1 Flat Field and Kodak EBX.

◄ **NUTMEG**
This shot illustrates well that often you need the contents of two or three packs of something to make it look as if you have one pack full. In a conventional shot, the nutmeg would fill the tub and be spilling out from it.

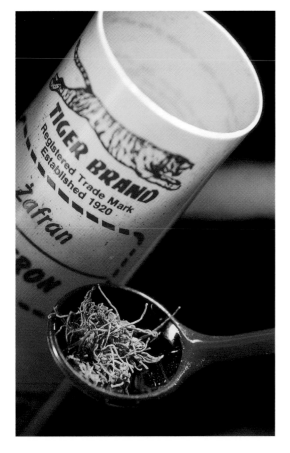

Once again, it is quicker and cheaper to keep things straight at the taking stage rather than having to play around electronically later.

Those pack and product photographers who still use film are very unlikely to shoot 4x5in any more: a 6x7cm or 6x9cm back on a 4x5in camera delivers more than adequate quality for the vast majority of applications and is very much cheaper to run. Keeping costs to a minimum is usually essential in this field, hence the widespread adoption of digital: the initial investment is frightening, but if you are shooting a lot of pictures, the savings on film can make it worth while, unlike in most areas of studio photography.

◄ **SAFFRON, TUB AND SPOON**
This is moving steadily away from the straight pack shot. The lacquer spoon and the spice tub are both held by Climpex clamps (pages 74–5). Remember that many clients insist on having the pack in shot, even when you can make a better picture of the contents alone.

◄ **SAFFRON**
In extreme close-up, depth of field is simply not adequate in this shot – and besides, it's not really recognizable. The spoon in the previous shot gives it a much more culinary emphasis.

increasingly often are) you can true up the verticals in Adobe Photoshop or another image-processing program – though a long lens is still advisable, or you can use T/S (tilt/shift) lenses.

▼ **SAFFRON AND SPOON**
Arguably the most successful shot of the series, this is no longer a pack shot at all.

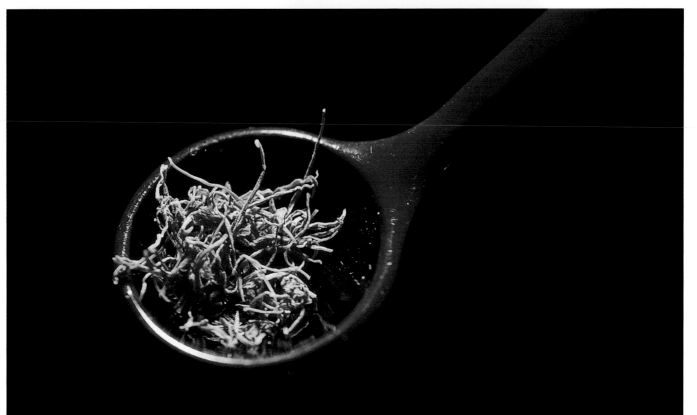

GLASS

With any shiny surface, you are shooting reflections as much as you are shooting the thing itself. With glass, to make life still more interesting, you are often shooting *through* the thing itself, as well. This is what makes glass one of the most demanding of all subjects to light and expose correctly.

Another problem is that glass is prone to flaws, chips, scratches, smears and fingerprints. These pass unnoticed in everyday life, but as soon as you select a piece of glass to photograph, you become all too aware of them. Do not try to kid yourself that they will be less apparent in the final picture: invariably, they will be more apparent.

Selection and *very* careful placement can help with flaws, but the only answer to smears is careful wiping, preferably with a linen glass-cloth (cotton sheds more lint), supplemented if need be with some form of glass cleaner: camera lens cleaning solutions are good. The best answer to fingerprints is cotton gloves, the sort that are sold for handling fine photographic prints.

Lighting and backgrounds

Generally, you do not need much space to photograph glass, because the subject itself is rarely very big. A table-top is often all you need, though transillumination can make slightly more demands on space, and we use quite a lot of transillumination when photographing glass.

We normally use a sheet of glass or Perspex supported on a couple of trestles. Another useful trick is a 'goal post' type support, with the cross-piece threaded through a roll of draughting film. Light this from behind, and you have a bright, diffuse background such as was used for the picture of the light bulb on page 142.

Another trick you can do with transillumination is to colour the transilluminating light with gels, either subtly (for warming or cooling, for example) or more aggressively for a dramatic effect.
You rarely need powerful lights, unless you are using small apertures on large-format cameras. Tungsten is all but essential if you want hard, directional light: we use a little focusing spot, as

▶ **SLIVOVITZ**
As he so often does, Roger chose backlighting for dramatic effect, using a single snooted electronic flash head as the light source. This led, however, to two problems. One was that the label was too dark. This was remedied with a mirror in front of the bottle, just out of shot to camera left, angled to bounce light back onto the label itself.

The other problem was that the deep, rich blue of the cap was not 'reading': it was pretty much a silhouette. The remedy for this was a small diffuse reflector, again just out of shot, bouncing a little light back onto the cap. It was supported with Climpex (pages 74–5), though another way to do it would be with an assistant.

LINHOF TECHNIKARDAN 4x5IN, 210/5.6 RODENSTOCK APO-SIRONAR-N, LINHOF 6x7CM ROLL-FILM BACK, KODAK E100VS.

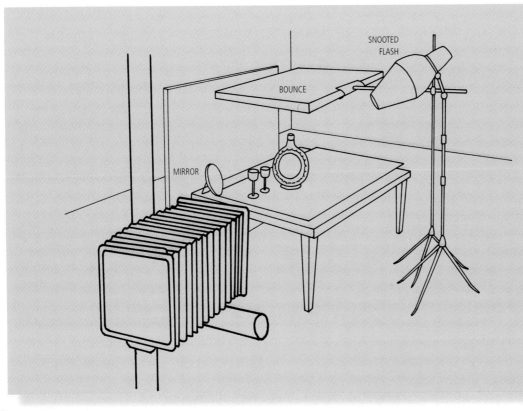

◀ **LIGHTING**
Strong, slanting light is a favourite way of lighting alcoholic drinks, as it suggests warm weather and relaxation; someday we should try shooting on a grey,overcast day to emphasize the warming effect of a drink. The textured surface is a piece of hardboard (Masonite) painted with plain white emulsion into which had previously been mixed a generous handful of sawdust.

SNOOTED FLASH

BOUNCE

MIRROR

far from the subject as possible, preferably at least 2m (6ft) away. Unexpectedly, the light seems hardest when the lamp is turned to the flood setting rather than to the tightest possible spot.

As with jewellery, it is usually a mistake to try to capture 'sparkle', because 'sparkle' is generally created by slight movements of the eyes and head so that the catch-lights on the subject move. In a photograph, its viewpoint frozen in time and space, such 'sparkle' does not exist. For this reason, diffuse light is often more useful than hard, directional light. Equally, though, hard, directional light can cast fascinating shadows, so it is not to be despised.

Watch out, always, for over-large specular or semi-specular highlights, whether reflected or refracted: big, featureless white areas seldom look

◄ BULB

The bulb is lit from behind with a powerful (500W) but fairly distant (1.6m/5ft) focusing spot, at the flood setting as described in the text, so as to give a hard reflection. The edge of the envelope was, however, hard to distinguish against the white background, so Roger added a strip of black flock background material to bring out the shape more clearly.

LINHOF TECHNIKARDAN, 210/5.6 RODENSTOCK APO-SIRONAR-N, KODAK E100VS. (RWH)

attractive. Once you start looking for them, you will see the characteristic washed-out square reflection of a soft box in all too many shots that are taken glass shots.

Equipment and materials

We generally prefer medium format, usually 6x7cm: switching to large format gives no real advantages in image quality, though being able to use camera movements (page 38) is an advantage; for this reason we normally use a roll-film back on a 4x5in camera.

If we do use 35mm, we prefer slow, sharp, fine-grained films such as Ilford 100 Delta in black and white, and Kodak EBX in colour slide. Sharpness is often very important in photographing glass as a means of communicating the hard, clear edges of the subject.

PLASTICS AND POLARIZATION

Generally, much the same observations apply to clear plastics as to glass, though an option that may be worth exploring is to light transparent plastics from behind with polarized light, then use a polarizer on the camera. According to the type of plastic, and the stresses in it, bi-refrigence will produce brightly coloured patches, lines and swirls to a greater or lesser extent.

▲ **DECANTERS**
▲ **PAPERWEIGHTS**
Marie used the same (very simple) technique for both of these pictures. Under a glass-topped table, she put her (then newly acquired) soft box, and then shot looking down on the table. Exposure in such cases is hard to determine: a good rule of thumb is to take a through-lens meter reading, or a broad-area reading with a hand-held meter, then bracket 1, 2 and even 3 stops over.

NIKKORMAT FTN, 50/2 NIKKOR, FUJICHROME 100.

FOOD

Food, more than most areas of photography, is something that you really need to care about in order to photograph it well. You should almost be able to smell the aroma in a good food photograph, and to feel the textures on your tongue; your imagination should supply the very taste of the food.

Today, two main styles have replaced the highly formal 'banquet' style that was popular for much of the twentieth century. One is the 'plate as artwork' or 'minimalist' style, in which small amounts of food are artistically arranged on a (usually oversized) plate. The other might be called the 'plate in a setting' or 'environmental' style, and relies as much on props as on the food itself: not just plates, but also tables, walls, whole kitchen and garden settings.

Minimalism is normally most successful with cold food – hot food can look a bit, well, cold – and it requires flawless settings: it is not until you look at a few plates that you realize how badly they scratch and scuff in everyday use.

The environmental style can handle almost anything, but taken to extremes, you can lose sight of the food: there is so much rustic stonework, surrounded by so many flowers and peasant-weave tablecloths and napkins, that the food becomes secondary.

Styling and the glycerine myth

On a full-scale food shoot there will be at least one cook, one food stylist (whose job it is to arrange food on the plate), plus the photographer and at least one assistant. We have, however, found that we can shoot quite acceptable food if we work together, just the two of us, and with a third person it starts to be quite easy. But then again, both of us can cook, style and shoot.

In the bad old days, many and unpleasant were the tricks that were used to 'gloss up' food for photography. Glycerine was commonly used to lend a sheen to meat; salt and sugar were tipped into beer to make it foam up; cigarette smoke was blown into shot to simulate steam, always assuming that the steam wasn't crudely drawn in on the negative.

Although such tricks are still used from time to time, alongside more modern tricks such as acrylic

ice-cubes and spray-on condensation for 'iced' drinks, the vast majority of photographers prefer to work with real, edible food. After all, it is easier to make food look edible if it actually *is* edible, and if you aren't feeling slightly sick at the thought of what has been done to it.

The real secret of convincing photography with real food is speed. A good (if slightly extravagant) way to get the shot you need is to have two or more substantially identical dishes prepared, one after the other. The first is used to set up the lighting and composition and do the Polaroids (page 40), and the second is used for the actual shoot.

In practice, you can often get away with just one dish, if you do the set-up first with dummy subjects such as empty boxes, film canisters and wadded-up tissue paper, and we would recommend that you do this all the time that you are learning.

Lighting and backgrounds

If you are not using an 'environmental' setting, you will do well to amass as large a collection of

▶ **ANTIPASTO TO ZAKUSKI**
This was shot as a cover for a book on the 'little foods' that are commonly used as the starter to a meal but can also be a light meal in themselves.

LINHOF TECHNIKARDAN, 210/5.6 RODENSTOCK APO-SIRONAR-N, KODAK E100SW. (RWH)

▼ **LIGHTING**
A soft box overhead provided 'sky' light, while an 800W Beard focusing spot was used for the 'setting sun'. A couple of upright sticks were used to cast shadows on the table to create the impression of light coming through a window: from memory, they were broken chair legs.

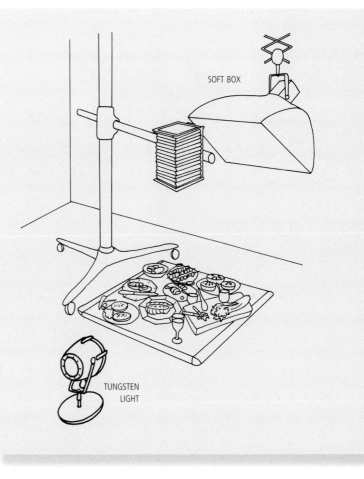

SOFT BOX

TUNGSTEN LIGHT

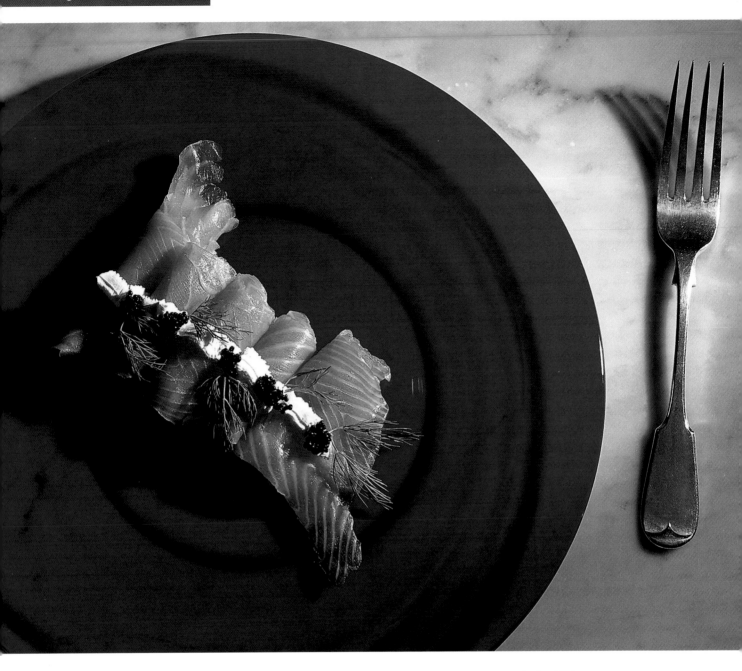

backgrounds as you can. The most successful are often those associated with country or gracious living. The big picture on page 145 was shot on a kitchen table that we had made to measure from recycled timber by a specialist: the scarred, battered wood would be associated in most people's minds with a country kitchen. Other backgrounds we have used include a wide range of tiles (including quarry tiles), stone (marble, granite, slate, again in the form of tiles or in the case of the marble, recycled from Victorian washstands), a century-old damask tablecloth (with 1890s silver cutlery to match), sackcloth, flints from the beach, and more. We also buy a lot of single plates!

Often, we shoot daylight-balance film under 3,200K tungsten lighting for a 'setting sun' look,

but you need to experiment to find the right film and exposure – Polaroids are not very reliable for this purpose – and you need a sympathetic printer: 'attractively warm' can all too easily turn to 'sickly yellow'.

◄▲ **SMOKED SALMON**
The original shot included the whole plate and a white marble background, and looked very bleak, (*left*) lit as it was with a single flash head. Cropping in closer restored Roger's original intention, which was to contrast the orange salmon flesh with the deep blue glass plate.

LINHOF SUPER TECHNIKA IV, 135/8 SCHNEIDER REPRO-CLARON, FUJI RDP.

Equipment and materials

Although we have shot a lot of food on 4x5in, there is really no need to do so any more, except perhaps for full-page illustrations in the glossiest of magazines: modern 6x7cm films are more than adequate. You need seriously sharp lenses, however, preferably of a focal length significantly longer than standard: we never use anything shorter than 135mm on 6x7cm, roughly the equivalent of 65mm on 35mm or 210mm on 4x5in. Not only does this give a comfortable working distance, it also minimizes the risk of the lens steaming up!

'Warm' film stocks are a better bet than 'cool', and you may care to warm things still further with 81-series filters; unless, of course, you shoot daylight film under tungsten light.

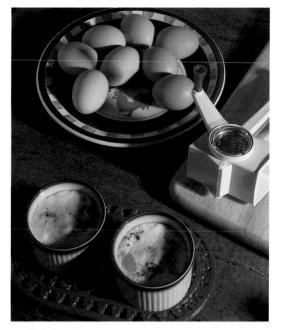

◄ **OEUFS EN COCOTTE**
Including ingredients and kitchen tools can add interest to a dish that basically doesn't look like much – though an all-metal Mouli grater might have looked better than the modern plastic one.

LINHOF SUPER TECHNIKA IV, 135/8 SCHNEIDER REPRO-CLARON, FUJI RDP. (RWH)

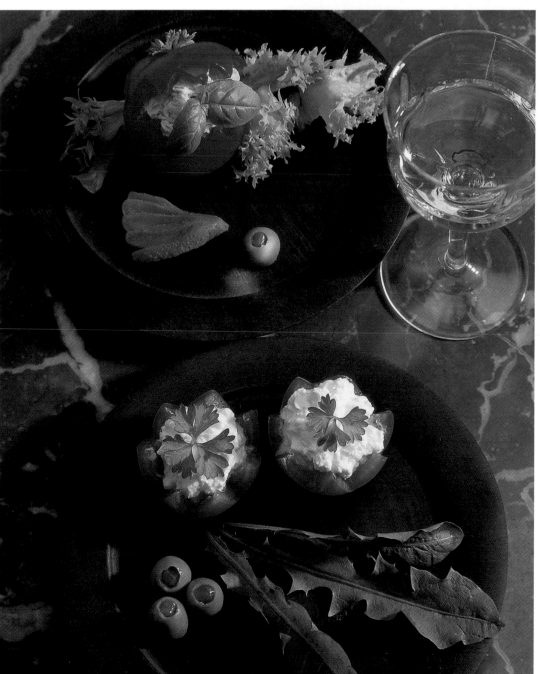

◄ **STUFFED TOMATOES**
The wooden plates came from an Oxfam shop; the marble background once graced a Victorian washstand; and the dandelion leaves came from the garden.

LINHOF SUPER TECHNIKA IV, 135/8 SCHNEIDER REPRO-CLARON, KODAK EPN. (RWH)

147

HOW-TO AND STEP-BY-STEP

'No, you do it like *this*.'

It's much easier to understand how to do something if someone demonstrates it for you, whether you are sewing a seam or stripping a gun. This is why there is always a market for how-to and step-by-step pictures. To anyone who suggests that a video tape is better, we say: try getting a VCR into the garage (or anywhere else you need it) and then getting it to run at the same speed you are working. With greasy fingers. And try seeing fine detail on a TV screen.

The first thing you need to do is to establish 'target behaviour', which is what you want your reader to (be able to) do after reading the sequence. This may sound obvious, but think of some of the 'how-tos' you have seen.

Next, assess your audience realistically. A car maintenance sequence for young housewives will require a different slant from one for experienced motor mechanics.

Third, break the sequence down into as many steps as are needed for clarity, but not too many more. If there is something that is particularly tricky – a way of threading a tool between two components, for example – then illustrate it, and mention that it can be tricky.

Fourth, remember that people are rarely insulted by even the most basic information, so long as it is not presented in a patronizing fashion. For example, what do you mean when you say 'Agitate the print in the developer'? Stick your fingers in and splash it around? Much better to say, 'Rock the developer tray gently, so that a low wave travels across the surface of the developer every few seconds.'

Fifth, use words as well as pictures. A picture may be worth a thousand words, but we have all encountered computer icons, or those little drawings that give us the washing instructions for clothes, where the thousand words come from our side, not theirs, and consist of imprecations at the idiot who drew this stupid picture that could mean anything. Keep the instructions brief but relevant.

Sixth, if a caption looks as if it is going to be disproportionately long, ask yourself if you cannot use two pictures instead. If all else fails, use the same picture twice, to make layout easier.

Seventh, if at all possible, avoid 'how-not-to'

shots. People remember these as easily as the 'how-to' shots: sometimes, it seems, more easily.

Eighth, be consistent. As far as possible, shoot from a constant viewpoint and at a constant scale. If you are going to change viewpoint or scale or both, as you may often have to do, make it clear that you have done so. Use the caption if need be.

Story boards and shooting

You needn't actually physically draw a story board: if you're more comfortable with words, just write out a shot list. Under the drawings (or the shot list headings), write the captions.

Using this as a framework, try a 'dry run' with someone who doesn't understand the subject, to see if it works. No matter how stupid and nit-picking their questions may seem, pay them careful attention. If they can misunderstand, so can someone else. And watch what you are doing (or the subject-matter expert is doing) to see if there are any extra points that need to be incorporated in the story board.

Once you are sure that the story board or shot list is as good as it needs to be, and you have the set-up ready (see below), you can start shooting.

Rehearse. Make sure you can shoot in the right sequence; that you can see what is going on; and that your model (if needed) can stop at the required points.

▼ **LIGHTING**
A soft box, directly over the subject, provides a broad, almost shadowless light that enables the photographer to concentrate on the subject without worrying about the effect that the precise viewpoint or degree of close-up will have on the image.

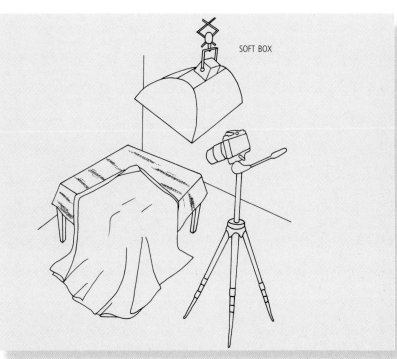

SOFT BOX

1 Fold the selvedge over, then make a second fold so that the selvedge is concealed under patterned fabric.

2 Pin the fabric in place every 5–8cm (2–3in). As you are working, the pins can always be repositioned if necessary to make way for an individual stitch.

3 Working from the non-pattern side (so that the knot on the end of the thread will be concealed), thread the needle through the fabric and bring it back through, just catching the edge of the rolled hem.

4 Draw the thread through, and repeat step 3, at a distance of about 3–5mm ($^1/_8$–$^1/_5$in). Note how each individual stitch (including the initial knot) runs 'backwards' against the direction of stitching.

5 Repeat. This is not rocket science. Unless you are taking a needlework examination, slight variations in thread length and thread spacing do not matter. Smaller, more frequent stitches are of course what your great-grandmother would expect to see.

HEMMING

In this sequence, the hands of the seamstress are omitted in the interests of showing the needlework clearly. If this is at all possible, it is well worth trying. The thread is darker than you would normally use for this fabric: we chose it so that it would show up better in the photography.

NIKON F, 90–180/4.5 VIVITAR SERIES 1, KODAK EBX. (RWH)

Overshoot. If you can slip in an extra picture at any stage, do so. These may be superior to your original ideas; they may provide useful supplementaries, if the caption gets too long (see previous page); and they are always a better idea than having to do a re-shoot.

If someone's hands are in shot, try as far as possible for a 'p.o.v.' (point of view) shot, as though the reader were in the position of the demonstrator. If the position is slightly strained, as it may be when you want to show how someone is doing something but their hands would normally be in the way, mention this in the caption too.

Always try to shoot as close as possible. 'How-to' shots are often run very small, and it is all too easy for the important detail to be lost if there is too much extraneous information in the frame.

Try to include an indicator of scale. Hands are ideal. Otherwise the tip of a screwdriver, or even a little mm/inch scale can be useful. This is particularly important if you are switching between longer shots and extreme close-ups.

If there is someone in shot, make sure that they are reasonably presentable: they needn't be stunning beauties, but they need to be clean and well turned out, without dirty fingernails, love-bites and so on. You might consider a touch of translucent powder, even with male subjects, to kill over-'hot' reflections.

If there are safety considerations such as machine guards, eye protection, gloves and so on, make sure that they are evident.

Presentation

Whether the sequence is for publication in print or for an audio-visual sequence (including transfer to video), label the slides (or prints, or image files) clearly and number them in sequence.

Even then, allow for the possibility that a designer or layout artist may scramble the order, or use the same image twice or more, or get the orientation wrong, whether upside down or 'flipped' into a mirror image. All three have happened to us. Check all proofs very carefully indeed, and if you are given proofs of inadequate quality, so that you cannot judge whether they are right, say so. Then check the final product again: it is by no means unusual for corrections to be ignored, or for final layouts to be done with less-than-final sequences.

Lighting and backgrounds

Broad, soft lighting, with a soft box or umbrella, obviates harsh shadows and is easier to handle. By the same token, neutral backgrounds are generally best. Plain white (or sometimes grey) Colorama is good, though we prefer fabric whenever this is possible, preferably a neutral cream or a white builder's drop cloth.

Equipment and materials

Generally, 35mm will deliver all the quality that you need, and it is much easier to find close-focusing lenses. It is surprising how often you need to be able to focus down to one-quarter or one-third life size, and even life size is frequently called for.

Although we have used medium format cameras, there is little or no advantage in doing so in most cases. If the client insists on medium format, a bellows-equipped SLR such as the Mamiya RB67 is much easier than one where you have to use supplementary lenses.

CLEANING SEQUENCE FOR CO_2 PISTOL

We apologize in advance to anyone who is allergic to guns, but this air pistol was the only thing we could readily find that was easy to disassemble and reassemble and had a small part that sprang out when you least expected it – an important point in many 'how-to' sequences. We could have used a watch, but we could not have got it back together again afterwards!

Such a sequence also makes the point that you have to be more careful with some how-tos than others. Get the sewing sequence wrong, and no great harm is done: give the wrong sequence with a firearm, and the reader can blow his head off. Fortunately, with a compressed-gas pistol, once the CO_2 cylinder is out it cannot discharge accidentally, unlike a firearm with one 'up the spout'. Even so, good firearms practice should always be applied even to imitation weapons used as props, let alone to working air pistols.

It would also be customary to print an enormous list of disclaimers and (for some markets) additional advice such as (for example) the likely effects of readers putting the muzzle in their mouths and pulling the trigger, or attempting to light a camp fire with the ammunition. But you have to make *some* assumptions about the intelligence of your readers.

The lighting (and equipment) was the same as for the sewing sequence: Frances sat off to camera right, with a short-sleeved blouse to make it easier to keep her sleeve out of shot.

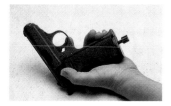

1 If the safety catch is on 'Fire', a red dot will show.

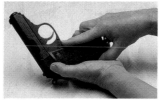

2 Push the safety catch to 'S' so that you cannot see the red dot.

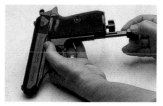

3 Press the magazine release catch (under the left thumb in this shot) and withdraw the magazine.

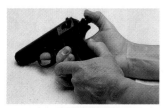

4 With both grips in place, unscrew the gas cylinder retaining screw to the limit of its travel. There will be a sharp hiss as the cylinder disengages.

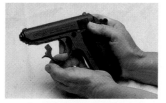

5 Hook a thumb or forefinger under the left grip and pull upwards.Remove the left grip: it is retained by two captive springs.

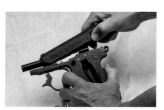

6 Remove the gas cylinder. It is easiest to turn the gun on its side so this falls out. Clean out the cylinder space.

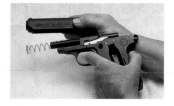

7 Cock the hammer. The slide will not come off otherwise.

8 Pull the trigger guard down. It is hinged at the back, and is held in place only by a strong spring.

9 Pull the slide backwards and (towards the end of its travel) upwards. When the slide is free at the back, allow it to move forwards against the slide spring.

10 When the front of the slide is clear of the barrel, it can be removed and cleaned. The slide spring may also be removed and cleaned.

11 The slide catch (with attached hairpin spring) tends to fall out but is easily replaced.

12 The hairpin spring needs to be tucked behind the slide catch when it is replaced. The slide spring has the flared end at the front.

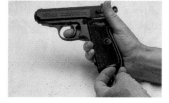

13 Hook the front of the slide over the barrel and pull backwards, the reverse of step 10 above.

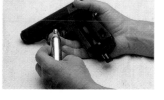

14 At the end of its travel, the slide must be pulled back and slightly downwards in order to engage with the slide rails.

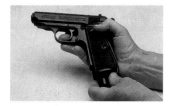

15 Release the safety catch (steps 1 and 2 above) and pull the trigger to release the hammer. The gun is now ready to reload.

'EXPLODED' PICTURES

'Exploded' photographs, showing the relationship of the different components of something, have two advantages over artwork. One affects the reader, the other, the publisher. Both should be in the photographer's mind.

For the reader, a photograph should be less open to misinterpretation: the subject should be more recognizable and comprehensible. From the publisher's point of view, photographs are usually quicker and often cheaper. Briefing should also be quicker; re-dos should be needed less often; and mistakes (if they are made) should be easier to explain and rectify.

There is also something to be said for 'exploded' pictures as competition entries, where they may win on novelty alone, or on humour value. Judges are so used to seeing incompetently nailed-together digital pictures, with internally inconsistent lighting and disparities of scale and perspective, that a competently executed shot can be a blessed relief.

Equipment doesn't particularly matter, except that if you are planning to scan an image, you will need a suitable scanner. Even a 600x1, 200dpi flat-bed scanner at 1,200dpi can give adequate results from 6x7cm, allowing enlargement to approximately 33x43cm (13x17in) as an ink-jet print or 22x29cm (8½x11½in) as a photomechanical reproduction.

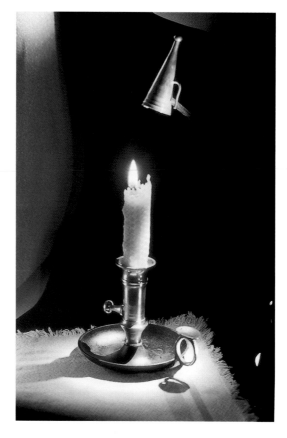

The basic route

The cheapest and quickest approach is simply to set the components down on a (preferably) transilluminated surface, with broad, overhead lighting, preferably from a soft box, and shoot straight downwards.

◄► CANDLE AND SNUFFER
Run a support rod through a background so that it will be concealed by the object supported: a fairly obvious trick, and easy enough once you know how.

▼ LIGHTING
With anything shiny like this candlestick, you need white bounces aplenty to get the highlights where you want them: you are basically photographing reflections. A single lamp provided all the illumination that did not come from the candle; tungsten is warmer than flash and matches the candlelight better.

▲ SPARE BULB
The spare bulb for an AAA Mag-Lite is hidden in the complex bottom end. A simple shot like this makes it easier to find, and easier to reassemble (and harder to forget bits — we forgot the spring in the first version of this shot).

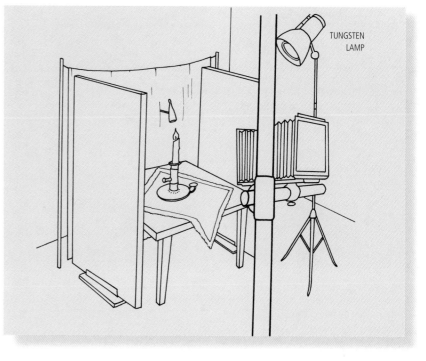

TUNGSTEN LAMP

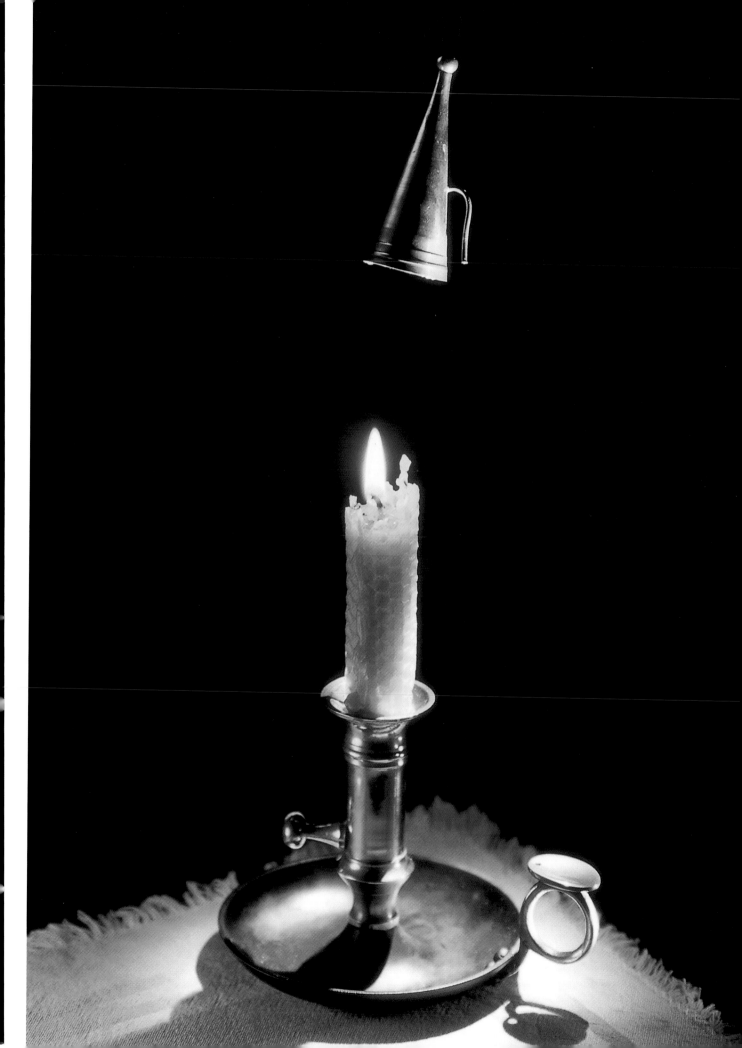

Try to keep a reasonable balance between overhead light and transillumination. If the background is too bright, and the overhead light too dull, the subject will always look grey and 'flat'. If the background is too dull, and the overhead light too bright, there will be shadows. Generally, weak (or no) shadows are preferable to overly harsh ones.

Watch out for flare. Whenever you are dealing with a transilluminated background, this can be a problem. A clean, new, multi-coated prime lens will give less flare than an old or dirty lens; or one that is single-coated; or a zoom. To minimize flare, use the deepest possible lens hood and mask off any areas of the light table that are outside the field of view.

To stop things nearer the camera looking disproportionately large, use a longer focal length or camera movements (pages 38–9). Alternatively, exploit perspective distortion, with the most important thing nearest the camera. A useful trick here is to make the set 'upside down', working away from the camera position, so that the top of the set is the bottom of the picture.

The de-luxe approach

A top-flight 'exploded' picture is built using a forest of wires, bamboos, scaffolds, double-sided adhesive tape and other supports to hold the parts in their best relationship. The unwanted parts are removed afterwards.

The most traditional way to do this was to 'block' big negatives (or even transparencies) by painting out all unwanted detail with opaque medium or red dye, or by cutting a red mask to shape. This is a skilled undertaking and should not really be attempted on anything that is smaller than 8x10in/20x25cm film or at the smallest 18x24cm/7x9½in. We have done it, but

can hardly recommend it today.

Another route, scarcely less skilled, was to make a big print and retouch that, usually with an airbrush. By working at two or three times the intended final reproduction size ('two up' or 'three up'), any flaws are minimized when the picture is shrunk for final reproduction.

Today, the easiest approach is without question digitally, in Adobe Photoshop or something similar. Scan the original; clone out the bits you don't want; and there you are. Even so, there are a number of tricks worth knowing.

It's always best to do as much as possible at the shooting stage. A few minutes extra in the studio can save ten times as long at the computer.

◀▼ BLOCKING A NEGATIVE
Fifteen or twenty years ago, this was one of the easiest ways to create an 'exploded' photograph – though as you can see, we weren't careful enough in positioning the 'tea-strainer' diaphragm, so it doesn't look quite right.

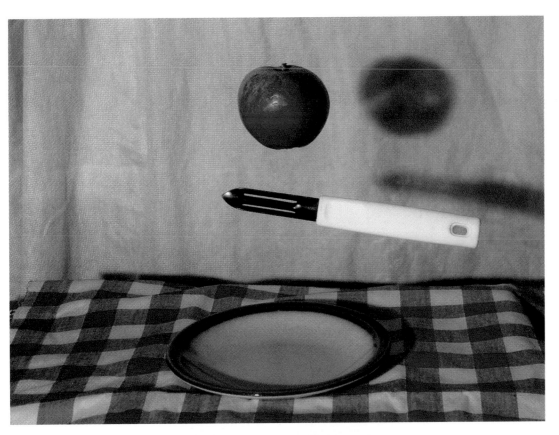

◄ ▼ **APPLE**
The two small pictures show the complete set-up, and the part that was photographed for retouching; the larger picture shows the final shot. The great thing about Adobe Photoshop and other imaging programs is that they allow you to 'clone in' backgrounds, removing the cotton and the support for the peeler and even allowing the background to be 'seen' through the handle of the peeler. Setting up the shot like this keeps lighting consistent and minimizes time in Photoshop. The picture was shot with a Ricoh RDC-i700.

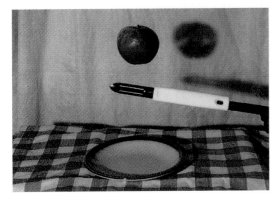

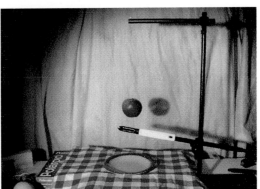

Broad, soft lighting is usually easiest, though you may need to use small shaving mirrors to light individual components.

Work with someone who is familiar with the product unless you are justifiably confident of your ability to disassemble and reassemble it (unless they don't mind getting it back in pieces).

With a complex set and conventional (silver halide) photography, always shoot a Polaroid if at all possible – or leave the set in place until you have seen the final shot. Professionals specializing in this sort of work use Climpex or something similar, as described on pages 74–5. Unless you value your time at nothing, these pay for themselves in the first few shots. Another invaluable tool is 'Wobble Wedges' (page 75), and small, inexpensive hot-melt glue guns are extraordinarily useful. So are self-adhesive Velcro

hook-and-loop material; Blu-Tack and similar silicone putties, the sort of thing students use to secure posters to the wall.

Fishing line is fine, strong and cheap. Ultra-fine tungsten wire is even stronger and finer, but a lot more expensive. It can be purchased from companies catering to the movie industry. At the other extreme, be aware of the usefulness of cheap, handy supports such as empty Polaroid boxes, 35mm film canisters, matchboxes, coins and so on. Don't neglect the possibility of gluing some components to vertical sheets of (spotlessly clean) glass – but watch out for reflections.

Avoid brightly coloured supports if at all possible, as they may reflect in things and may therefore require more spotting. Blacks, whites and greys are a lot safer in most cases.

APPENDIX: DECONSTRUCTING LIGHTING

◀ **ROGER AND FRANCES**
The key is a big but relatively hard side-light to camera left: you can tell it is low from the absence of bright highlights on the upper parts of the arms of Frances's silk blouse, big from the overall evenness of the light; but the edges of the shadows (look at Frances's hand) indicate that it is harder than you might expect. In fact it is a Lastolite UmbrellaBox. The fill – look at the catch-lights in the eyes – is quite small, low, and to camera right.

Working out how a picture was lit is rarely difficult, and once you know how to do it, every picture that you see and admire is as good as a textbook. What is astonishing is how few people ever attempt to acquire this basic and easily learned skill.

First, look at the shadows. Their direction will tell you where the key light comes from: camera left, camera right, above, backlighting, whatever. Look at their edges: soft-edged shadows mean a broad source, hard-edged shadows, a point source or a tightly focused source.

With big sets, do not be surprised by conflicting

keys. They should never be obvious on the main subject – two nose shadows, going in opposite directions, is plain proof of incompetence – but they may exist elsewhere: look at chair-legs and other unimportant areas. Look also for very faint shadows that are almost (but not quite) swamped by the key or fill lights: these often indicate the whereabouts of effects lights or 'kickers'.

Next, look at the highlights. The biggest giveaways are catch-lights in eyes. A classic combination would be one higher and stronger, the other smaller and weaker: the former would be the key, the latter, the fill. Other good places to look for highlights are on bare skin; on folds in fabric; and of course in any shiny subjects in the picture, such as glass of any kind, polished metal, or shiny paint and plastic.

Reflections often reveal the actual shape of the lights: the familiar square of a soft box, the tall, thin shape of a strip (a long, narrow soft box); the ugly and distinctive shape of an umbrella; the disconcerting doughnut of a 'bowl and spoon', or the much smaller shape of a plain reflector.

Now look at the intensity of the shadows. This

will tell you how much fill is present, and in conjunction with the other two signs you should be able to make a good guess both at where the fill is, and at how big it is.

There are always things that will fool you, though they will decline steadily in number as you gain experience and see more and more sorts of lighting. But even at first, you may well be surprised at just how much you can work out, how quickly, how often.

▲ SHARLENE AND STEVE

The key is a broad but relatively hard light well above the subjects, almost directly over the camera: look at the direction and hard edge of the shadows, which argue for the light being some distance away. In fact it was a 120x90cm (4x3ft) soft box. There appears to be no fill light: the fill comes from the bright, reflective background.

NIKKORMAT FT3, 70–210/2.8 SIGMA APO, KODAK EBX. (MMK)

◄ ZORKII 4K

The shadows clearly indicate a very broad, soft source, close to the subject: a soft box, directly overhead. It is slightly forward of the camera, or the top-plate would reflect the soft box much more brightly.

NIKON F, 90–180/4.5 VIVITAR SERIES 1, KODAK EBX. (RWH)

ACKNOWLEDGMENTS

A book like this is an accumulation and distillation of influences, experience, tips and ideas gathered over many years, and it is impossible to thank everyone. What we wanted was a book that demystified studio photography, and showed that it need be neither expensive nor difficult, while still giving some idea of the sheer range of what can be done: something more than the usual camera-club shots and basic how-to explanations.

If we have succeeded – and we think we have, though (as usual) never quite as well as we should have liked – then our first and greatest thanks must go to Marie Muscat-King, who is credited on the title page. The range and quality of her pictures never cease to astonish us. It is worth mentioning that we met her at our local camera club, about five years before we started this book, and that from the late 1990s onwards her pictures started to creep into our books and articles. The way she sees is quite different from our own vision, and we are grateful for the opportunity to use her images. Without her, this book would have been illustrated with a far more limited range of pictures: many of her shots are, we think, the best in the book. The really boring how-to shots, on the other hand, are ours.

It is unusual to thank a deceased friend in the acknowledgments to a book, but in this case it is fully understandable: Colin Glanfield (1935–1999) was Roger's first 'gaffer'. He taught him first the basics of studio photography, and then later – almost until the day he died – a good number of refinements. You are not forgotten, mate.

Otherwise, in alphabetical order, we should like to thank the following: Camerex in Exeter, who keep our 35mm cameras in working order; De Vere, whose colour head sits on our mighty 5x7in enlarger; Gandolfi, whose large format cameras we love, especially in 5x7in; Ilford, whose black and white films and papers we use almost exclusively; Jobo: the vast majority of our films are processed in a CPE-2; Lastolite, manufacturers of an unparalleled range of studio and lighting accessories; Nova, through whose tanks and washers almost all our prints pass; Bill Orford, who keeps our medium and large format cameras and lenses in good order; Paterson, whose film developers we use more than any other; Polaroid, without whom no studio photographer can work as quickly or easily; RK Photographic, the UK importers of Meopta enlargers and lenses; Tetenal, whose processing chemistry we use for monochrome paper and all colour processing; and Tiffen, whose single-format easels make repetitive printing quick and easy.

As we have noted in other books, these thank-you lists may seem like rather tedious bread-and-butter duty, but there is certainly more to it than that. These people are the backbone of the business: without them, photography is reduced to mere snapshots. Support them, and in doing so you are supporting the hobby/business/craft/science/pastime that we all love.

RWH
FES

INDEX